W9-AEY-143

For my parents, who inspired me with
botany and the beauty of plants.

AROUND THE
WORLD
IN
80
TREES

LAURENCE KING

Published in 2018 by
Laurence King Publishing Ltd
361–373 City Road, London,
EC1V 1LR, United Kingdom
T +44 (0)20 7841 6900
F + 44 (0)20 7841 6910
enquiries@laurenceking.com
www.laurenceking.com

Text © 2018 Jonathan Drori

Illustrations © 2018 Lucille Clerc

Jonathan Drori has asserted his right
under the Copyright, Designs, and
Patents Act 1988 to be identified as
the author of this work.

This book was produced by Laurence
King Publishing Ltd, London

All rights reserved. No part of this
publication may be reproduced or
transmitted in any form or by any
means, electronic or mechanical,
including photocopying, recording or
any information storage or retrieval
system, without permission from
the publisher.

A catalogue record for this book is
available from the British Library

ISBN: 978-1-78627-161-7
Printed in Italy

Jonathan Drori is an ambassador
for the Woodland Trust

WOODLAND
TRUST

woodlandtrust.org.uk

FSC
www.fsc.org
MIX
Paper from
responsible sources
FSC® C023419

AROUND THE
WORLD
IN
80
TREES

Jonathan Drori

Illustrations by Lucille Clerc

Laurence King Publishing

Contents

4

Introduction

The Trees

CENTRAL AND SOUTH ASIA

EAST ASIA

SOUTH EAST ASIA

OCEANIA

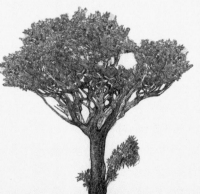

Introduction

I grew up near the Royal Botanic Gardens, Kew, London. My parents, an engineer and a speech therapist, shared a passion for plants and they inspired my brother and me with beauty and botany. This tree was used for deadly poison, that one for chocolate, another to insulate the communications cables that criss-cross the Earth. Here was a species with flowers that change colour when they are pollinated. We used all our senses: a lick of latex from an opium poppy was particularly entertaining, mostly for the look on friends' parents' faces when we told them. Virtually every story about a plant was part of a wider one about animals or people. I learned about the horror of the slave trade when my father gave me a tiny piece of *Dieffenbachia*, known in the United States as 'dumb cane' for the effect it had on the tongues and throats of plantation workers who had been too vocal about their lot. Those visits left me with a lasting interest in plants and their relationships with people, although I don't think anyone told me what a tree actually was. We just knew them when we saw them.

After a career that included making science documentaries, I found myself returning to Kew, this time as a trustee. I also joined the boards of the Woodland Trust and the Eden Project, and the Council of Ambassadors of the World Wide Fund for Nature, all

organizations that engage the public with the natural world. I soaked up the expertise around me and combined it with my own experience. Several TED talks and 3 million views later, I realized that there is public interest in plant stories that cross disciplines – hence my urge to write this book.

With a few provisos, the broad definition of a tree is a plant that has a tall, woody stem; it can support itself and lasts from year to year. Botanists debate how tall such a plant must be to qualify. I've decided not to be too precious about this: some of the trees in this book, such as jojoba, are frequently shrub-like but justify their place by growing much higher when the conditions are right. And anyway, what is a shrub if not a small tree?

The world's trees are astonishingly diverse – we now know that there are at least 60,000 distinct species. Unable to run away from animals that would love to eat them, they manufacture unpleasant chemicals as a deterrent. They exude gum, resin and latex in order to swamp, poison and immobilize insects and other attackers, and to exclude fungi and bacteria. Those defences give us chewing gum, rubber and the world's longest-traded luxury good, frankincense. Trees, such as the alder, which have adapted to live in wet places, have wood that resists rotting in water. The city of Venice was literally founded on such trees. Trees did not evolve to satisfy human demand, however. Over millions of years they adapted to environmental niches, to defend themselves and to ensure the survival and dispersal of the next generation. The best adapted bore more progeny and spread.

For me, the most satisfying tree stories are the ones in which a piece of plant science has surprising human ramifications. The relationship between the mopane and a single species of moth augments the diet of millions of southern Africans. The hybridization of the Leyland cypress was a rare botanical event whose consequences speak volumes about the British and their attitude to privacy. I have chosen the 80 tales in this book for their interest and their diversity, but they illustrate only a tiny fraction of the myriad ways in which trees and humans interact.

I still join plant- and seed-collecting expeditions as a videographer. In this book, like Phileas Fogg in Jules Verne's story, I have set out eastwards from my home in London. The trees are presented roughly in that direction and are grouped by geographical region. Being rooted to the ground, trees have an inexorable link to the habitat in which they grow, and every location forges different relationships among landscape, people and trees. Lindens (or limes) and beeches look familiar to a British eye, but the German affinity with those same trees has a nearly mythic quality. In the hot, dry conditions of southern Africa, baobabs go to extraordinary lengths to find and conserve water, and under a frazzling Middle Eastern sun, being able to slake one's thirst from a pomegranate fruit bursting with juice is laugh-out-loud special. In its native and biodiverse boreal habitat, the Dahurian larch reveals unusual adaptations to the cold, while the humid warmth of rainforests supports elaborate relationships, such as that between the Malaysian durian and the bat. Many Australian species, such as the *Eucalyptus* genus, secrete resins and essential oils that protect them against herbivores, while the trees of Hawaii, which lacks native grazing mammals, have had less need to develop spines and unpleasant chemicals. In Canada, the climate causes maple leaves to mount a gorgeous autumn display of colours. Back in Europe, the same species appears drab in comparison.

But it's not all about location. Trees have marvellously intricate relationships with other organisms. There are common themes – the clever tricks they play to achieve pollination, the bargains they make to have their seeds dispersed, even the ways they entice their enemies' enemies. In light of this, for some species, I have suggested a thematic hop to another tree. Many other connections can, of course, be made, and many different trips around the world can be taken. I hope these journeys and juxtapositions will encourage readers to contemplate the trees they encounter.

The complex relationship between organisms is also one among many factors that make global warming such a threat. For example, when flowers blossom earlier in the year than they used to, then – if the tree depends on particular pollinators that aren't around at that

moment – the species may not be able to reproduce. Or insects, on which a completely different plant or animal species may depend further down the line, might emerge with nothing to eat.

Scepticism about climate change is worth mentioning because mistrust of climate science, whether wilful or misguided, has a bearing on the survival of many tree species. Some people think climate change is about belief or opinion, the way they might think about politics or art. But the scientific method is quite different. Scientists form hypotheses about the world and search for evidence to support or confound them. They expose the results of their labours to other scientists before they publish them widely, inviting the professional community to pick holes in their methods, their arguments and their conclusions. If the results are surprising, other scientists will try to replicate the experiments and observations, again submitting their papers for peer review. This scrutiny is time-consuming and humbling but makes science special. When peer-reviewed research tells us that we are undergoing rapid climate change and that human activities are at the very least exacerbating the problem massively, then we should listen. Science is based on doubt and on evidence, not on politics or faith. Our species should expect to live and learn, and to adapt its behaviour accordingly.

The range and variation of trees form only one way of thinking about their incalculable value. One of my earliest memories is of a spectacular cedar of Lebanon, near our home. One winter morning we found it dead, its trunk and limbs strewn haphazardly and being sawn up. It had been struck by lightning. That was the first time I saw my father cry. I thought about the huge, heavy, beautiful thing that was hundreds of years old and that I had thought invincible, and wasn't, and my father, who I had thought would always be in benign control of everything, and wasn't. I recall my mother saying that there had been a whole world in that tree. I remember puzzling over that.

My mother was right. There was a whole world in that tree, and so there is in every tree. They warrant our appreciation, and many of them need our protection.

London Plane

Platanus × acerifolia

With large maple-like leaves and towering height, the London plane is a tree of pomp and circumstance, a symbol of a nation at the height of its powers. The branches begin high up the trunk so that mature trees have a lofty, architectural quality, giving plenty of shade without restricting the view at street level. Planted throughout London in the nineteenth century to complement the city's imposing squares and thoroughfares, the plane was the ideal symbol for the capital of a growing empire. Visitors, watching in awe and envy at state processions along plane-lined boulevards between Parliament and Buckingham Palace, would have got the message: here was the centre of a powerful, industrialized country, stable and confident enough to plan a century ahead, where even the trees were incorruptible. How British.

Except that the London plane is not merely an immigrant but one of mixed parentage: the multiplication sign in the scientific name denotes a hybrid, in this case between the American sycamore and the Oriental plane, which is native to southeastern Europe and southwestern Asia. Introduced by plant-hunters, the two trees probably met and mingled towards the end of the seventeenth century, although there is debate about whether this was in England, Spain or – *quelle horreur!* – France.

The London plane is an excellent example of heterosis, or 'hybrid vigour', whereby the offspring of two species or varieties that have each been isolated and inbred can show remarkably increased vitality and strength. The London plane was just such a cross and embraced with enthusiasm the burdens of city living.

In the heyday of its planting, the plane grew up alongside pumps and factories – the nineteenth-century engines of Empire. But the Industrial Revolution, which harnessed steam power, also left London black with soot. Few species could survive such insult, but the London plane is especially well adapted to urban life, having a special trick that helps it thrive in polluted air. Its bark is brittle and, because it cannot adapt to the fast growth of the trunk and branches underneath, it drops off in flakes the size of a baby's hand. The pleasingly random dappling left behind on the trunk resembles army camouflage and represents a critical part of the tree's defence. The bark of the London plane, like that of many other species, is dotted with tiny pores, a millimetre or two across, called lenticels, which

allow the exchange of gases. If these become clogged, the tree suffers. The ability of the plane to slough off a layer of grime that it has removed from the atmosphere helps to keep both this city-dweller and its human companions healthy.

Today, the London plane makes up more than half of London's trees. Berkeley Square has the most impressive specimens (planted with remarkable foresight in 1789 by a local resident), but there are plenty of others, lining the Thames riverside, populating the city's magnificent royal parks and serving as the city's shade and lungs. Town planners from around the world have had plenty of opportunity to consider the advantages of the tree for their own cities, and what was originally an almost exclusively London phenomenon has spread across the temperate world. Paris, Rome and New York have gained, at the expense of London's uniqueness.

But even this most stately of trees is not always dignified: in autumn and winter, dangling pairs of seed-balls festoon it, creating quirky silhouettes that pander to smutty schoolboy humour. The pom-poms also provide food for birds and the raw material for itching powder. On a sweltering July afternoon, though, London's planes are a glorious and imposing spectacle and a reminder of a time when this was the centre of the world.

Leyland Cypress

Cupressus × leylandii

The story of the Leyland cypress turns on the peculiarly English preoccupations with privacy, gardening and, of course, class. In the nineteenth century, when British plant hunters brought back the hardy yellow cedar from Oregon and the faster-growing but more feeble Monterey cypress from California, they had no idea of the mayhem they would cause more than 100 years later. These conifers are not closely related, and in their native habitats, 1,600 kilometres (1,000 miles) apart, they would never have hybridized. In mid-Wales, however, they were planted close together and managed to breed. The monster offspring is popularly called Leylandii after Christopher Leyland, who owned the estate where the fateful mating occurred.

Slim, upright and resistant to both salt spray and pollution, Leylandii is alarmingly vigorous – able to leap more than 1 metre (3 feet) a year, often to a height of 35 metres (115 feet) or more. Planted in a row, the trees quickly form an oppressively dense, dark-green wall. But it wasn't until the late 1970s, when garden centres became widespread and improved propagation techniques enabled Leylandii to be mass-produced reliably from cuttings, that the tree became available to all. And that's when the trouble started.

In the English suburbs, where people live close together yet have private gardens, prying neighbours and being overlooked are obsessions. But the UK has planning laws that limit the height of man-made fences between properties to 2 metres (6½ feet). What the paranoid suburban householder needed was a living fence that would be beyond the scope of regulation and which would grow at breakneck speed into an immensely tall, impenetrable screen. Leylandii perfectly filled that gap in the hedge market, and over the next 20 years it became the go-to solution for anyone seeking seclusion. By the early 1990s, half of all trees being planted by the English public were Leylandii.

Instant privacy came at a price, however. Neighbours discovered that precious little would survive in gardens overshadowed and acidified by Leylandii. The angry occupants of lower floors complained of perpetual twilight and obstructed views. Adding insult to injury, Leylandii was regarded suspiciously by 'proper gardeners' and the upmarket press as a vulgar tool of incomers and the nouveau riche, fuelling a feud among the class-conscious.

By the late 1990s, Leylandii hedges were a cause célèbre. The media loved publishing stories of feuding neighbours coming to fisticuffs over lost light. Hedge strife caused a suicide and at least two murders. One politician, representing the leafy west London suburb of North Ealing, observed that, 'for those who were driven more by hate than a desire for privacy, Leylandii had become a weapon of choice, as much as a gun or a knife'.

Repeated debate and discussion of Leylandii ensued in both houses of Parliament; the House of Commons returned frequently to the subject and spent a total of 22 hours in solemn consideration. In the House of Lords, the matter was raised by the encouragingly named Lady Gardner of Parkes. By 2005 there were more than 17,000 concurrent known hedge disputes between neighbours (and doubtless many others unreported). That year, district authorities were given new powers to use Anti-Social Behaviour Orders against nuisance hedges. Known to the English as ASBOs, these somewhat controversial restraints on citizens have been associated, often unfairly, with working-class problems, such as reining in delinquent teenagers on public housing estates and curtailing the behaviour of Staffordshire pit-bull terriers – dogs that, come to think of it, are another aggressive and problematic hybrid.

By 2011 the total British Leylandii population was a staggering 55 million, and by now it is likely that the trees outnumber humans. But at least there's a rather British compromise between privacy and the right to light – for now.

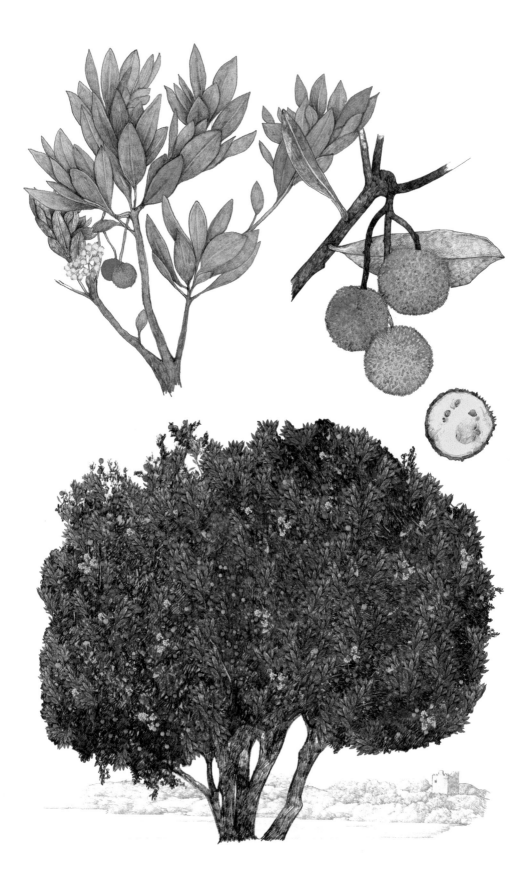

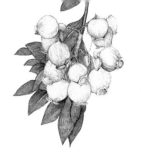

Strawberry Tree

Arbutus unedo

The strawberry tree is native to the western Mediterranean and the windswept southwest of Ireland but – mysteriously – not to Britain. The most likely explanation is that, whether by accident or by design, Neolithic sailors brought the species with them from the Iberian Peninsula some time between 10,000 and 3,000 BC. This theory is supported by DNA analysis of the Eurasian pygmy shrew, which apparently made the same journey, and of Irish people, some of whom have genetic similarities with communities in northern Spain. Whatever their provenance, wild strawberry trees seem glamorous and exotic in County Kerry.

A dense and twisting evergreen reaching about 12 metres (39 feet) in height, the strawberry tree has attractive bark, reddish and peeling, which complements its vivid foliage. Cream or rose-blushed flowers on pink stems appear a couple of dozen at a time, like drifts of miniature hot-air balloons. Sweet-scented and a rare autumnal bloom, they are a pretty treat for us and valuable to bees at a time of year when nectar is scarce. Strawberry-tree honey has a bitter taste, but is popular on the Iberian Peninsula, where the species is common.

Fruit formation is delayed for five months after pollination, so – very unusually – the urn-shaped flowers appear side-by-side with the previous year's now-ripening fruit. Despite the name, the fruits resemble tempting scarlet lychees more than strawberries – but there is a reason that they are not cultivated more widely. Promisingly yielding when ripe, the fruit's flesh is golden-yellow but it has a disappointing, mealy texture and a flavour that is reminiscent of peach or mango but subtle to the point of blandness. The name *unedo* is a contraction of *unum tantum edo*, attributed to the Roman naturalist and commentator Pliny the Elder, meaning 'I eat only one.' They do become almost palatable when over-ripe enough to have started fermenting: the little kick of alcohol definitely helps, and may have been the original inspiration for *Aguardente de Medronho*, a fiery liquor distilled by Portuguese farmers who collect the wild fruit.

Madrid's coat of arms depicts a bear stretching for fruit from the *madroño*, the strawberry tree. According to local popular etymology, the Spanish capital city and its arboreal symbol have a common root in *madre*. The words are almost certainly unrelated, but the desire to connect them reveals *Madrileños'* affection for their 'mother tree'.

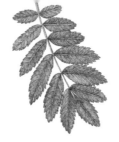

Rowan

Sorbus aucuparia

The rowan is a small, exceptionally hardy deciduous tree, widely spread across central and northern Europe and Siberia, and very much at home in the windy Scottish highlands. Its clusters of pretty cream flowers have a strong scent and plenty of nectar to attract hordes of pollinating insects. In bad weather, when insects are scarce, the flowers can self-pollinate, a practice that has the genetic disadvantages of inbreeding but which beats having no progeny at all.

By early autumn, the rowan's slender branches are bowed, laden profusely with pea-sized berries in bright orange or scarlet bunches of 20 or more. (To be accurate, the berries are actually 'pomes', which, like apples, are formed at the swollen base of a flower. Examined carefully, flower remnants are indeed visible opposite the stalk – in the pattern of a pentagram.) Undeterred by the problems of nomenclature, birds are attracted to the bright colour; in ancient times the berries were used as bait for bird-catching, called *aucupatio* in Latin, from which the rowan's formal name is derived. After the feast, birds excrete the undigested seeds far and wide, along with a handy dollop of fertilizer.

The seeds germinate a year or two later, sometimes in clefts and crags, or even among the moist detritus of hollows in other trees. Such 'flying rowans' were thought to possess powerful magic that could protect against witchcraft.

The rowan has bestowed another kind of protection that would once have been considered magical. Its unripe berries contain sorbic acid, which has anti-fungal and antibacterial properties, while being relatively harmless to people. Synthetic sorbic acid and its derivatives are now widely used in the food industry as preservatives, guarding us from mould and infections.

Rowan berries contain a preservative. Date stones (p. 72) have remained viable after 2,000 years.

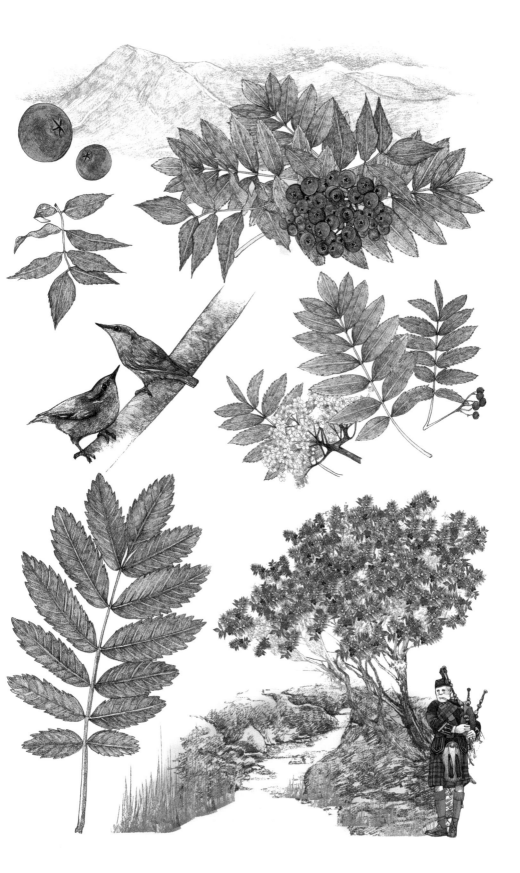

Silver Birch

Betula pendula

The silver birch is an able pioneer. Its pollen bursts in clouds from its catkins and throngs of tiny, winged seeds fly far on the wind. Some 12,000 years ago, as the last ice age thawed, the birch was one of the first trees to colonize newly exposed earth, which is why its native range extends so far: from Ireland, across northern Europe and the Baltic states, beyond the Urals and far into Siberia. Birch forests are impressively biodiverse: deep roots pull up nutrients that are recycled on to the topsoil when leaves drop, and gaps in the canopy generously allow other plants a look-in.

With cascades of delicate, pendulous branches that sway in the breeze, the silver birch is as graceful as a ballet dancer. Its fluttering leaves are pale-green diamonds, serrated and borne on slender twigs, warty from their resin glands. Its implausible paleness is an adaptation, helping trees that lack the shade of dense foliage to keep cool trunks in the day-and-night sunshine of a northern summer, or in the glare of snow. The bark of young birches is invitingly smooth. As the tree matures, however, thickened, dark, corky patches appear near the ground in order to protect the tree from fire. The thickened bark can be boiled to extract a tarry resin that inspired the Latin name *Betula*, from the same linguistic stock as bitumen. Some 5,000 years ago, the locals used bark resin as an antiseptic chewing gum – pieces have even been found that still bear tooth-marks.

In 1988 the Finnish people – ever enthusiasts for democracy – voted the silver birch their National Tree. Their choice had little to do with its commercial use for pulp and ply, nor its excellence as firewood, but was an expression of emotion. By day, the distinctive monochrome pattern of snow-clad birch forests is dazzling and disorientating, but during long boreal nights, their moonlit, ghostly forms take on an eerie power. Birches abound in the folk tales of northern peoples and many superstitions and rituals surround the tree. Birch sap, which rises in the last throes of winter, just before bud-burst, is taken as an early spring tonic. Tapping is delightfully simple: drill or stab a small hole on the south side of the tree and pop in a tube. The resulting fluid looks and tastes like slightly sweetened water. It does contain some important vitamins and minerals, although possibly not enough to warrant its almost mythic reputation for health-giving properties.

The birch has been revered for centuries for its ability to renew and purify – and to subvert spells and sorcery. Some Finns still place birch saplings in doorways as symbolic protection. Birch twigs are sometimes infected by a fungus called *Taphrina*, which causes them to branch chaotically into tousled nests called 'witches' brooms', and these have supernatural associations in many cultures.

While *Taphrina* attacks birch and causes haphazard growth, another, more familiar, fungus is the tree's partner. Trees often develop symbiotic relationships with mycorrhizal fungi, which intermingle with their roots and extend beyond them in a huge web of minutely thin filaments. These networks are especially good at extracting nutrients from the soil, which they pass on in an easily digestible form. In return, the fungus receives sugars from the tree. Individual tree species cooperate with particular fungi. The birch's life-partner is *Amanita muscaria*, the fly agaric, whose fruiting bodies (the parts we see above ground) are scarlet with white sprinkles – the archetypal toadstools of every fairy tale. Fly agarics contain a cocktail of mind-bending hallucinogens around which all manner of shamanistic rituals have evolved, particularly among Siberian tribes and the Saami people of northern Finland and Sweden. So far, so human – many cultures have psychedelic traditions. However, the fly agaric's psychoactive ingredients are not completely broken down in the body, but excreted. This offers the enticing possibility of intoxication – and a spot of social bonding – by drinking the pre-drugged urine of others. It's true that northern nights are especially long and the forests might have been lacking in other excitement. However, one can't help wondering whether this practice was really as widespread as the few historic travellers, who seem to be the common source of all the shamanistic pee-drinking stories, were told, and so eagerly reported.

The source of the world's best-known sap is the sugar maple (p. 226).

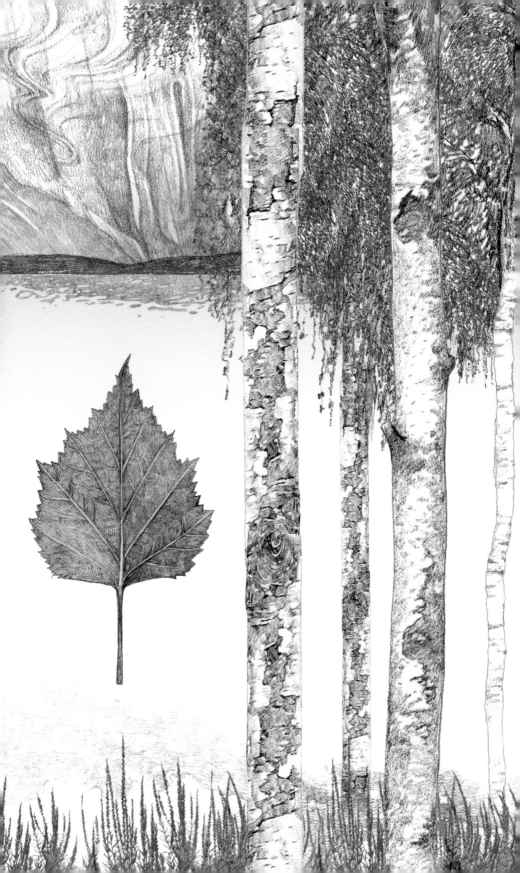

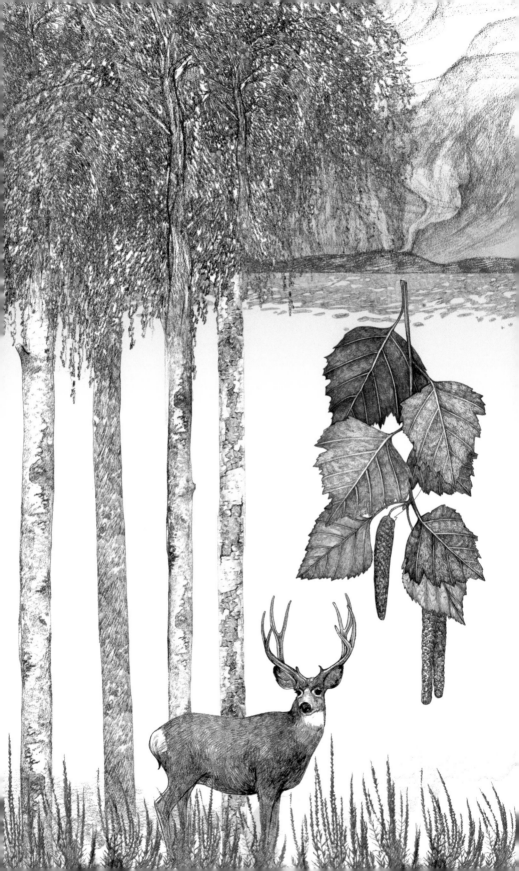

Elm

Ulmus spp.

Dutch Elm disease has little to do with the Netherlands other than the fact that the pathogen, which is thought to have come from eastern Asia, was first identified there. By coincidence, the best places in the world now to see elms are the Dutch cities of The Hague and especially Amsterdam, where more than 75,000 specimens line the canals and streets.

The elm species native to western Europe are beautiful and similar to one another. Often as much as 30 metres (98 feet) high, slim, stately and proudly irregular, they are densely twiggy at the extremities with clouds of foliage billowing from a few big, upward-pointing limbs: a characterful favourite of Old Master paintings. Elms are deciduous, with serrated leaves that are distinctively asymmetric, beginning higher up the stalk on one side than the other. They like a lot of light, flourishing in open landscape and hedgerows rather than dense stands. They are tolerant of city pollution and rot-resistant, and in medieval times their timber was commonly used to make water pipes.

The downfall of the elm was hastened by a quirk of history. One particular species, the English elm (*Ulmus procera*), had been transported to western Europe by the Romans, who used it to support and train their vines. Despite producing clusters of small coral flowers and masses of seed – each centred in a flat, papery disc called a samara and able to catch the wind – these elm trees were generally infertile. Instead, they were spread from cuttings or by root suckers (shoots sprouting near the base of the tree), resulting in genetically identical clones – all of them susceptible to the same pests and diseases.

The first Dutch Elm epidemic, in the 1920s, fizzled out, but the second wave, in the 1970s, caused by the highly aggressive fungus *Ophiostoma novo-ulmi*, led to an environmental disaster and killed hundreds of millions of elms across Europe and North America – 25 million in Britain alone. The many street and even town names containing 'elm' and 'ulm' are a reminder of the loss to the landscape and to the web of insects and birds that depended on old elms.

The disease is spread by beetles that bore through the bark, carrying fungal spores with them. Damage is caused by toxins in the fungus and also by the tree's attempt to block its spread by sealing the system that

transports water and nutrients. In early summer, swathes of leaves turn yellow, then brown, wilting and withering. A large tree can be dead in a month. The surface of the bark may appear undamaged but underneath, the horrific but compellingly beautiful telltale starburst of radiating tunnels made by beetles is often visible.

Elm bark beetles like only to colonize trees of substantial radius. Hedgerow saplings still propagate by root suckering and develop healthily, but they succumb to attack after their first few years. Pockets of large elms survive in just a few places, such as on England's southeast coast (where they are isolated by the prevailing wind and a natural barrier of treeless hills) and, thanks to the citizens' slavish efforts, in Amsterdam. The Dutch first tried synthetic fungicides, but those were only marginally effective and poisoned other parts of the ecosystem. Much more successful has been a preventative inoculation each spring into healthy trees of a different, harmless fungus that seems to stimulate the tree's own defences. The city authorities combine the annual injections with scrupulous tree monitoring and hygiene. Attentive citizens report suspicious material and there are mandatory inspections of trees, even on private land. Contaminated wood is immediately cut and destroyed. The annual infection rate has dropped to just 1 in 1,000 trees. And at last, decades of painstaking breeding have produced at least ten fungus-resistant elm cultivars, which are now being planted abundantly in Amsterdam and elsewhere.

Fungi and their carriers arriving from abroad may encounter little natural resistance and can therefore wreak havoc. Given how hard it is to control international trade and the associated movement of pests and diseases, we should at least maintain the greatest possible genetic diversity in our tree species, so that when the worst happens, there is a pool of genes conferring useful traits and from which nature can breed afresh, possibly with our help.

Fungi aren't all bad. The western hemlock depends on nutrients released by fungi from rotting logs (p. 204).

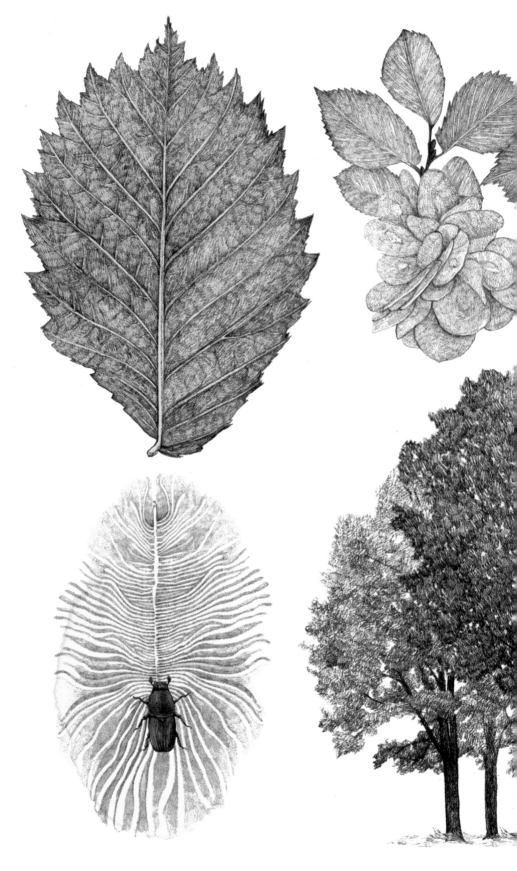

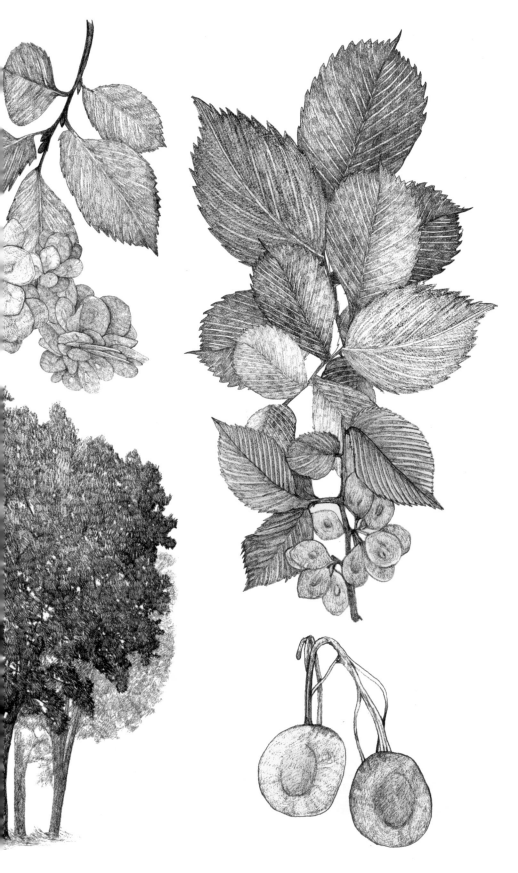

White Willow

Salix alba

I n wet soil, the willow is ludicrously easy to propagate: cut a stem, pop
it in wet ground and ... er ... that's it. The roots and suckers spread
widely and make a beeline for water, a talent that can cause havoc when
a willow explores the tiniest leaks in pipes and sewers and then infiltrates,
expands and clogs. By a riverbank, however, the willow's mass of tangled
roots prevents erosion and provides shelter for wildlife.

There are about 450 species of willow, widespread across Europe,
and the frequent intermarriage between them means they have much in
common and are easily distinguished as a group. Mature white willows can
reach 30 metres (98 feet) tall with graceful foliage but sometimes lopsided
crowns. The leaves are long and narrow, initially velvety on both sides but
tending to lose their nap on the upper surface as they mature, giving the
tree a silvery-grey appearance from afar, hence the common name. The
flowers, borne on slender catkins in early spring, are especially striking since
they appear before the leaves. Looking like long, fluffy caterpillars with a
dusting of egg-yolk-yellow pollen, they are particularly attractive to both
bees and flower-arrangers.

In English, 'willowy' can be used to describe anything particularly
slender and flexible. Since prehistoric times, thin willow stems, or osiers,
have been woven into baskets, boat frames, fences and fish traps. Osier-beds
once stretched along the banks of European waterways to supply the trade.
A recent trend for organic artworks – sculptures and even furniture woven
from the stems and branches of living willows – can feel gimmicky but also a
touch magical, which is appropriate for a plant that has had long association
with superstition.

One species, *Salix babylonica* – the weeping willow – got its name from a
mistranslation of Psalm 137: 'By the rivers of Babylon, There we sat down
and wept, When we remembered Zion, Upon the willows in the midst of
it, We hung our harps.' The tree in question was probably the Euphrates
poplar, not a willow, but the association between drooping willows and
sorrow stuck. Throughout Europe, the practice of wearing a wreath or
hat made from willow to signify mourning lasted for several centuries in
the Middle Ages, at least in popular song. Eventually the willow's gloomy
connotations broadened to include a lover's rejection, and 'wearing the
willow' came to signify that a woman was not available to another man.

In modern Dutch, to hang up your cigarettes on the willows means giving them up.

Superstition has created a link between willow and sadness, but it has a connection with the relief of physical pain that is based on good chemistry. Ancient Egyptians were already using willow to treat fever and headaches, and in about 400 BC Hippocrates prescribed willow bark for rheumatism. In the Middle Ages there were scores of European examples of willow's effectiveness against fever; and a popular cure for toothache was to take a splinter of bark and insert it between gum and tooth. We now know that willow bark contains significant amounts of a chemical called salicin, which can be converted in our bodies to substances that have analgesic and fever-reducing effects. This 'magic' might therefore have worked even without the second part of the cure, which was to return the now-bloody sliver to the tree, to carry the pain away with it. In the mid nineteenth century salicylic acid was finally isolated and turned into what is now a ubiquitous treatment for fevers and frets, consumed in about 100 billion pills a year. That drug is aspirin. (It was named after another plant with similar chemistry, the meadowsweet, which at the time was called *Spiraea*.)

Willows' affinity for water has enabled them to flourish in the Low Countries, where they are a dominant feature of the countryside. However, in keeping with a largely man-made agricultural landscape, they are not left to grow naturally but are pollarded. The tops of the trees are pruned severely each year to just a few metres high, forcing the growth of large, knobbly, club-headed stubs from which long shoots grow prolifically to form a bushy crown (well above the reach of browsing cattle). For hundreds of years, pollarded willows have been grown for the supply of stems and as distinctive boundary markers. Inextricably linked with the region, they feature repeatedly in paintings by Rembrandt and Van Gogh. In Belgium, some say that the pollarded willow is a metaphor for the country's people – solid, restrained and hard to knock over.

Willows thrive by water. But what is the maximum height that leaves can be from a tree's roots (p. 206)?

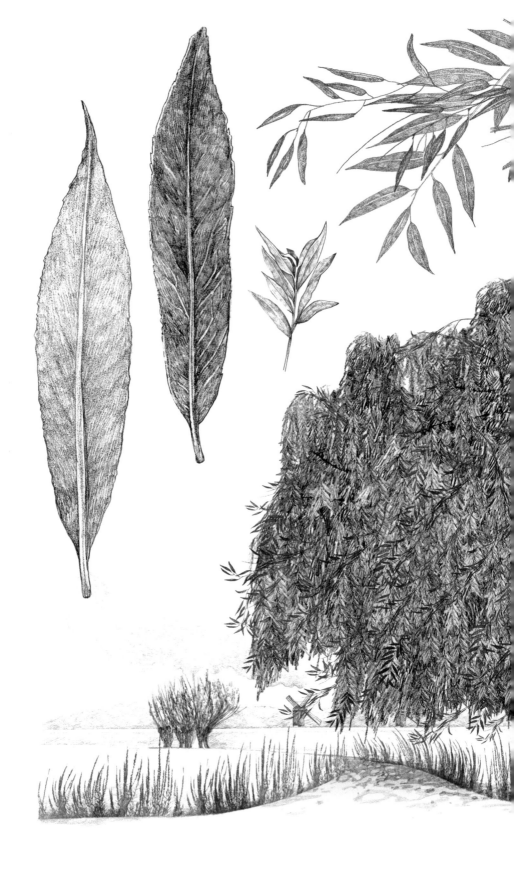

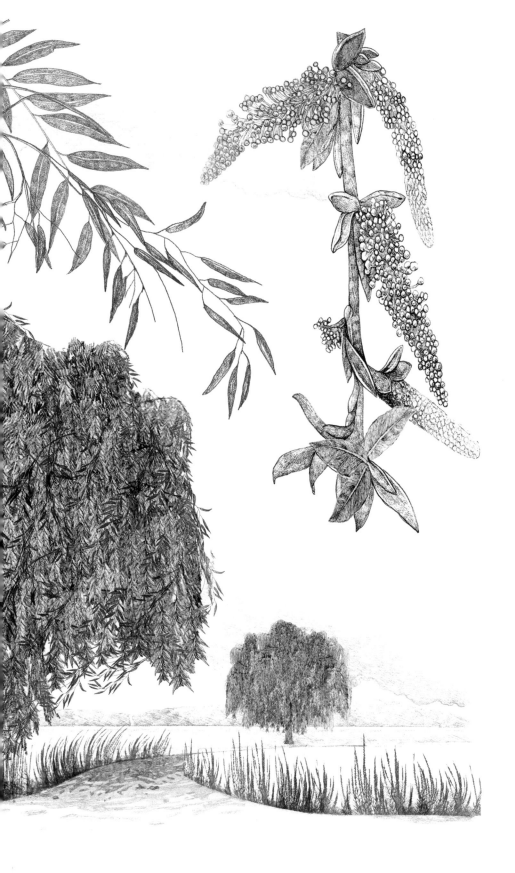

European Box

Buxus sempervirens

The little box tree's small evergreen leaves and their tolerance for constant trimming and tweaking make them ideal for topiary. Native to southern Europe, from the Atlantic to beyond the Caucasus, box is most common now in France, on the Spanish slopes of the Pyrenees and in southern England, where suburban topiarists take special pride in eccentric shapes. The French particularly enjoy order in their gardens and, from Albi to Versailles, the grounds of every cathedral and grand chateau sport box in formal low hedges and geometric patterns. This use has a long history: the Romans gave us 'topiary' from the *topiarius*, the garden designer who produced miniature ornamental landscapes (*topia*) and menageries of toy animals from box trees.

Box flowers are nondescript, but their scent polarizes opinion; for some it is headily reminiscent of resin and country childhood, while others sense mainly the whiff of cat pee. Aristotle, in his *Book of Marvels* (*De Mirabilia*), described honey from boxwood as having a heavy scent, but he knew its danger: 'They say it makes healthy men go mad, but that epileptics are cured by it immediately.' We now know to avoid boxwood honey because it contains various alkaloid poisons.

Boxwood grows at a snail's pace, and is the heaviest of European timbers. Its annual rings are so closely laid that the delicately yellow wood is uniform, finely textured and hard as nails. In the second half of the nineteenth century, this rare combination made it the material of choice for minutely detailed carving of engraving blocks, used for printing illustrated books and newspapers. It was a huge industry. In the 1870s there were hundreds of European firms specializing in woodblock illustration. (Pleasingly, there were even engravings illustrating boxwood being used for engraving.) The wood had to be imported in large quantities from as far afield as Persia, and box stocks inevitably dwindled. Dozens of substitutes were tested without success until, fortunately, other printing techniques took over, such as cylinder offset printing and copper-plate etching.

Boxwood is associated with music as well as art. The ancient Egyptians used it to make lyres, and for several hundred years its stability and capacity to be accurately turned and drilled have meant that it has been used for woodwind instruments such as oboes and recorders.

Lime Tree, Linden

Tilia × europaea

In North America, *Tilia* is known as 'basswood', from 'bast', the tree's inner bark, which is often used for cordage and mats. However, across Europe the lime, or linden, has more romantic and nostalgic associations. Typical German villages have a central lime tree, a meeting place and the symbolic heart of the community, where medieval legal judgments were made *sub tilia* – under the lime tree – as an assurance of truth. Linden trees were also associated with Freya, the Germanic goddess of love, spring and fertility, and their shade became the scene of fairy-tale trysts between knights and maidens. Nowadays Germans fondly remember having their first kiss under linden branches, even if they never did. Proust played on this in *À la recherche du temps perdu*, in which the narrator dips a madeleine cake into lime-blossom tea, triggering a chain of involuntary memories.

The lime is a substantial tree that can prosper for a millennium. Easily 40 metres (130 feet) high, it takes on imposing, craggy girth with age and has rapidly dividing branches covered in seductively heart-shaped leaves. The creamy-yellow flowers, known as *tilleul* in France and *Lindenblüten* in Germany, are widely used to make a soothing herbal tea. Throughout central Germany the trees are planted in glorious avenues, providing deep and sweetly scented shade in summer. To linger in a linden grove in June is almost addictively intoxicating. Bees are attracted by the fragrance, too, and the pale honey they produce is richly flavoured – fresh and woody, with a hint of mint and camphor. However, the nectar is heady stuff; it contains a sugar, mannose, that makes them woozy if they overdo it. The ground beneath a lime is often dotted with befuddled bees.

Lime trees harbour aphids that excrete honeydew, a sugar solution enjoyed by ants but an irritation to urban car owners. It rains down in fine droplets and adheres to vehicles, which soon become coated with dust and city detritus. The expensive Mercedes and BMWs that are parked on Berlin's best-known boulevard, *Unter den Linden* ('under the lime trees'), often suffer the effects of the double rows of trees after which the street is named. But, even to a people noted for their inclination to order, a little grime is a small price to pay for such powerful emotional appeal.

The whistling thorn (p. 94) also has an interesting association with ants.

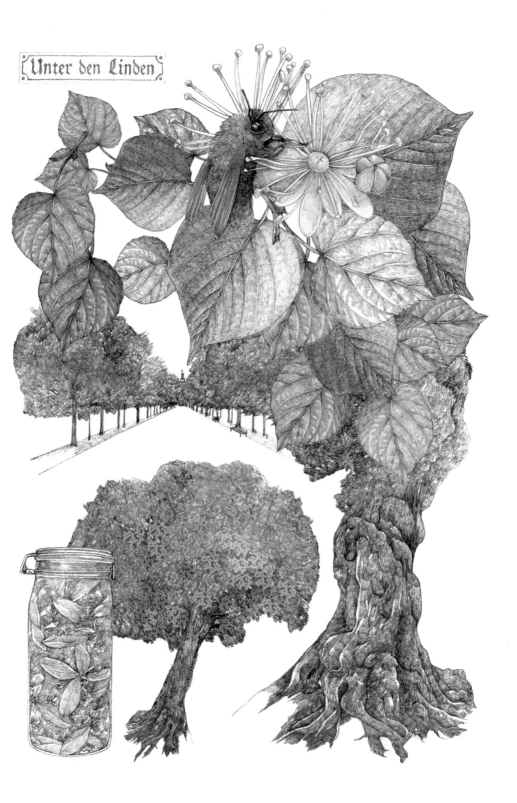

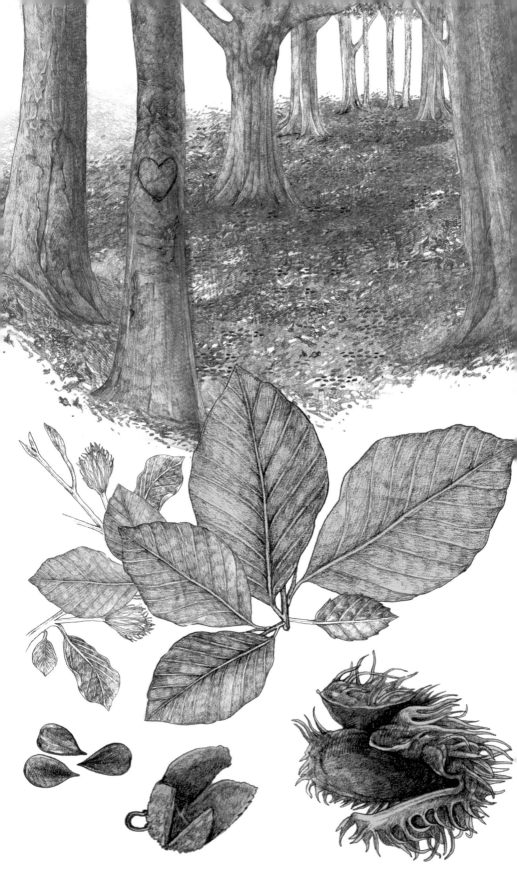

Beech

Fagus sylvatica

Statuesque and resolute, beeches are common throughout central and western Europe. The leaves, which have a distinctively undulating edge, are silken-haired and lime-green when new, darkening as they mature. Successive layers of leaves overlap; the resulting gloom deters less shade-tolerant species from growing and makes beech forests, which lack shrubs close to the ground, strangely quiet. In autumn the beech nuts, or 'mast', support many animals and, in hard times, people too – the scientific name *Fagus* is derived from the Greek stem for eating.

The beech has a smooth complexion, even in old age. When other tree species, such as oak, grow in girth, their new bark forms a layer underneath the old. Unable to expand, the old bark cracks and forms deep ridges. Beech bark, however, can expand sideways to accommodate growth and stays even by continuously shedding its top layer in minuscule fragments.

The German superstition that beeches repel lightning may have a scientific explanation: lightning probably hits different tree species of a similar height equally often, but beeches may be less prone to damage. Sleek beech bark is easily wetted by rain, so that when lightning strikes, electric current can flow easily down the outside of the tree, causing little damage. In contrast, the dry crags of oak or chestnut encourage electricity to flow through the wetter centre of the tree, where it causes water to boil explosively, ripping the tree asunder. Or, more prosaically, oak trees may be more common than beeches as single trees in the landscape, and are therefore more likely to be struck.

The beech's smooth bark has a long association with writing. The Roman poet Virgil admitted to incising beech-bark graffiti, and Saxons and other early Teutonic peoples used beech wood or bark panels to carve runic and other inscriptions. When early books had leaves of vellum, the protective front and end covers were frequently beech boards. Over time, the words for beech trees and the written word in many languages became intertwined. In German, for example, a beech is *Buche*, a book *Buch* and the letters of the alphabet are known as *Buchstaben* – literally, the marks made on beech-wood slats. Medieval European writing desks were often made of beech; before Gutenberg, letters were carved from its bark for early experiments in printing. Today's trees often bear hearts and Cupid's arrows, the scars of satisfying the twin desires to declare love and fill the blank page.

Horse Chestnut

Aesculus hippocastanum

Scarce now in its native Greece and central Balkans, the horse chestnut flourishes in the parks and avenues of temperate cities worldwide, thanks to centuries of affection from landscape gardeners and town planners.

In Kiev, an early nineteenth-century craze for planting horse chestnuts never abated, and tourist brochures rightly boast that there is nowhere better to enjoy them. They're everywhere. With solid trunk and limbs and a classically bell-shaped silhouette, each tree becomes a towering candelabrum by May, when the characteristically ample and sticky buds of early spring have burst into distinctive fans of five or seven leaves and constellations of exuberant flower 'candles' lure tourists and pollinators alike. The bees transfer pollen, which contains the forerunners of male sex-cells, from tree to tree and are rewarded with energizing nectar. As the nectar is drunk, the individual flower helpfully changes colour, from yellow to orange to carmine, signalling to the industrious bees that they should busy themselves elsewhere. This attractive show of mutualism allows the trees to concentrate on making nectar in flowers that have still to be pollinated, while bees avoid wasted journeys.

The tree's substantial seeds, released from their spiny, padded husks, are improbably shiny and, of course, chestnut-brown. In Britain, children are drawn to these precious 'conkers' for a game of the same name. Players skewer a hole in their conker, thread it on to a shoelace, then take turns trying to smash their opponent's conker by hitting it with their own. Key elements of gameplay are the inevitable and surprisingly sophisticated negotiations over scoring rules, what happens when strings get tangled, and the earnest denial of having secretly baked or pickled one's conker.

While the 'conker tree' calls to mind playful childhood days, the horse chestnut is also an upsetting reminder of Europe's darkest hour. During World War II, Anne Frank could see a horse chestnut from a window in the Amsterdam attic where she lived in hiding. She wrote in her diary that winter's bare branches, which would surely flourish in spring, inspired her with hope. Sadly, she was betrayed and did not survive, but when the tree itself died in 2010, saplings grown from its seeds were distributed as beacons of optimism and living symbols of the desire for a society of mutual understanding and respect for diversity.

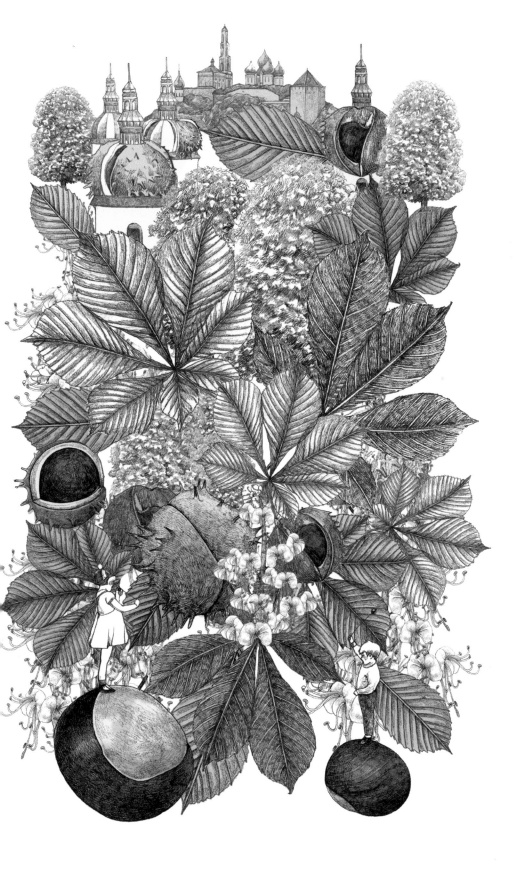

Cork Oak

Quercus suber

The cork oak matures slowly. A low, spreading evergreen with thick, twisted branches, it can easily live for 250 years, acquiring a huge crown if it is grown in the open. In spring, pretty strings of yellow flowers form a delightful contrast to its dark-green foliage. The leaves have spiny lobes not unlike holly, but spongy, and often with a velvet nap.

This is a tree that needs the moist maritime winters and hot summers typical of the lower slopes of hills around the western Mediterranean. From the Atlantic coast to Italy and from Algeria to Tunisia, cork forests cover about 26,000 square kilometres (10,000 square miles), although more than half of the world's cork comes from Portugal, and most of the rest from Spain.

The wood of the cork oak is unremarkable, but the thick bark is special indeed. According to Pliny the Elder, Roman women of his day appreciated the insulation and lightness of cork-soled sandals as much as the extra height it gave them. In fact, having evolved to protect trees from fire, cork's thermal insulation is so good that it has been used to shield the fuel tanks on NASA's Space Shuttle. Surely, though, the most common association is with wine.

A cork oak's bark is adapted to defend trees from fungi and microbes. It is exceptionally impermeable, even to air, and almost completely inert, and no other untreated, naturally occurring plant product can remain unchanged in contact with so many substances. It is resistant to water, petrol, oil and, of course, alcohol. Its cells can withstand extreme compression while retaining their springiness – perfect for squeezing tightly into the neck of a bottle. As a bonus, when cork is cut lots of microscopic cups are formed, and those myriad tiny vacuums prevent corks from slipping from a smooth glass neck. In antiquity, Greek and Egyptian amphorae had cork plugs, but it was reputedly the celebrity vintner monk Dom Pérignon (yes, him) in the seventeenth century who promoted the marriage made in heaven. Today, in English, a wine-bottle stopper is simply a 'cork'.

The cork oak is rare in being so willing to regenerate its bark, which can be harvested once the tree is about 20 years old and then repeatedly, roughly every decade. The bark is stripped from the trunk up to a height of about 2.5 metres (8 feet) and from sections of larger branches, in late spring

and early summer, when semi-cylindrical sections separate easily from the tree. It is a skilled operation. The stroke of the axe must be confident, or the cork will dissipate most of the energy, yet not so powerful as to damage the inner bark, which would prevent regrowth. A middle-aged tree can yield more than 100 kilograms (220 lb), which – being such a light substance – is an awful lot of cork. Then comes the romantic process of making stoppers. The bark is boiled, scraped, cut, trimmed and flattened under pressurized steam before a massive high-precision hole punch cuts batches of corks from each strip, ready for the world's wineries. Within weeks of stripping, the exposed trunk turns from smooth, golden brown to a rich, dark red with a rougher finish. Harvested cork oaks look curiously naked, like Englishmen paddling in the sea, their trousers rolled up to expose reedy sunburned legs below.

Cork oaks are just one component of a uniquely sustainable mixed farming system called *montado* (or *dehesa* in Spain), in which, alongside cork production and other hunting and foraging strategies, sheep, turkeys and pigs are fed on cork oak acorns. Like many traditionally managed habitats, the *montado* supports many rare and endangered species, such as the Iberian lynx, the imperial eagle and the black stork, as well as woodpigeons, cranes and finches, and all the little critters they feed on.

Sadly, though, this balanced system is under threat. Occasionally wine takes on a musty odour caused by a chemical called trichloroanisole, to which our noses are so extraordinarily sensitive that one thousand-millionth of a gram in a glass is noticeable to the average drinker. Reports in the 1980s and 1990s of batches of poor-quality cork causing tainted ('corked') wine prompted some wine producers to source artificial stoppers. The biochemistry of cork is now better understood, production is carefully controlled and cork hardly ever taints wine, but many producers acquired a taste for screw-tops and plastic 'corks'. That's a shame, because the survival of the *montado* ecosystem depends on its value as a source of cork. When that demand disappears, the economic pressure to use the land in other ways becomes irresistible. So, if you drink wine, choose cork and enjoy the added pleasures of protecting biodiversity and supporting a harmonious way of life. Cheers.

Acorns of the tanoak (p. 202) have long been an important food for people, not just for animals.

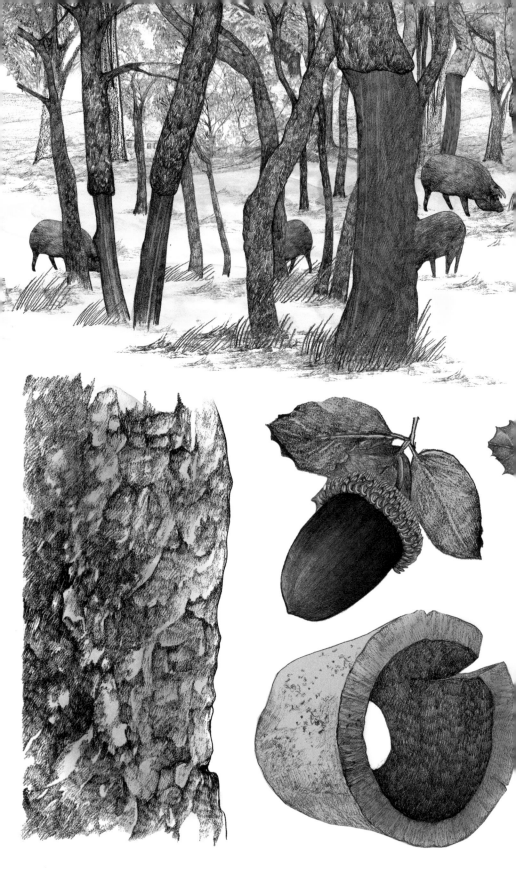

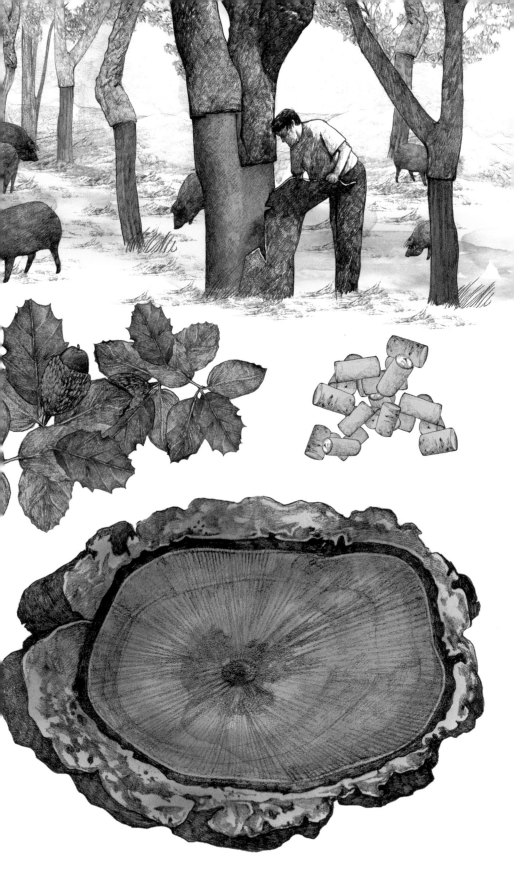

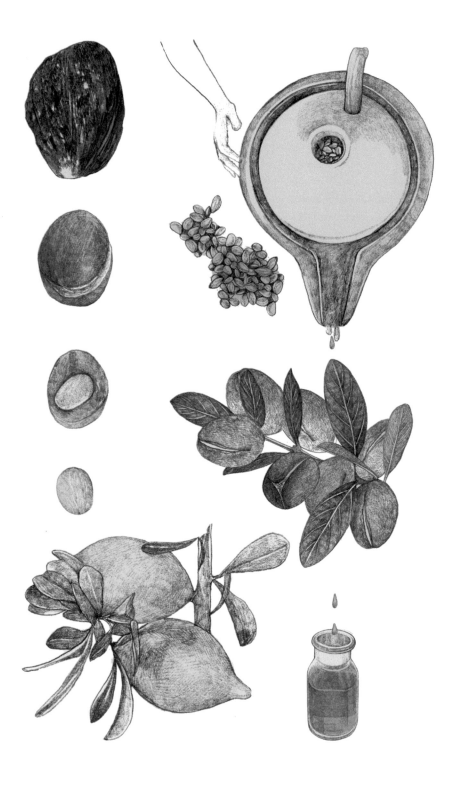

Argan

Argania spinosa

The argan is found in southwestern Morocco and parts of Algeria, where its deep roots stabilize arid soil, a last bastion against the Sahara. Typical of semi-desert trees, the argan has small, leathery leaves and is gnarled, slow-growing and thorny as hell, the better to repel hungry herbivores. It is all the more surprising, then – not to mention surreal and even ludicrous – to see goats aloft in its branches. Surely goats don't belong in trees? It turns out that these especially nimble animals have learned to avoid the thorns, and it's not the leaves but the fruit they're after.

The argan fruit is a golden oval, the size of a small plum, sometimes elongated at one end. Thick, acridly bitter peel surrounds a sweet-smelling pulp, which is mouth-puckeringly astringent – to humans, anyway. In the centre is a nut, hard as nails, protecting one or two small, oil-rich seeds. It is this argan oil, used for food and cosmetics, that is the mainstay of the local economy and supports approximately 3 million people.

In midsummer the fruit become dry, blacken and fall to the ground. To extract oil, the process has been to collect the fruit, including the neatly stripped kernels that goats have excreted or spat out. The resulting goaty flavour did not prove universally popular in the export market, so groups of Berber women remove all the pulp by hand (they feed it to the goats, of course), then crack the nuts, traditionally, between two stones. (This sociable process is rapidly giving way to modern mills.) The seeds are ground to a paste and kneaded to extract the oil, which has all the culinary uses of olive oil in Mediterranean countries and is the base for *amlou*, a dip made with ground almonds and a little honey. The oil is also used locally to treat skin diseases and heart ailments, and is fashionable (and pricey) in wealthy nations as a healthy salad oil and as the basis for hair products and anti-wrinkle creams.

The relationship between humans, goats and argan is complicated. The extra income from oil exportation is not necessarily good for the trees, because when business booms, a traditional store of wealth in the region is … goats. When there are too many of them in the trees, despite their jolly appearance, they turn their attention from the fruit to the leaves and do much more damage.

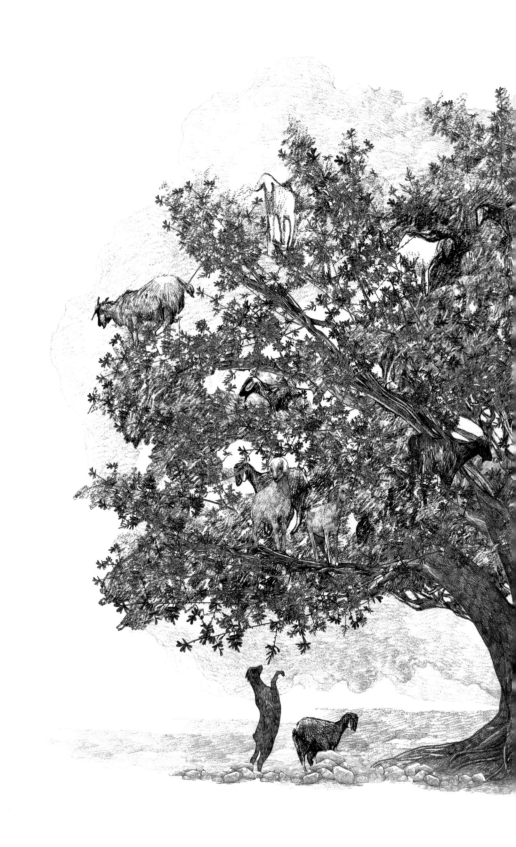

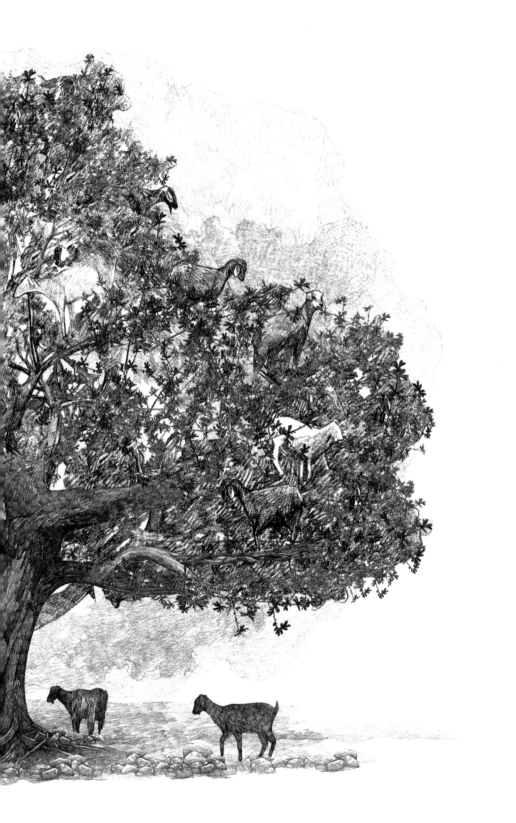

Holm Oak

Quercus ilex

The holm oak comes from countries bordering the northern Mediterranean coast and is especially common across Spain. A grand and solid tree with a huge head of densely leafy branches, its charcoal-grey bark is broken into small, irregular plates. Its oval leaves resemble those of holly (*ilex* in Latin and *holm* in Old English), from which it takes its name. Prickly only when young, the leaves' upper surfaces are conspicuously dark and, unusually for an oak, evergreen; old leaves fall about two years after new ones emerge. The foliage is well adapted to dry climates; the underside of each leaf, a warm-grey felt, is blanketed in fine hairs, which both reflect light and trap a layer of stationary air next to the leaf, reducing evaporation.

Abundant sprays of golden catkins in the spring are followed six months later by acorns. Some trees, such as willows and birches, produce roughly the same number of seeds each year and scatter them to the wind. Others, especially those that have large seeds attractive to hungry squirrels, like beeches and oaks, have another strategy. They have a series of lean years with very little seed production and then, every so often, all the trees in the neighbourhood synchronize to produce bumper crops in what are known as 'mast years'. Holm oaks and other mast trees do this to satiate predators, ensuring that despite the best efforts of squirrels, there are more than enough acorns to germinate. If they simply produced the same number of acorns every year, predator populations would adjust so that no seedlings would survive. Mast years are stressful, and most oak species store nutrients from the year before, in readiness to go all-out producing acorns. The holm oak instead grows masses of extra leaves in mast years to produce food for its extra acorns. Foliage becomes much denser and the following season the tree needs to recover; there are fewer acorns, it sheds more leaves and it produces narrower tree rings.

The supply of acorns feeds black Iberian pigs, from which the famous Spanish ham *jamón ibérico* is made. They eat 6–10 kilograms (13–22 lb) of nuts a day, nimbly discarding the acorn's cupule and other indigestible components. At the other end of the gastronomic scale, Spanish scientists showed recently that an extract of holm oak acorns helped meat patties to retain their flavour when cooked, chilled and reheated.

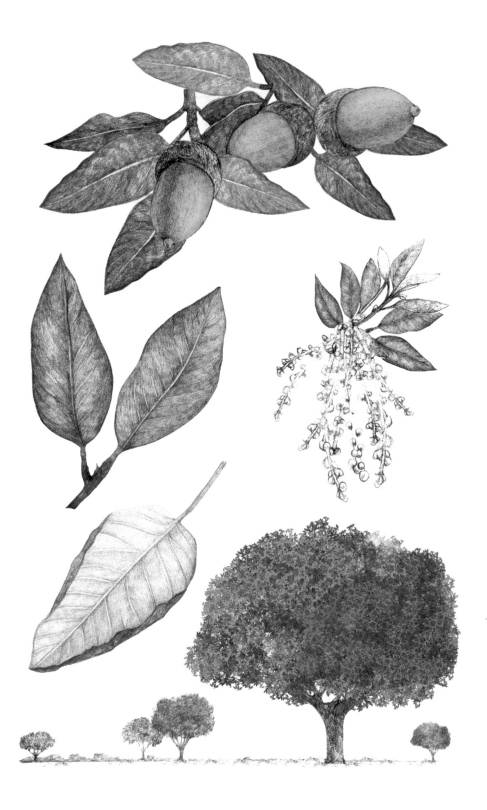

Sweet Chestnut

Castanea sativa

The sweet or 'Spanish' chestnut is native from Albania to Iran, and has been cultivated around the Mediterranean for more than 2,000 years for its starchy, tasty fruit. Chestnuts, which are nutritionally similar to wheat, can be ground into flour or coarse meal, and were historically a staple food in many parts of Europe, especially in rugged areas where cereals are harder to grow, such as the French Cevennes, the foothills of the Italian Alps and, particularly, mountainous Corsica.

Left to its own devices, the sweet chestnut is a deciduous tree up to 35 metres (115 feet) tall, with a solid, substantial trunk surprisingly wide for its height sporting rich, ruddy-brown bark, often deeply grooved and spiralling upwards. The leaves are large and deeply serrated and the tiny flowers, squeezed on to slender yellow spikes, give their flavour to chestnut honey, which has a distinctive bitterness that is not to everyone's taste. Chestnuts ripen in autumn, nestled in pale-green, spiny, squirrel-proof husks that can be teased apart gingerly with gloved hands to reveal the shiny brown jewels within. The best varieties for eating will have just one chestnut within the husk, while those used for feeding animals may have two or three smaller fruit inside. In Corsica and in the Cevennes, chestnuts are roasted and caramelized before being ground into flour.

The chestnut forest is a man-made landscape that needs a lot of human intervention. The trees are pruned into low, broad shapes and usually grafted to marry hardy varieties with fruit-bearing ones. There are probably 60 different kinds of chestnut cultivar in Corsica alone; this diversity is a vital buffer against climate change as well as pests and diseases, and is vital for cross-pollination. For food production, the trees need cosseting, tending, grafting and pruning, as well as keeping the ground clear and the weeds at bay. The hard work is worth it, however: the particular array of varieties grown by local villages contributes to their *goût de terroir*, or local flavour – an important source of identity and pride.

Successive waves of outsiders have tried to dictate to Corsicans how they should run their lives. Beginning in the Middle Ages, the ruling city-state of Genoa, wishing the island's semi-nomadic pastoralists to settle down, increase their efficiency and – above all – pay tax, passed laws commanding individuals to plant and tend chestnut trees. Corsicans embraced chestnuts but created a whole cultural system, called *castagnetu*,

that fitted existing social relationships. Land continued to be held communally, and sheep and pigs were managed by villages alongside the fruiting trees.

By the time the French took over in the mid-eighteenth century, *castagnetu* had become central to Corsica's identity. The French misunderstood the work that was required to keep the chestnut yield high, holding the trees responsible for the island's economic and even moral underdevelopment. Seeing *castagnetu* as an excuse for laziness, the French attempted to impose cereal production, even though the chestnut system actually supported one of the highest population densities in Europe. In a similar way to those who have tended the cork oak forests of the Iberian Peninsula, Corsicans again adapted their lives to create a holistic system of living with the land, accommodating chestnuts and cereals, people and animals, that required social knowledge and long-term planning: chestnuts trees bear fruit only for future generations.

World War I bled Corsica of its labour. Some trees were felled for timber and others succumbed to fungal disease. Now *castagnetu* has again come to symbolize resistance to external forces, and since the 1980s it and the trees at its heart have seen an upsurge in local support.

Slightly sweet chestnut flour is still used to make *pulenta*, which is tastier and earthier than cornmeal polenta, and also a crumbly, flattish bread – chestnuts lack gluten, a binding agent. The flour is also used for Pietra beer, a pleasant enough drink, though disappointingly lacking in actual chestnut flavour. On the other hand, *crème de marrons* (sweetened chestnut purée) is God's gift to the crêpe.

Another rather bitter honey is made by bees visiting the strawberry tree (p. 16).

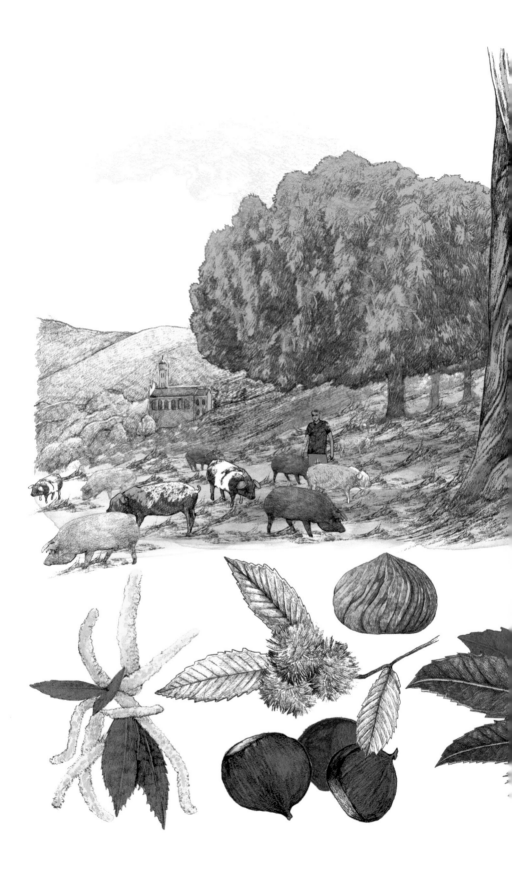

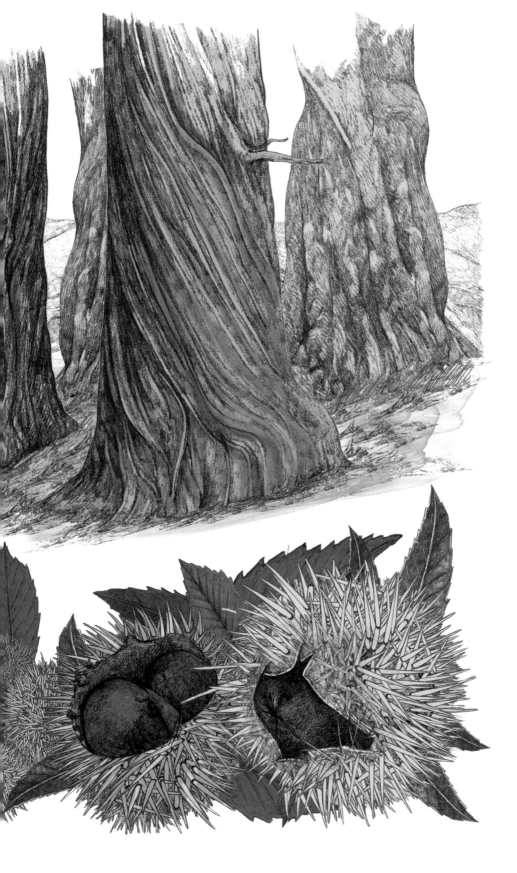

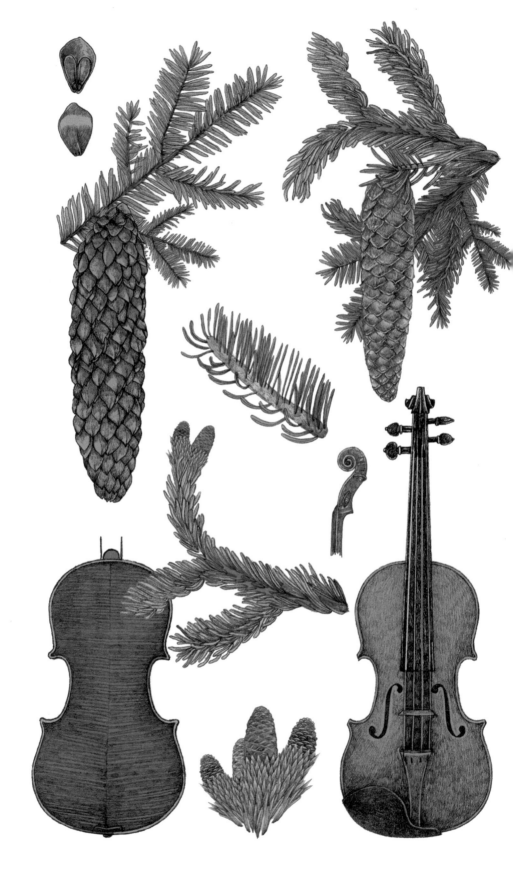

Norway Spruce

Picea abies

The Norway spruce's native range includes a swathe of northern Europe as well as the mountains of the centre and south. A pyramid-shaped conifer with a greyish-brown, scaly trunk and long, cylindrical cones, it commonly grows to 50 metres (165 feet) tall, although its lower branches tend to droop after 20 years or so. The main trunk can live for 400 years, but when branches make contact with the ground they occasionally take root and form a new trunk. By this process, called 'layering', a tree in the Dalarna area of Sweden called 'Old Tjikko' has a root system with remnants that can be carbon-dated to an age of about 9,500 years, although its present trunk is a sprightly few hundred years old.

Imagine a classic Christmas tree and it's likely that you are picturing a Norway spruce. In fact, as a thank-you for wartime help, Oslo donates one each to New York and Washington DC and one to London each year, to be placed in a central square of each city during the festive season. Its role as a holiday centrepiece is not, however, the primary reason why this tree endows us with some of our most moving moments: that is thanks to its 'tonewood', which is used to make the soundboards of the most world's most valuable stringed instruments.

All sounds we hear are movements of air, but the vibration of a single string is barely audible because it slices through the air, setting only a tiny volume in motion. To make an instrument, we need a soundboard to transfer the energy from the plucked or bowed string to a larger movement of air and thence to our ears. Stiff materials make the best soundboards because they can transmit vibration efficiently from molecule to molecule; in a more elastic material, energy is squandered as the sound waves travel through it. A soundboard should not be too dense, either, or too much energy would go towards setting its molecules in motion, damping the sound. Many other factors affect the timbre and individual character of an instrument: the direction of the grain, the size of the cell walls, even the varnish.

Norway spruce is not a very heavy wood, but for its light weight it has extraordinary stiffness. This highly unusual combination means that a 2 or 3-millimetre (⅒-inch) thick panel of Norway spruce can radiate sound more consistently and intensely than any other wood. Not all Norwegian spruce is the same, however. When altitude, poor soil and low temperature conspire to make it grow particularly slowly, the wood is even stiffer, giving

a violin a more sonorous and pleasing tone. The most special guitars, violins and cellos – exceptional instruments that delight audiences for their incomparable quality of sound – all have soundboards of slow-grown alpine spruce.

When the luthiers Stradivari and Guarneri needed tonewood for their exquisite violins, they used Norway spruce from the Italian Alps, a day trip from their workshops in Cremona. One reason why these seventeenth- and eighteenth-century instruments are so special is that they were made using wood that had grown during the 'little ice age' that began around the fifteenth century and lasted for several hundred years. This was a period of low solar activity when unusually cold weather caused even the unhurried alpine trees to slow their growth even further. They laid down exceptionally narrow annual rings, leading to very stiff and consistent tonewood: the foundation for the golden age of violin-making.

With the demise of the forests around Cremona, much of the supply of wood now comes from Switzerland, where foragers working for small family firms search for the least knotted, slowest-grown 'resonant trees'. Trees are felled during the cold, dormant months, and traditionally just before the new moon, and there are strict limits on the number of trees that can be taken. After being felled and sawn into billets, the wood is seasoned, very slowly indeed. Drying time is at least ten years, by which time a violin-sized slice will ring clearly when tapped with the knuckles – and command a commensurate price. Fifty-year seasoning is said to be even better.

In an attempt to re-create such a valuable material in our warmer times, researchers have inoculated newly sawn spruce with a special fungus to eat away non-structural parts of the cells, making the wood lighter without affecting its rigidity. Early results sound promising but, for now, the method for creating the very best tonewood is little changed from the time of Stradivari. After all, what's a few extra decades between a tree that has been growing for two or three centuries and a violin that will give pleasure for at least that time again?

Balsa (p. 178) is also very stiff for its weight.

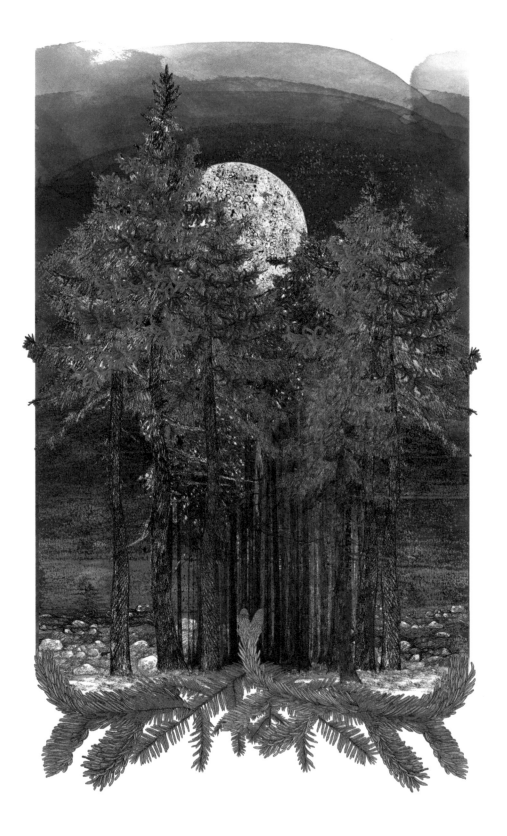

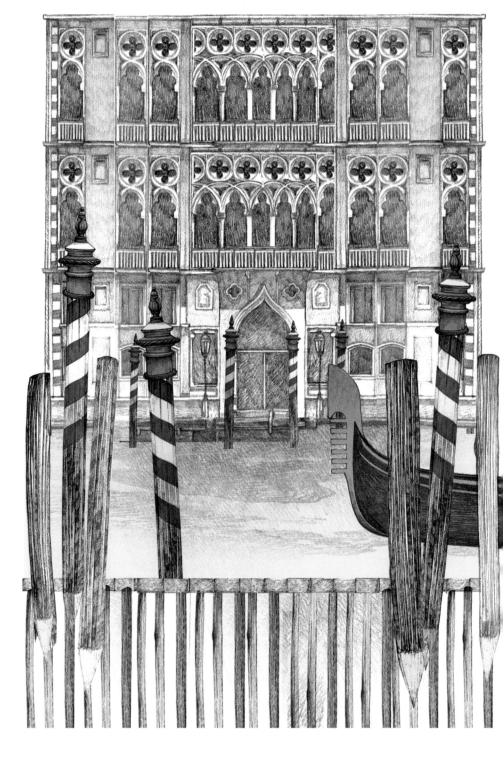

Alder

Alnus glutinosa

On the surface, there is little to distinguish the alder. True, the mauve-bloomed buds and drooping catkins are the florist's friends. Its dark, racquet-shaped leaves are frequently notched at the tip, never pointed, and the young twigs are often sticky, hence *glutinosa*. And that's about it. But looks can deceive, for the wood itself is special indeed.

Alder loves water, and grows best along riverbanks and in sodden places. Rarely among trees, it has a symbiotic relationship with nitrogen-fixing bacteria that live in nodules, sometimes the size of an apple, in the trees' roots. In exchange for sugars, these bacteria create fertilizer for the tree, enabling it to invade, and flourish in, waterlogged, infertile ground.

As timber, alder wood maintains its special relationship with water. In the twelfth century, as the inhabitants of the Venetian archipelago sought to stabilize and expand their marshy home, they would have noted the plentiful alder's existing use for floodgates. They knew that in the presence of air, moist alder would rot quickly, but that while it was submerged the wood would stay intact. In fact, as long as it remains immersed completely, alder wood will keep its compressive strength for hundreds of years, the chemicals in its cell walls making it hard for rot-causing bacteria to spread. The Venetians realized that alder foundation piles could stay strong enough to support great buildings, and they had the monumental chutzpah to turn that knowledge into a dream city in a lagoon.

By systematically walling off and draining small areas, Venice's engineers could drive piles through the mud into the subsoil – about nine per square metre/square yard – so that their tops would still be well below the level of the lowest tide. Layers of crushed brick and stone were then poured around and between the piles and thick larch planks laid on top, to distribute the huge weight of stone above. The largest buildings needed thicker oak piles, but much of Venice, including the Rialto Bridge and many huge bell-towers, was literally built on alder wood.

Alder thus underpinned the architectural bravura that enabled Venice to shout its confidence to the entire region, but without this wood, the city-state might never have become a military superpower. The timber was renowned as the source of the very best-quality charcoal, readily powdered, of unmatched consistency and huge strategic importance. Gunpowder made with alder charcoal could fire shot and cannonballs further and faster;

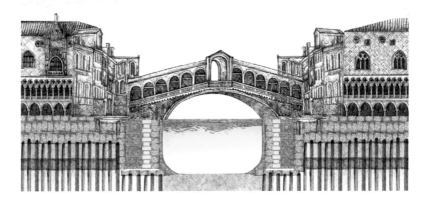

grenades and mines would explode more destructively than those made with inferior charcoal from other sources. Even today, the best-quality gunpowder comes from alder. And charcoal was the one substance that could burn with the fierce heat necessary to smelt iron, fundamental to the making of tools and ships' components.

By the end of the fourteenth century the foundry or *getto* area of Venice (later to become the 'ghetto', the Jewish quarter) had some of the world's most efficient smelters, fired by alder charcoal. The city's Arsenale had become the world's biggest industrial facility, where 16,000 production-line workers could turn out fully fitted and armed ocean-going vessels at the astonishing rate of one a day. Founded on mercantile and military muscle, medieval Venice was a far cry from today's romantic theme park.

The city's appetite for all kinds of timber was voracious: alder, of course; oak for the largest piles and for ships; beech for oars; and vast warehouses of cheaper woods used for cooking and heating. The wood supply therefore had to be tightly controlled. Large swathes of forest on the mainland were set aside for state use, and by the mid sixteenth century there was an army of official inspectors, map-makers and woodland guardians who even burned permanent brands into the most valuable trees. They scrutinized the work of lumberjacks and sawyers, and the guild of raftsmen who brought the wood along waterways, through the lagoon, to market.

Each kind of timber had its part to play, but it was alder charcoal that forged the fittings of merchant and military vessels and formulated the powder for their cannons. It was alder piles that bore the housing for the artisans who built them all. Some 700 years later, those piles still support the so-called Floating City: the glorious buildings and the tourists too.

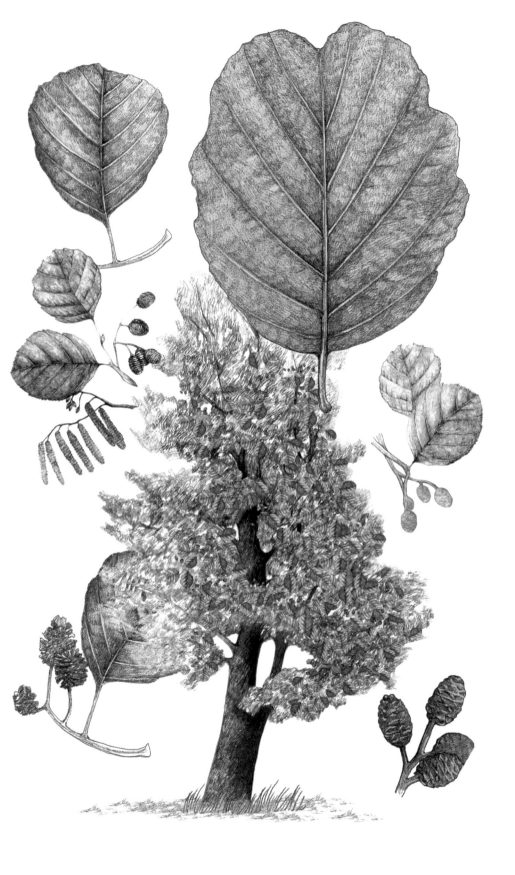

Quince

Cydonia oblonga

Native to the Caucasian Mountains and Iran, where the summers are hot and the winters harsh, the quince is a small twisted tree that needs at least a fortnight below 7°C (45°F) every winter if it is to flower properly. Quince fruits are larger and more knobbly than apples or pears, to which they are kissing cousins. All three are 'pome' fruit, meaning that the fleshy part is the enlarged base of the flower, from which the petals have long since fallen. Yellow with a downy grey fuzz, quinces are astringent and hard when raw.

Turkey has the largest number of quince trees, accounting for a quarter of the world's crop. However, it was Cydonia in Crete, just across the Aegean Sea, that gave its name to quince via Latin *cotonium* and French *coings*. In England, quinces have the medieval resonance of jousting and syllabubs, although until the nineteenth-century spread of sweet fruit that require no cooking, they were present in every kitchen. In the southern Mediterranean, they are used in sweet and savoury dishes and have been part of the menu, culture and cultivated landscape since Classical times.

Quinces are truly the food of love. In Greek mythology, the golden 'apple' awarded by Paris to Aphrodite, goddess of love and beauty, was doubtless a quince. By about 600 BC Athenian women were enjoined to eat quince on their wedding nights to give grace to their wit, breath and voice. The fruit perfumed Roman bedchambers, and in Renaissance art it symbolized ardour, fidelity and fertility. Even today, quince is traditionally baked into Greek wedding cakes. Indoors, its heady perfume is practically intoxicating, a quality that must have contributed to its reputation as an aphrodisiac. Its pale flesh that blushes a lustrous ruby-red when sufficiently heated would surely have been another sign.

Like most modern crops, quinces are at risk from inbreeding. Over the millennia, farmers have selected traits that mattered to them – in this case, large, tasty fruit. However, crossing and re-crossing from an increasingly focused population has caused genetic diversity to narrow, potentially sapping the trees' ability to adapt, for example, to warming winters, or to fend off evolving pests and diseases. The wild relatives of our crops, such as the forebears of quince trees in the Caucasus, contain the original genetic diversity that we may need for breeding, and which we must protect.

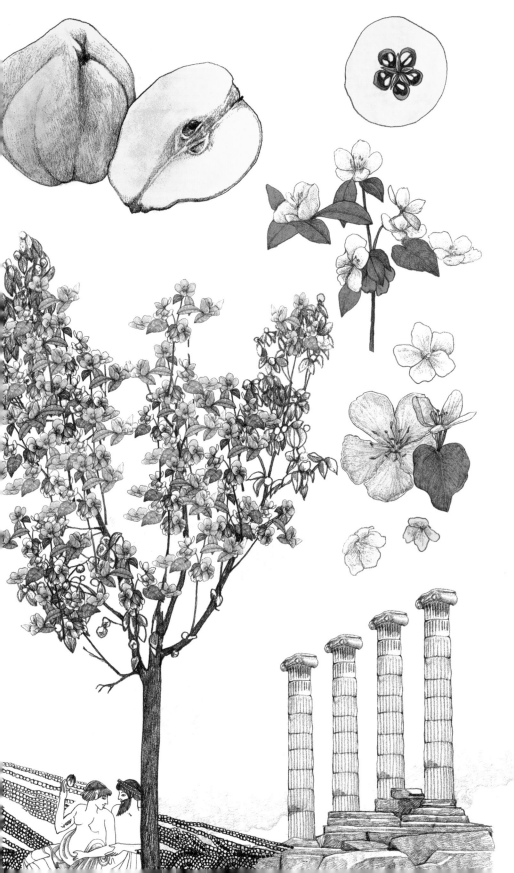

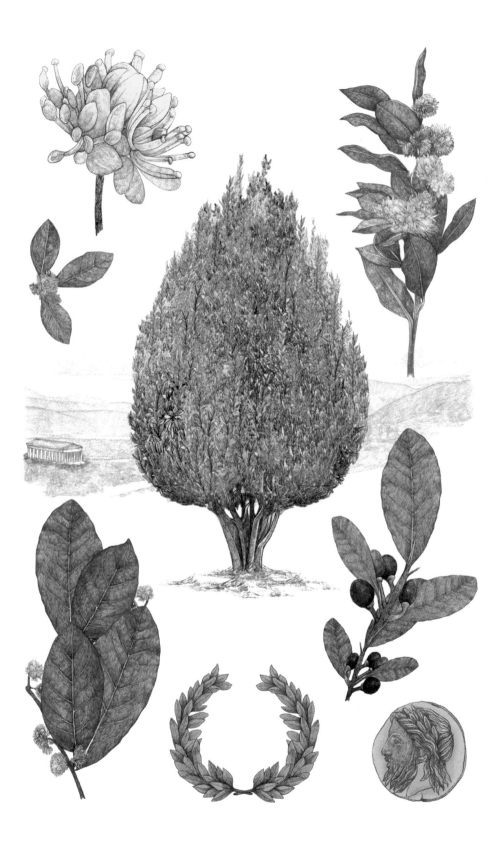

Laurel, Bay

Laurus nobilis

The bay tree or laurel, an evergreen of the western Mediterranean, can be a clipped and primped patio ornament, a bushy shrub for the kitchen garden, or a splendid 15-metre (50-foot) tree. Pretty clusters of small, short-stalked yellow flowers are followed, on female plants, by glossy black berries with a single seed. Laurel leaves are tough and dry, accumulating aromatic oil in special glands within the dark, glossy, boat-shaped exterior. They are used in pickles and savoury dishes – a particular treat inserted into wedges of lemon, roasted and squeezed over fish. Some southern Europeans grate the more pungent berries instead.

Laurel was sacred in Greek myth. The virginal nymph Daphne, pursued by the lustful god Apollo, chose virtue over pleasure and called to her father for help. Hearing her plea, he put her out of harm's way by turning her into a laurel. Frustrated Apollo decided that if Daphne couldn't be his wife, he could at least possess the tree that she had become. Laurel adorned his hair evermore, and since antiquity Apollo has been depicted with a laurel wreath. The tree was associated with purification, and returning Greek generals originally wore laurel to purify them of bloodshed. Over time their wreaths, and those of the Romans after them, became linked to victory and then more generally with achievement.

The modern Greek word for 'laurel' is still *dáfni*. The English word comes from Latin, in which wreaths were known as *bacca lauri* ('laurel berries'), which gave us 'baccalaureate' and, via French, 'bachelor' in the context of attaining a university degree. Meanwhile, Nobel Prize winners and national poets are 'laureates', and Italian students wear laurel wreaths on graduation day, though surely not to rest on them afterwards.

Laurel seeds are dispersed by birds, which also spread the rowan (p. 18).

Fig

Ficus carica

Figs are the fruit of desert orchards. With deep roots, famously able to seek out water, they can also insinuate themselves into crevices and sprout from walls. They can grow as straggly bushes or as trees up to 12 metres (40 feet) high with smooth, elephant-grey bark. Leafless in winter, their broad, rough-to-the-touch leaves appear in late spring, just when people and animals start to need the shade.

Despite the best efforts of painters over the centuries, fig leaves are generally too deeply lobed to have reliably covered the nakedness of Adam and Eve. However, the fig and its fertility-related stories have featured in all the cultures of the Middle and Near East, where it has been cultivated for at least 4,000 years. Appropriately, the botanical story of the fig is one of sex and gender.

The fig 'fruit' itself can be male or female and is a fleshy, hollow flask, lined on the inside with a thick carpet: a mass of tiny florets. (This container is called a syconium, after the Greek *sykon*, meaning fig; the word 'sycophant' is from the same root and probably referred originally to ancient do-gooders who informed on anyone illegally side-stepping an export ban on the fruit.) There are two kinds of fig tree. Female trees, with female flowers, bear the juicy fruit that we eat. Male trees bear dry, inedible 'caprifigs', in which some of the flowers are male and some female. (Caprifigs take their name from goats – the only creature that will eat them.) The challenge is to get the pollen from male flowers inside the fig on the caprifig tree over to the female flowers, which are inside the fruit growing on a female tree.

The flowers of most trees are either wind-pollinated or gaudy and sufficiently sweet-nectared to attract pollinators, which deliver pollen efficiently straight to the female parts of a flower. Members of the *Ficus* genus do things differently: each species relies on a specific wasp for pollination. The *Blastophaga* wasps that pollinate *F. carica*, the common edible fig, are female, stingless and tiny – just a couple of millimetres long. The way they do it is deliciously baroque. Wasps of both genders hatch inside the male caprifigs. Even before a female wasp emerges, a male wasp will mate with her, then burrow his way out and die. At this stage, the male flowers inside the caprifig produce pollen. After a brief rest, the female makes her way out of an exit hole made by a male wasp, dousing herself

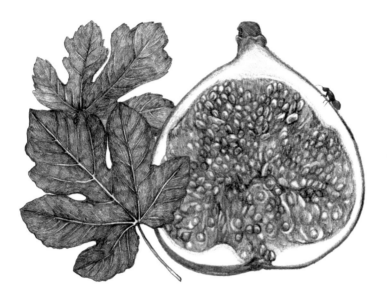

in pollen as she goes. Guided by scent, she flies off in search of another fig, in order to lay her eggs. When she finds one, she squeezes through the little hole at the base of the fig, stripping off her wings and antennae in the process. If she happens to have entered a caprifig, she lays her eggs, which will eventually hatch to continue the cycle. But if she enters a female fig, she will discover that she has been conned. Although she wanders from floret to floret, spreading pollen as she goes, the flowers in the female fig won't fit her anatomy; she cannot lay her eggs. The flowers are pollinated and scores of tiny seeds develop, but there will be no wasp larvae. The female wasp is doomed, and enzymes in the plant gradually digest her. The female fig swells and sweetens, attracting bats and birds – and humans – to spread its seeds; a laxative ensures that seedlings get a nutritious start.

Some fig varieties have been bred to be parthenocarpic, meaning that they don't require pollination. However, in Turkey, which is the biggest producer of figs, the most historically popular and by consensus the most delectable fig variety is the Smyrna, named after the Turkish Aegean coastal region now known as Izmir. This variety, as well as its Californian derivative the Calimyrna and others famed for their flavour, is proudly wasp-pollinated. Early attempts to grow the Smyrna fig in the United States ended in failure because growers initially dismissed as baseless mumbo-jumbo the Middle Eastern peasants' tradition of hanging branches of caprifigs in their orchards, but in fact it is a well-observed encouragement to wasps to act as sexual go-betweens.

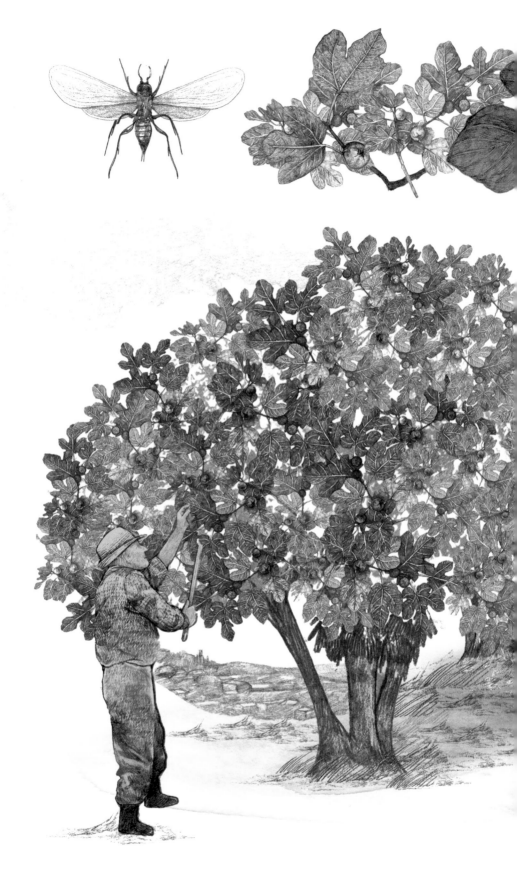

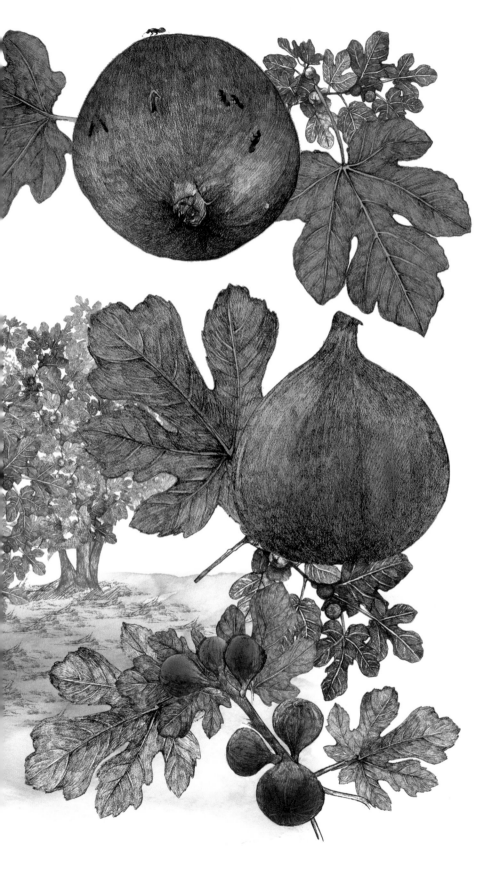

Mediterranean Cypress

Cupressus sempervirens

The cypress is unusual in having two quite different forms. The original variety, *horizontalis*, features in the Bible. Native to the eastern Mediterranean and Near East, where it is still found in the wild, it is properly ancient-looking, 30–50 metres (100–165 feet) high, substantial and spreading, with gnarled branches that grow sideways. The other variety (*stricta*) is fastigiate: the branches grow almost vertically, parallel to the main trunk. This slender Johnny-come-lately depends on human intervention to propagate it from cuttings, and was probably an ornamental Roman cultivar. Popular throughout the Mediterranean, its columnar shape punctuates southern France and the Tuscan landscape of Italy like an exclamation mark. In the formal setting of the Boboli Gardens in Florence, cypress trees stand like sentries along a 300-year-old avenue.

Cypress leaves are dark and stubby, with a distinctive greyish-white criss-cross pattern of scales, well adapted to dry, bright conditions. Wind-pollinated male and female flowers grow on the same tree; at first glance the male flowers, with their stripes of brown and cream, look like a swarm of bees. The fertilized female cones eventually turn silvery grey. Walnut-sized, they ripen in late autumn, parting their scales to release seeds, although a few cones generally remain stuck tightly shut as fire insurance, ready to scatter the next generation when the heat has passed.

The Egyptians used resinous cypress wood for sarcophagi and for insect-proof chests, and the tree gave its name to Cyprus, where it was native. The mines on the island were of vital strategic importance to the Romans as their main source of copper, which they alloyed with a little tin to make bronze. They called copper 'metal from Cyprus', *aes Cyprium*, and that became *cyprum*, then *cuprum*, the source of the chemical symbol Cu that is used today. In many languages, the modern words for copper are related to this species via Cyprus.

The tree, and hence the island, is named after Cyparissus, a mythical figure whose father was friendly with the Greek god Apollo. Cyparissus accidentally slew the god's favoured stag and, full of remorse, begged that his grief would endure forever. Apollo transformed him into a cypress, its resinous sap representing his tears. The cypress became the symbol of the immortal soul and eternal death, and even an emblem of the underworld; it is still widely planted in cemeteries.

Date Palm

Phoenix dactylifera

The subject of 3,000-year-old Hebrew literature, Assyrian bas-reliefs and Egyptian papyri, the edible date probably originated somewhere between northeast Africa and Mesopotamia and may have been cultivated in the Middle East for six millennia. An iconic fruit in all the cultures of the region and a staple food containing up to two-thirds sugar, the date has altered the course of history by enabling large numbers of people to live in deserts. The best place to spot date palms now is Egypt, which has 15 million of them, and produces more than a million tons annually. Staggeringly, only about 3 per cent of that is exported.

Botanical pedants claim that the date palm is technically not a tree because it lacks standard woody tissue, but for the rest of us their ability to support themselves with strong trunks is good enough. Their stems, scarred by old leaf bases, grow to 25 metres (80 feet) and carry 20–30 leaves, each stretching up to 5 metres (16 feet) long. When supplied with underground water or irrigation throughout scorching, dry summers, they can live for 150 years. Each tree is either male or female, and pollen from the males must reach the flowers on the females if they are to bear fruit. Rather than trusting to wind or insects, the date palms' owners hand-pollinate the flowers. This has traditionally meant shinning up trees, a process that is now being replaced by spraying pollen from hoists. Generally, dates are propagated commercially by cloning from tissue culture or heaping earth around the base of the trunk and planting the resulting root suckers. This minimizes the number of non-fruiting male trees and gives reliable control over the scores of cultivars that now exist.

In 2005 date stones that had been found at the ruined fortress of Masada, by the Dead Sea in Israel, were carbon-dated to about 2,000 years old. Given a little water, fertilizer and hormone treatment, one of them germinated successfully. The seedling, a male, is thought to be the only living representative of the Judaean date palm, a variety known to Josephus and Pliny the Elder as being especially hardy and desirable. It was named Methuselah and planted at a kibbutz in the Negev desert; by 2017 it was about 3 metres (10 feet) tall and had flowered and produced pollen. The hope is to mate it with females, also from the Judaean desert, that researchers have coaxed to germinate. Who knows what useful traits these new, ancient fruit might have?

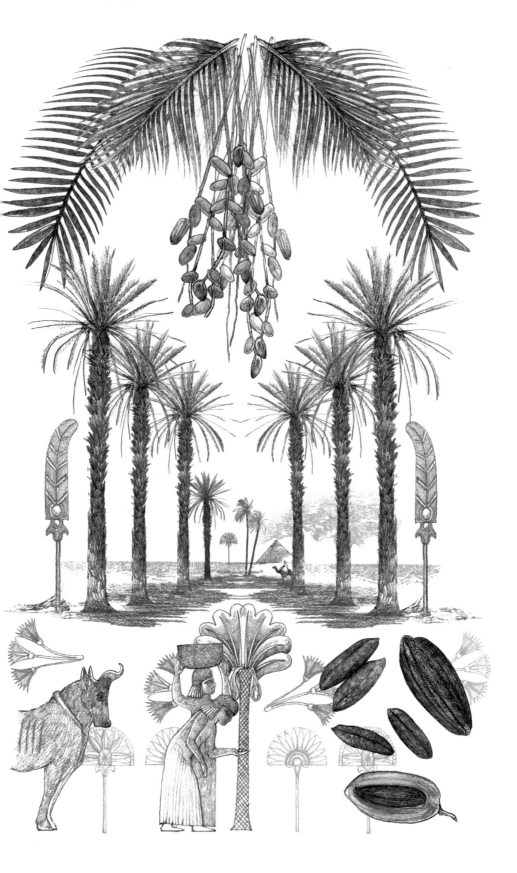

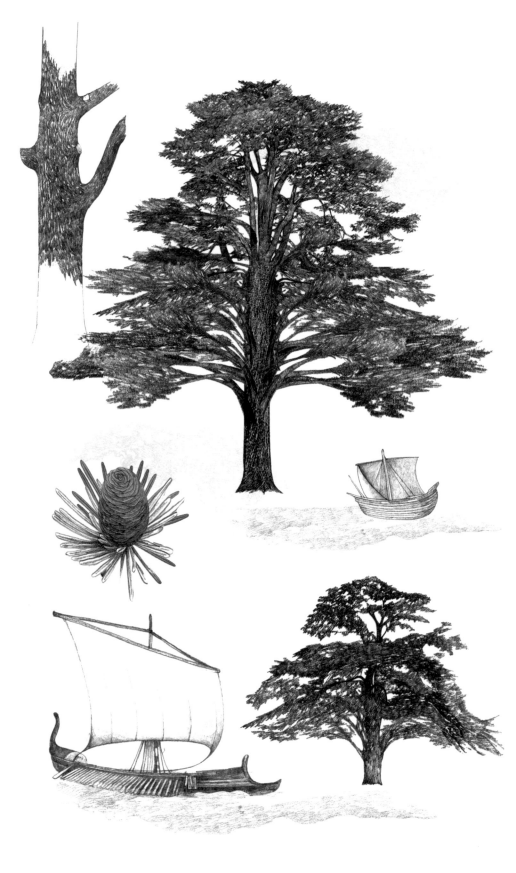

Cedar of Lebanon

Cedrus libani

It is no exaggeration to say that the magnificent cedar of Lebanon played a critical role in the development of civilization. We know, from core samples of soil and the pollen they contain, that 10,000 years ago vast cedar forests stretched across the eastern Mediterranean towards Mesopotamia and what is now southwestern Iran. Its native range is now confined to isolated mountains in Lebanon, Syria and southern Turkey, although it is a popular ornament in parks and large gardens in western Europe and parts of the United States. How the mighty are fallen.

The mature cedar of Lebanon is improbably graceful for such a substantial tree – it can be 35 metres (115 feet) high, with an imposing trunk up to 2.5 metres (8 feet) across. Unusually, especially for a conifer that grows in snowy conditions, the branches are almost horizontal; it is no wonder that those branches are so solidly built, although, alarmingly, mature specimens now and then shed a bough – sometimes weighing several tons – for no apparent reason, and not necessarily in bad weather. Bottle-green or blue-green densely packed needles grow in tiers. The bark is dark grey and exudes a perfumed balsamic resin, which makes a saunter through a cedar grove quite special. Oval cones, roughly the size of a large lemon, are produced only every other year and break up on ripening, scattering numerous tiny seeds.

Tolerant of freezing weather in winter and prolonged summer droughts, with wood that is durable, resistant to decay, gorgeously reddish, delightfully fragrant and available in conveniently large pieces, the cedar of Lebanon had everything going for it. That was probably its downfall. In the ancient world, cedar was a valuable commodity. Cedar wood was used for temples and palaces in Assyria, Persia, Babylon and beyond. It was heavily traded by the Phoenicians, a maritime people who used the timber for ships, buildings and furniture. Cedar resin was used for embalming by the ancient Egyptians, and its shavings have been found strewn in pharaohs' tombs alongside cedar-wood chests. Cedars are mentioned in the Bible and they were used for the roof of Solomon's Temple in Jerusalem in about 830 BC. Sanitation in those days was probably rather hit and miss, so cedar's disinfectant and insect-repellent properties, along with its sweet scent, would have been especially welcome. Cedar oil is still widely used to

repel clothes moths, and in southern Turkey *katran*, a tarry cedar extract, protects wooden structures against insects and rot.

Ancient stories emphasizing human dominance over nature often featured the cutting of cedars. In the *Epic of Gilgamesh*, inscribed by Sumerians about 4,000 years ago, the eponymous hero overcomes Humbaba, the half-beast, half-divine guardian of a wild cedar forest, and then, in a show of power, razes the trees there. The real-life over-exploitation that probably inspired the story also gave rise to some conservation efforts, and in AD 118 the Roman emperor Hadrian even created an imperial cedar forest. However, preservation since then has been patchy. In Lebanon itself, the cedar is culturally important; the national anthem refers to the glory of the country lying in its cedars, 'its symbol of eternity', and it appears on the Lebanese flag. The authorities have tried to protect the last few magnificent stands from development but, despite the tree's common name, the best place to see the largest numbers of naturally occurring cedars of Lebanon now is in the Taurus Mountains of southern Turkey.

Recently, global warming has prompted the search for forest species that will thrive in central Europe. Early experiments indicate that the cedar of Lebanon may fit the bill. Climate change may turn out to be a much-needed fillip for the species, but just now it is hard to imagine the immensity of the ancient cedar forests protected by Humbaba.

Cedars are notorious for occasionally shedding branches. For the wollemi pine (p. 152), it's routine.

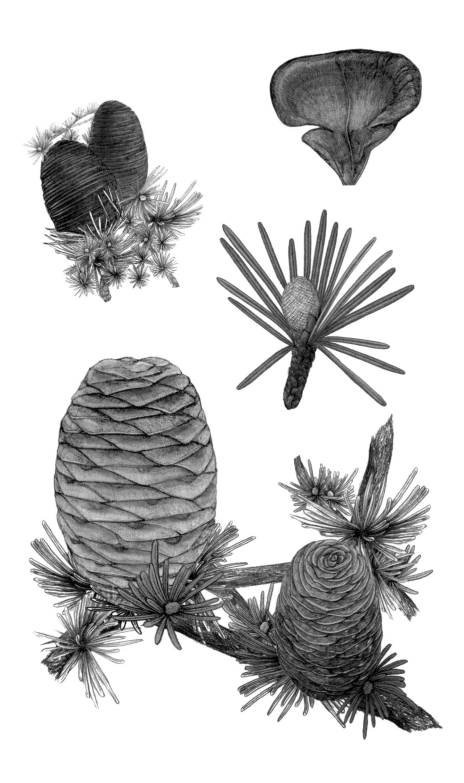

Olive

Olea europaea

Squat, gnarled and remarkably tolerant to heat, drought and goats, cultivated olive trees can easily live for 1,000 years and bear fruit for much of that time. Their leaves are a dark greyish-green above and silvery underneath, from microscopic scales that reduce evaporation in heat and high wind, creating a shimmering look that is almost definitively Mediterranean. Each tiny scale is just ⅙ mm (¹⁄₂₀₀ inch) across – with sufficient magnification they look like overlapping frilly parasols.

Spain and Italy are now the olive tree's biggest producers, but it has a special connection with the Middle East, where the tree has been used since Neolithic times and cultivated for at least the last five millennia for food, medicine and – especially – oil. In many languages, the very words for 'oil' (among them the Italian *olio* and the French *huile*) derive from the ancient Greek term for olive. Olives have the highest energy content of any fruit, and have been valued as much for fuelling oil lamps as for sustenance. Hebrew and Arabic have similar words for olive: respectively *zayit* and *zeytoun*, which derive from a common root, possibly connected to brightness.

The olive tree is loved and respected in Judaism, Christianity and Islam, associated with light, sustenance and purification. In the Old Testament flood story, the dove brought an olive twig to Noah on the ark, a sign that the waters and God's wrath were both abating. The olive branch has since come to represent peace, which is altogether too rare and precious in a region that is home to Jews, Muslims and Christians, to Arabs, Israelis and Palestinians. How can these neighbours and cohabitants be persuaded that whatever the rights and wrongs of history, they must help their children to find a way to coexist that ensures stability and fulfilment for all? Perhaps the tolerant olive, with its symbolism and shared cultural heritage, could be an inspiration to those who might pour oil on troubled waters.

Olive leaves have minute scales (shown below) to reduce water loss. The leaves of holm oaks (p. 48) have evolved a different method.

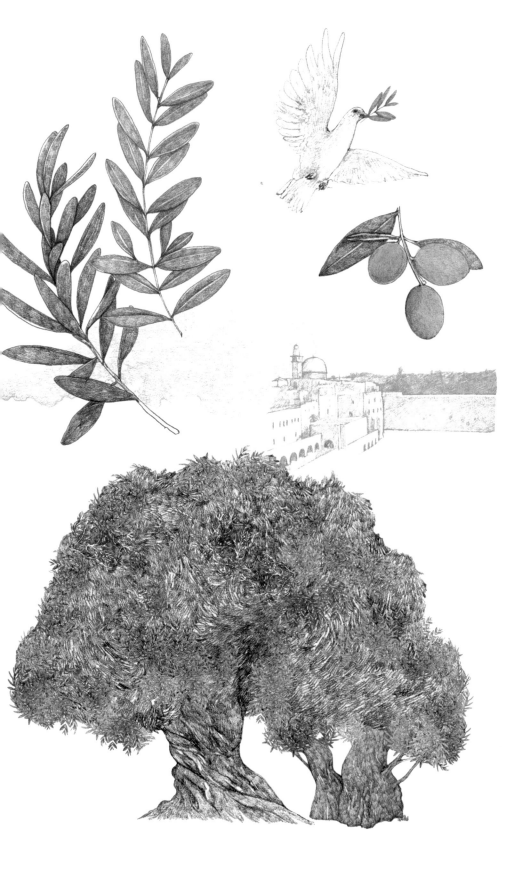

Kapok

Ceiba pentandra

A mature kapok is a huge and impressive thing: the tallest tree on the African continent, soaring as high as a 20-storey building, with a huge, dense canopy. When young, the trunk is bright green and smooth to the touch, with a peculiar structure. Groups of branches form distinct horizontal layers and conical spines erupt from the surface. It grows quickly, dropping its lower limbs and developing a stout grey trunk with impressive snaking buttresses, sometimes large enough to form human-sized hiding spots. A large kapok is its own island of biodiversity. Its giant branches support aerial plants and are home to countless species of insects and birds. Frogs spawn in the little pools of water that collect high in the branches.

During long dry spells kapoks drop their leaves. Individual trees don't flower and set fruit every year, but when they do, they do it with gusto and before the leaves reappear, so there's nothing to distract pollinators or stand in the way of seed dispersal. The small clusters of flowers garlanding bare branches seem bizarrely artificial: pale yellow, with a waxy sheen and smelling of yesterday's milk, all the better to attract bats and moths to perform their nocturnal services. Every night during flowering, each kapok generously lays on more than 10 litres (21 pints) of nectar, making it worthwhile for bats to travel as far as 20 kilometres (12 miles) between trees, spreading pollen as they go. The fruit that follow are pendulous boat-shaped pods – hundreds on each fruiting tree – which ripen from green to leathery tan and contain perhaps 1,000 seeds each. The seeds are handy for oil, but the main event is the kapok fibre: the mass of fine, silky hairs in which the seeds are cocooned. As the pods split, they look from afar like thousands of cotton-wool balls, the inspiration for the other common name for the species: the silk-cotton tree.

The seeds and fibre carry on the wind, but the seeds' oily coating and corky structure also encourage dispersal by river and sea, which is probably how the kapok first arrived on the continent. It is originally from tropical America (and is now the national tree of Guatemala and Puerto Rico), and we know from pollen evidence that the kapok has also been growing in West Africa for at least 13,000 years.

Kapok wood/fruit fibres are hollow micro-tubes with thin cell walls and a surface layer of wax, an unusual arrangement that makes them

exceedingly light, yet, unlike cotton wool, strongly water-repellent. Until well after World War II kapok fibre was specified for stuffing lifejackets and lifebelts. While being strongly hydrophobic, it is enthusiastically oleophilic – it can absorb 40 times its weight in oil. This is an ideal combination wherever oil needs to be separated from water, such as in case of accidental spills. To protect its seeds, kapok has evolved to be mould-resistant and unpalatable to insects and rodents, making it a popular material for filling pillows, cushions and mattresses, and for stuffing toys and teddy-bears.

The most famous and symbolically important kapok tree in the world is surely the colossal landmark in the oldest part of Freetown, the capital of Sierra Leone. Former African slaves, who had gained their freedom by fighting for the British during the American War of Independence, are thought to have given thanks by this sacred tree when they returned in the 1790s.

Kapoks have a strong association with well-being, both physical and mental. Sierra Leonians still pray and make offerings to their ancestors for peace and prosperity beneath these trees, which are revered throughout West Africa as an abode of spirits. Because of their associations and their abundant shade, kapoks are often used as meeting places, and also traditionally by local healers treating mental problems in the community with what might elsewhere be called group psychotherapy.

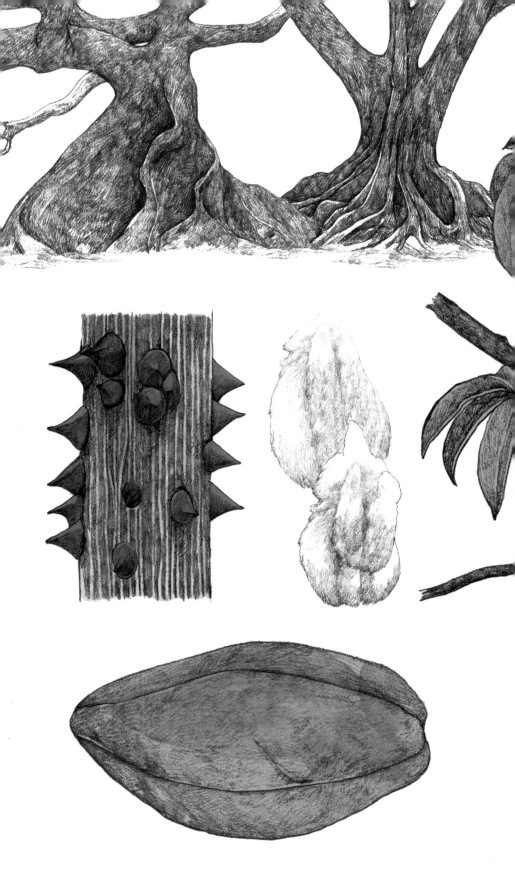

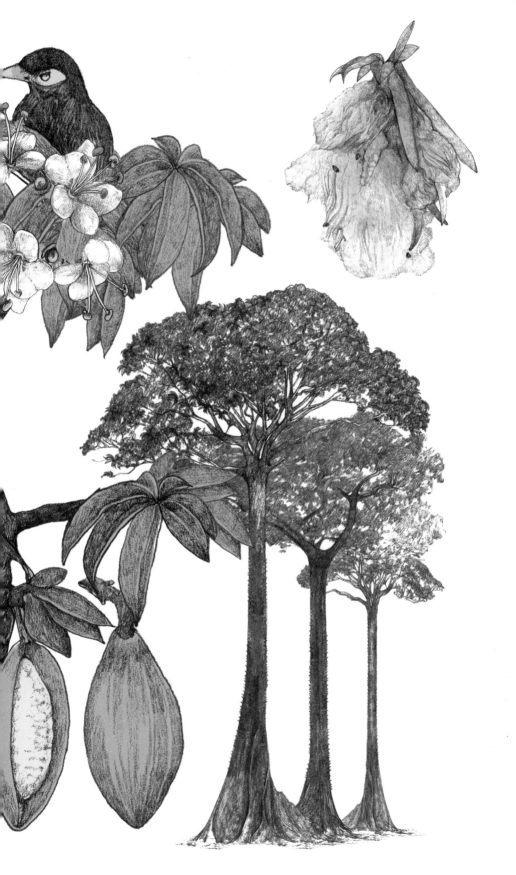

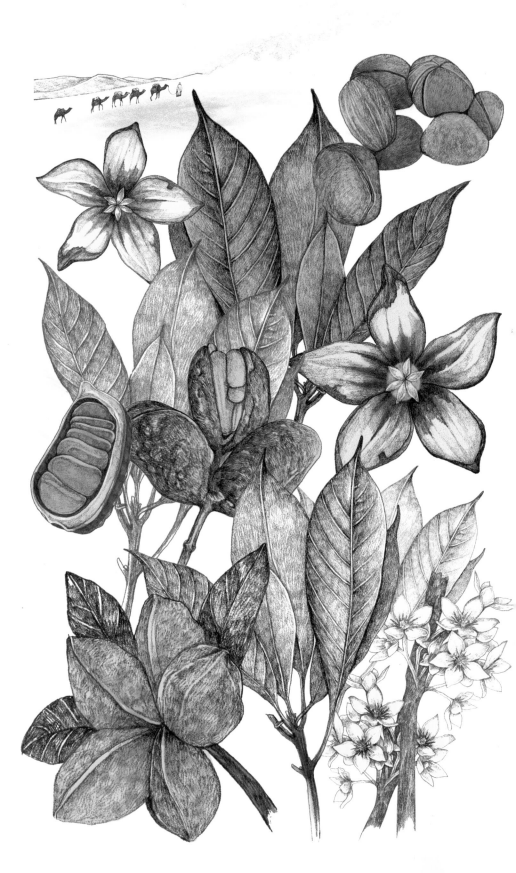

Kola Nut

Cola nitida

C*ola* is native to humid tropical West Africa. Two similar species –
C. acuminata, with pointed leaves, and *C. nitida*, with shiny ones – are
mid-sized evergreens, usually less than 15 metres (50 feet) high and
with a straight, squat bole. Its flashy pale-cream flowers are five-pointed
stars, each with a maroon starburst at its centre. The fruit look unpromising
– knobbly green pods 15 centimetres (6 inches) long that turn brown and
split to reveal a handful of smooth, chestnut-sized red or white seeds. But
these kola nuts pack a punch: they contain twice as much caffeine (a natural
insecticide) as coffee, alongside a handful of other stimulants and the merest
dash of strychnine. They are chewed continually and habitually throughout
the region, their initial bitter taste giving way to sweetness and, reportedly,
imparting a rosy glow to the world.

Some of kola's historical associations are disturbing, however.
Generally believed to allay appetite and thirst, kola nuts were loaded on to
transatlantic slaving ships, while powdered kola was added to water barrels
to make their stagnant contents more palatable. By the seventeenth century
kola had been planted in the Caribbean and the Americas and the nuts were
eaten occasionally by enslaved people there, both as a reminder of home and
to suppress hunger and fatigue.

A traded commodity for thousands of years and cultivated for
centuries, kola nuts also played a part in Africa's internal slave trade. Even
in the late nineteenth century, it was still being bartered for slaves arriving
in caravans from the Mediterranean coast and southern Sudan, to market
towns in what are now Ghana and Mali. Around the same time, kola began
to be touted in the United States for its medicinal properties. In the 1880s
it became one of the original ingredients in Coca-Cola, which also once
contained another natural pick-me-up: cocaine.

Today kola is sold in almost every West African market. Kola nuts are
a ubiquitous social lubricant, shared at greetings and farewells and marking
rites of passage. Here and there it has been the custom to bury a newborn's
umbilical cord with a kola seed; the tree subsequently becomes the property
of the child. Kola extracts are still used to flavour some 'natural kola' drinks,
and one can't help wondering whether tasty 'Sudan coffee', made from roast,
ground kola nuts, might be a profitable new sideline for cafés and a source of
income for farmers that, happily, wouldn't require forests to be cleared.

Baobab

Adansonia digitata

A cross cultures, the words for sharp or pointed objects tend to have fricative sounds (such as Fs and Ks in English) and those for rotund things have rounder sounds, like Bs, Ms and Ws. It is hardly surprising, then, that the baobab, also known variously as the *bwabwa*, *mwamba*, *mubuyu* or *mowana*, is one of the blobbiest trees on the planet.

Baobabs are strange, occasionally locally abundant but often solitary, and probably live up to 2,000 years. The most common species, *Adansonia digitata*, has five or seven leaflets attached like fingers to a central point, and is a familiar sight across most of the sub-Saharan African savannah. Folk tales give different accounts for its odd look, the most common theme being that it had ideas above its station and, after much to-ing and fro-ing, the Creator exasperatedly flung the baobab upside down with its roots in the air.

Large baobabs can be 25 metres (80 feet) high, with a similar circumference: you'd need a dozen tall tree-huggers to get the job done. The uncannily smooth trunks of huge older trees are almost always hollow, probably as a result of fungal infection, and the interiors have been put to use as shelters, warehouses, bars and even makeshift prisons. The baobab has a legendary ability to store thousands of litres of water in its soft, pulpy trunk – attracting thirsty elephants, which rip off pieces – and, perhaps uniquely among trees, it grows and shrinks markedly according to drought.

The baobab's large, pendulous white flowers last just a day and smell sour to the human nose. Lacking copious nectar, they instead provide thousands of stamens: food for fruit bats and bushbabies, which shower themselves in pollen and spread it as they browse. Most parts of the tree are useful. After the flowers, large, oval fruit develop, dangling on stalks up to 25 centimetres (10 inches) long. The fruits have a velvety brown surface and tart, powdery flesh that is made into a refreshing drink rich in vitamin C. The seeds are dispersed by elephants and baboons if people don't get to them first (to use them as a coffee substitute), and the regenerating bark gives fibre for weaving, supporting a flourishing trade in mats and hats.

In many African traditions baobabs are regarded, at least symbolically, as the home of the benign spirits of dead ancestors. Occasionally, the trees are associated with malevolent forces. Either way, such superstitions encourage greater reverence, and therefore protection, than these extraordinary trees might otherwise receive.

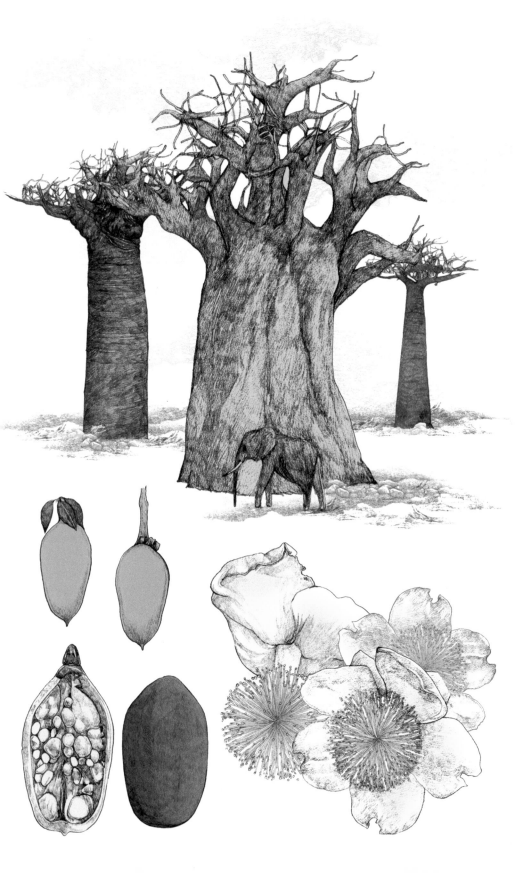

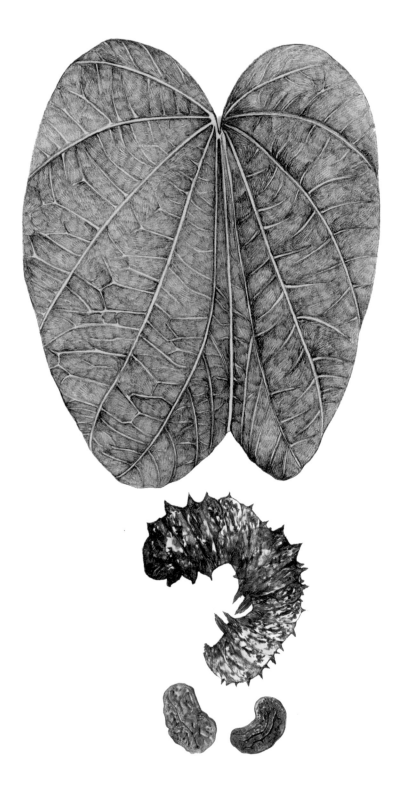

Mopane

Colophospermum mopane

Mopane trees grow in a belt across the middle of southern Africa. They support some of the continent's most important wildlife populations, including elephants and black rhinos, and are the source of a surprising food for humans.

A small deciduous tree reaching 15–20 metres (50–80 feet) high at most, mopane has relatively few main branches, which are smooth and grey when young but become wrinkled and rutted with age. Its delicate appearance is deceptive: on shallow or clay soils it can outcompete other trees to become the dominant species.

The leaves that appear after the dry season are distinctive. Each one is a pair of leaflets shaped like Renaissance angel wings, with a tiny vestigial third leaflet in between. When seen against the light, mopane leaves are stippled with translucent dots, tiny cavities containing turpentine-like resin. In very hot weather, the leaf wings fold together and droop, absorbing less light and heat, and reducing water loss. Thus, much of the time, mopane casts only dappled shade, encouraging an understorey of characteristic shrubs, which support insects and the birds that depend on them. Rodents and larger animals eat the foliage and fruit, and disperse seeds. The entire ecosystem is an intricate web called mopane woodland.

Mopane flowers are pollinated by wind, and trees often grow in dense stands, increasing the chances of pollen reaching its destination. For this reason the flowers, which do not need to attract insects or animals, are small, pale green and inconspicuous. The seed pods, dispersed by the wash of a brief downpour, each contain a single kidney-shaped seed, whose intricately patterned gummy surface is especially adapted to retain moisture.

Mopane timber is strong and termite-resistant, and it is the wood of choice for building village huts. Dense enough to sink in water, it has excellent acoustic qualities for saxophones and clarinets. But what sets mopane apart is the nourishment it provides to millions of people – not a product of the tree itself, but of a species that lives on it. At the end of winter hordes of large mopane moths (*Gonimbrasia belina*), which have the wingspan of a child's hand and are recognizable by their russet wings and bold eyespots, emerge from the ground, mate and lay their eggs on mopane leaves. In summer those eggs hatch into larvae. These 'mopane worms', undaunted by the resin in the leaves, are voracious, increasing their weight

4,000-fold in six weeks, but their feeding period is much shorter than that of other species, enabling the trees to recover. Within six months of being stripped, young trees grow back bushier, with smaller but more profuse leaves, and a total leaf area that is back to what it was before. Nobody yet knows why munching by deer, in contrast to complete stripping by caterpillars, does not elicit such a remarkable recovery by the tree.

The mopane worms are bigger than a middle finger. With black-and-white speckling, green-and-yellow bands and rows of little spines and hairs, they are decently camouflaged from birds but easily catch the hungry human eye. Thousands of tons of mopane worms are enthusiastically harvested in a season. They are pinched at the tail end and squeezed between finger and thumb downwards towards the head, ejecting slimy goo, green with partially digested leaves. After being boiled in salted water, they are dried in the sun and sold in markets and roadside stalls. They can be eaten just as they are – tasting rather like salty potato crisps – or added to vegetable stews.

Dried mopane worms have long been an enjoyable treat locally. They are 60 per cent protein, and also contain fat and important minerals, so they are exceptionally nutritious and an important food in lean times, particularly since they keep for months without refrigeration. However, the taste for mopane worms has spread. Increased demand from supermarkets and international trade, particularly to South Africa, has depleted the moth population and even caused taller trees to be felled in the quest for valuable but out-of-reach caterpillars, prompting various experimental schemes to restrict the harvest.

Mopane and european box (p. 32) have similarly strong and heavy timber.

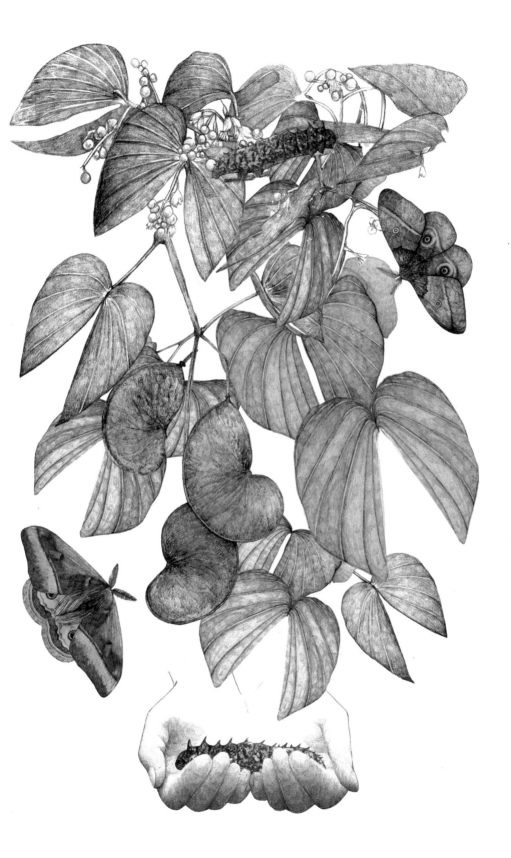

Traveller's Tree

Ravenala madagascariensis

Madagascar, an island larger than France, is a dream destination for naturalists. It has been isolated from the rest of Africa for about 150 million years and from India for 90 million, and settled by people only for the last couple of thousand, so species have evolved there to an independent tune. Almost all the native plants are endemic – they don't exist naturally anywhere else in the world – which means that many of their relationships with wildlife are also unique.

The island's iconic traveller's tree, known locally as *fontsy*, is half glorious, half ridiculous and all spectacular. It has the form of a huge fan on one vertical plane, an enormous and improbably symmetrical arrangement of paddle-shaped leaves, each up to 3 metres (10 feet) long and 0.5 metre (1½ feet) wide. In young trees, the regular plait of overlapping leaf stems bursts from ground level, but with age the trunk extends, straight, grey and composed of tightly compressed overlapping leaf bases that can reach 15 metres (50 feet) high. At this height, the tree is at its most surreal.

In a genus all of its own, the traveller's tree looks like a palm but is actually a member of the Strelitziaceae, a plant family that includes the flamboyant bird-of-paradise flower from South Africa, much enjoyed by gardeners with a penchant for the exotic. Many of those relatives ostentatiously display red and orange flowers and seeds that are attractive to birds, whose eyes are particularly sensitive to those colours and who will obligingly pollinate or disperse the species. The pale yellow flowers of the traveller's tree, however, emerge from tough and boringly beige-green bracts that resemble pelican beaks stacked in the centre of the foliage. What could possibly have the skill, and will, to prise open and pollinate such a thing? Enter the black-and-white ruffed lemur, a mammal that is endemic to Madagascar. With its permanently startled expression, the lemur seems to have emerged straight from a kids' cartoon, and is unbearably cute to human eyes. In return for copious sugary nectar, a major part of its diet, it transfers pollen on its fur from tree to tree. The lemur is endangered now and therefore, in the wild, so is the palm.

The fruits are 8-centimetre (3-inch) long woody seed capsules, which dry and split apart to reveal their hidden treasure: possibly the only blue seeds in the world. The arresting colour emanates from their arils, extra seed coverings that shine like lapis lazuli. The seeds have evolved to be

easily seen by lemurs. These forerunners of apes, or 'prosimians', have dichromatic vision and are able to discriminate between blues and greens, whereas red would be lost on them. The animals eat the seeds, some of which are excreted undamaged to become the next generation.

One origin of the tree's common name is the reputation of the species as a compass. It is said that its arc of foliage always faces a certain direction, perhaps in response to sunlight, although it is hard to pin down definitively whether this is actually true. (A straw poll of Malagasy botanists and time spent on inconclusive analysis of aerial photographs suggest that this would make a delightful PhD project.) The second reason for an association with travellers is that rain is channelled down the interlocking U-shaped leaves into the centre of the tree, which can accumulate as much as 1 litre (2 pints) of water. It gets pretty brackish in there and doubtless has all manner of wriggling things in it, but it is technically possible to insert a tube into the side of the stem and drink directly from the tree (although a water-purifying straw might be a safer bet than an ordinary one). With a stiff upper lip in the face of extreme circumstances, the tree could just be a lifesaver for travellers.

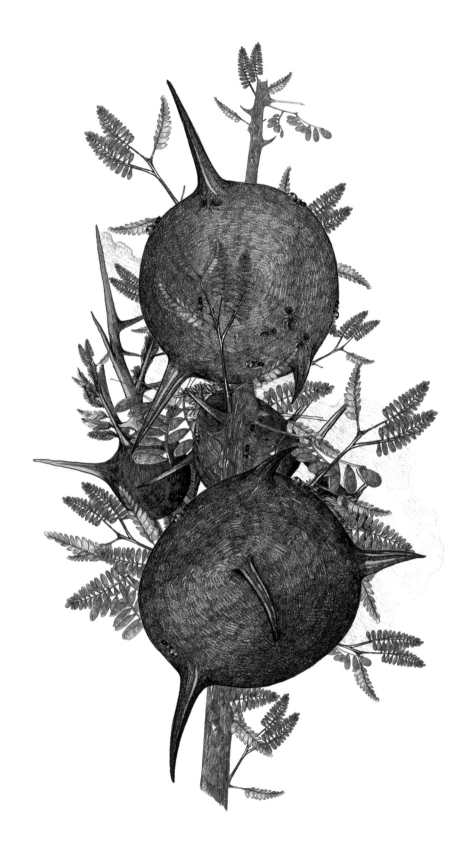

Whistling Thorn

Vachellia drepanolobium (also known as *Acacia drepanolobium*)

The whistling thorn is common throughout the savannah landscape of eastern Africa. From a distance, it's an unremarkable shrubby tree, growing to about 6 metres (20 feet) tall. However, all is not what it seems, for on a breezy day the tree itself makes a discordant, high-pitched whistling noise – and surely those frills of leaves are surprisingly dense for foliage that should be a tempting meal for animals? It is true that at the base of every leaf cluster there is a pair of straight white spines, each as long as a man's finger. They would ward off some herbivores, but giraffes are renowned for skirting such defences with their prehensile tongues. Elephants would take those thorns in their stride, and they would be inconsequential to insects.

If you venture closer, however, you will see that many of those thorns have bulbous, hollow bases: odd little sputniks the size of a walnut, soft and purple when young, hardening and turning black as they age. Small holes in these rough spheres cause the whistling as air flows past them. But why the little spheres and why the holes? Tap the tree a few times and the mystery is solved: hundreds of ants come rushing out of each swollen thorn, ready to defend the tree. Intruders are immediately set upon by hordes of biting ants. They race around emitting alarm pheromones, and this recruits more guards to the scene. A mouthful of stinging ants is an effective deterrent to even the largest herbivore, and villagers observe that domesticated goats, attacked while trying to browse on a defended tree, will never be seen returning to the same tree.

The swollen thorns are called *domatia*, or 'homes'. In return for their prefabricated housing and a supply of sweet nectar from glands along the leaves, the ants are well motivated to defend the trees from all comers. The nectar is rich in energy but lacks protein and fat, which means that the ants must forage for insects to augment their diet; the detritus they eject from the swollen thorns probably fertilizes the tree.

For the ants, with plentiful food and decent housing, this is the good life, and that explains why different ant species will compete for exclusive rights to a particular tree. If branches of neighbouring trees containing rival ant colonies become entangled, the ants will fight one another, with the losing colony being evicted from its tree. No wonder then that the ants

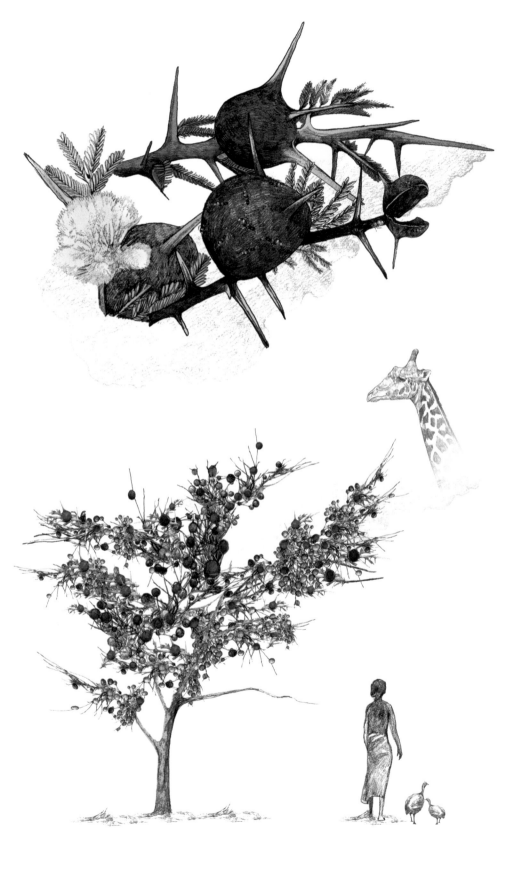

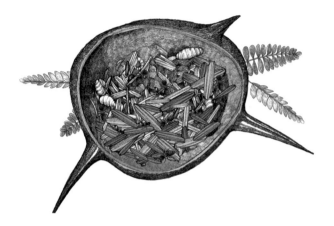

ruthlessly trim the lateral buds of trees and chew invasive vines, cutting themselves off from contact with neighbouring whistling thorn trees and reducing the chance of a hostile invasion.

Some poisonous or dangerous animal species are known to exhibit behaviour known as aposematism: signalling to potential predators to steer clear. Researchers have recently suggested that the whistling sound of the breeze through the thorn is an example of auditory aposematism. Just as a rattlesnake audibly warns all to keep away, the whistling itself may signal danger and might even stop an elephant from trampling a tree in the dark.

Paradoxically, though, the tree is healthier if it is attacked at least occasionally. A tree expends a lot of energy to make nectar, so if there aren't any big herbivores around, trees reduce the amount of nectar they produce and also the number of swollen thorns to house the ants. The ants respond by cultivating a replacement food source – they nurture aphid-like insects that suck the tree's sap and excrete sweet honeydew. But this sweet food attracts a second species of ant that takes advantage of the reduced defences and starts to occupy the trees. These new ants defend trees much less aggressively against herbivores, and they also benefit from holes made by a beetle that damages the trees. So, counter-intuitively, if there are no large herbivores, the tree doesn't need to provide such a warm welcome for stinging ant armies, which means that other insects start damaging the trees and the whistling thorn suffers. And if a tree suffers there will be fewer fruit and seeds, which are, after all, the next generation. If there *are* large herbivores around, the tree needs lots of ants to protect it, which means making lots of nectar, which means diverting scarce resources from making fruit and seeds … Nature is a balancing act.

The neem (p. 120) also has a clever method of defending itself.

Frankincense

Boswellia sacra

The arid lands of Oman, Yemen and the inhospitably mountainous region of northern Somalia are the home territory of a group of closely related species of *Boswellia*, which often takes the form of an inverted pyramid, just a few metres high. Its smooth bark is papery and peeling, and its leaves cluster at the ends of tangled branches. It can gain a foothold and cling to rocks on steep slopes with a cushion-like swelling at the base of its trunk – a useful way of avoiding animals. The sprays of winter flowers are glorious: each one has five creamy petals and ten pale stamens surrounding a centre spot that changes colour from yellow to dark red, signalling to pollinators that their work on that flower has been successful and that they should go to another for nectar. If the tree is wounded, tears of white or pale-yellow frankincense, a mixture of resin and water-soluble gums, are exuded from special ducts to discourage termites and other insects. It is this substance, which releases a fresh, balsamic fragrance when heated over glowing charcoal, that is *Boswellia*'s claim to fame. Rural people encourage the trees to weep by slicing off a patch of bark; they use occasional drips as a mouth cleanser but send the lion's share for export. It is one of the most valuable commodities from this impoverished part of the world.

Frankincense and myrrh (another local tree resin) were already valuable items for south Arabian trade by about 2500 BC, when the ancient Egyptians needed a supply of resin for embalming their dead. They considered antiseptic, scented frankincense to be 'the sweat of the gods fallen to Earth'. In about 1500 BC, in what was possibly the world's first imperial plant-collecting expedition, the Egyptian queen Hatshepsut explored the possibility of growing frankincense at home in Thebes to save the expense of importing it. According to inscriptions on temple walls, she sent five galleys, each powered by 30 rowers, to the 'Land of Punt' (thought to be the Horn of Africa), to fetch back incense trees, which were planted at Karnak on the banks of the upper Nile. The trees apparently failed to thrive in Egypt; Punt and southern Arabia continued to be the only sources of resin.

The Egyptians were not the only people eager for frankincense, and starting around 1000 BC, an overland Incense Route became increasingly well established, running from southern Arabia and the Horn of Africa

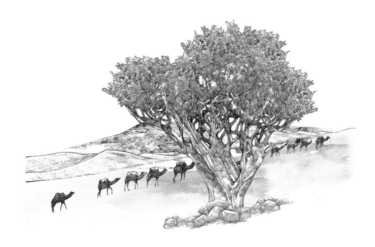

towards the Mediterranean and Mesopotamia. It was traversed by huge
and heavily guarded camel caravans supported by strategically placed
fortresses and rest stops. Strabo, the Greek geographer, likened the route
to an army in transit, and Pliny the Elder, writing in about AD 50, enviously
described the peoples of southern Arabia as 'the richest races in the world'.
The area became known as *Arabia felix*: happy or fortunate Arabia. When
frankincense was presented as a gift to Jesus it was worth more than gold;
according to some authorities, it was the most valuable substance on Earth.

However, the Incense Route gradually lost importance. To begin with,
Roman sailors navigated their way directly to producers. Then a decrease
in rainfall around the dawn of the Christian era meant that hungry animals,
needing forage, further damaged the already stressed trees (as they do
today). Finally, at the end of the fourth century AD the Christian Holy
Roman Emperor Theodosius forbade the pagan practice of making incense
offerings to household gods.

The Old French *franc encens* ('choice incense') is the origin of the
modern name (and 'perfume' is derived from *per fumum*, 'by smoke'). Over
thousands of years Babylonians, Egyptians, Jews and Greeks all required
incense for their temples – although 'religious use' may have had a broader
definition in those days. In the context of the Song of Songs, frankincense
was clearly regarded as an aphrodisiac and a signal of sexual bliss. Nowadays,
one must visit the Gulf States (where frankincense is in high demand for
up-market chewing gum) or Catholic or Greek Orthodox churches to enjoy
the mildly intoxicating fragrance of concentrated frankincense, a substance
that has been scraped from trees for at least five millennia.

*The flowers of the horse chestnut (p. 38) also signal to pollinators by
changing colour.*

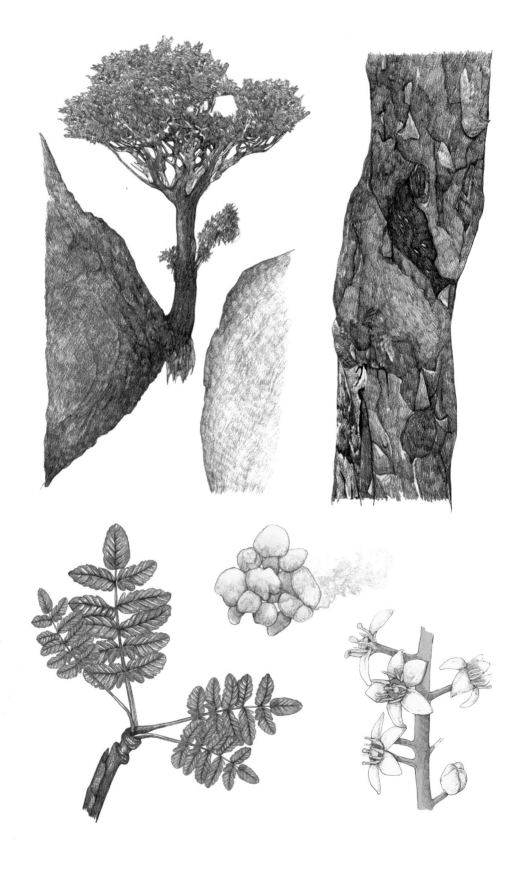

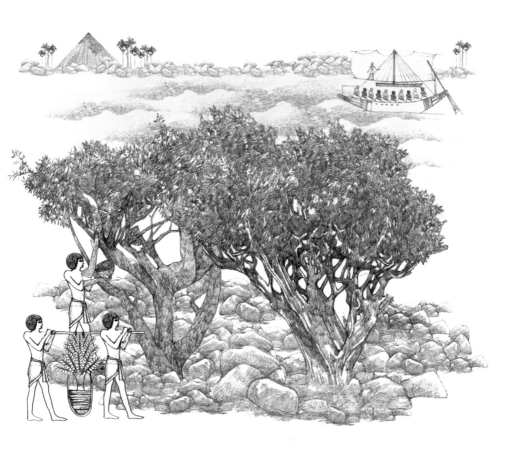

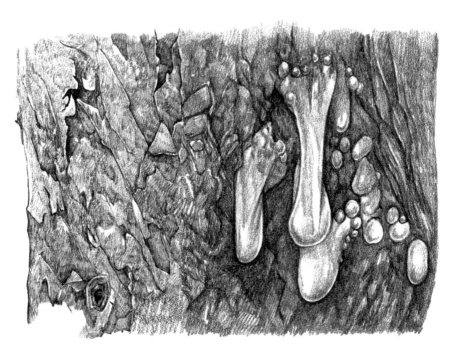

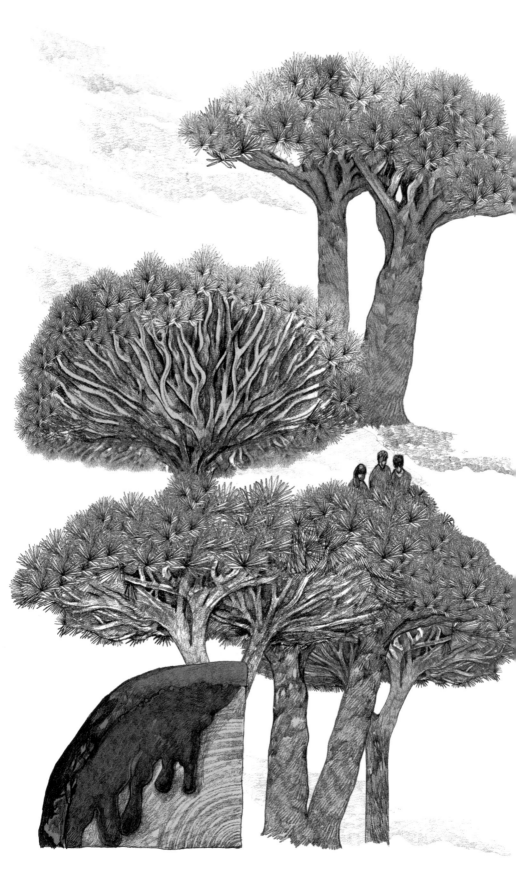

Dragon's Blood

Dracaena cinnabari

E ndemic to the Yemeni island of Socotra, off the Horn of Africa,
dragon's blood trees have an eerie, prehistoric aspect. Their bizarre
shape, like umbrellas blown inside-out, helps them to survive on
the arid, thin soil that covers the island's granite mountains and limestone
plateaus. Rainfall is rare there, but occasional mist condenses, drop by
drop, on the tree's slender, waxy, skyward-pointing leaves and runs down
to its branches. They too slope downwards, directing tiny trickles of water
towards the trunk and, eventually, the roots.

Dracaena's otherworldliness is heightened by the teardrops of
translucent blood-red resin that ooze from its wounded limbs. Local
residents encourage the flow by carefully incising the bark or prising apart
existing fissures and returning a year later to collect droplets and small
chunks of resin. As much as 0.5 kilogram (just over 1 lb) can be harvested
from a single tree. Heated, dried and formed into small slabs, it has the
creepy, powdery quality of dried blood. In seventeenth-century Europe,
this strange 'dragon's blood' was tinged with magic and prized as a cure-
all. It was prescribed for serious conditions and was also a reassuringly
expensive ingredient in love potions and breath-fresheners. Now we know
that the resin contains antimicrobial and anti-inflammatory compounds,
and it is still used locally as a mouthwash and to treat rashes and sores.

Why *dragon's* blood, though? Socotra was an important stop on trading
routes between India, the Middle East and the Mediterranean, and the
origin probably lies with Indian merchants who brought the resin to market
along with their Hindu myths. One of these involved a legendary fight,
on Socotran soil, between an elephant and a dragon, in which the dragon
gulped the elephant's blood before being squashed in the mêlée, spilling
the blood of both animals. In the first century AD the story reached a wide
audience when it was retold in a Greek shipping manual and repeated by
Pliny the Elder. Some 2,000 years later the scientific name *Dracaena* derives
from the Greek for female dragon, and the resin is called 'dragon's blood' in
many languages. In Socotra today, it is known in Arabic as 'the blood of two
brothers', a reminder of previous Indian cultural influence.

*Varnish containing dragon's blood resin was used by Stradivari to stain violins. The
wood he used to make them was Norway spruce (p. 54).*

Coco-de-mer

Lodoicea maldivica

In the seventeenth century European sailors began to report woody objects floating in the Indian Ocean that were the size and shape of a curvaceous woman's pelvis, true down to their inviting thighs and shapely cheeks. They were reckoned to be a double coconut that grew underwater, hence 'coco-de-mer', and were so rare, and deemed to possess such aphrodisiac and poison-neutralizing properties, that they became the prize of potentates. In the East Indies it was illegal for lesser mortals even to own them, and in the 1750s one cost £400 (nearly £70,000 today). A decade later they were observed to grow on palms in the Seychelles, where the seeds had long been revered by various island cults. Over-enthusiastic sailors looted the forests and flooded the market, making them affordable for well-to-do collectors.

The native coco-de-mer community now consists of just a few thousand individuals on two islands: Praslin and nearby Curieuse. They can live for 800 years, reaching an impressive 30 metres (100 feet) tall, and are dioecious, meaning that there are male and female trees, often growing in pairs. Males have phallic catkins as long as a man's arm, the biggest anywhere, with thousands of small yellow flowers. The females bear the largest flowers of any palm, as well as the colossal green-husked fruit. Madame et Monsieur de Mer are an attractive couple, and locals still harbour the superstition that one should not visit their groves at night for fear of inauspiciously interrupting amorous activities. Perhaps they just want to avoid injury: each fruit contains a single monstrous seed, the heaviest of any in the world, which can easily weigh 30 kilograms (65 lb).

How did they come to be so heavy? About 70 million years ago the seeds of the coco-de-mer's ancestor were already large but could still be dispersed by hefty animals, possibly dinosaurs. Then what are now the Seychelles and India drifted apart. The trees became isolated from those animals and had to adapt to germinating where they fell, in their parents' dark shadow. However, their nutritious seeds gave them a head start and enabled them to outcompete other species to reach the light. In a forest now crowded with their own kind and without external competition, it was down to pure sibling rivalry. The trees with the biggest seeds were the winners in the race for light, so the seeds grew bigger and bigger. The phenomenon is known as island gigantism and it affects animals too; the

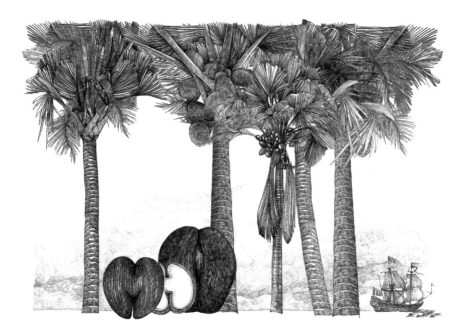

same process has given us the giant tortoises of the Galapagos and the
Komodo dragons of Flores, Indonesia.

 The coco-de-mer has such grand fan-shaped leaves that just a few are
enough to thatch a house. They funnel water and nutrients, such as airborne
pollen and the guano of the rare black parrots that inhabit the trees, down
to the trunk and thence to the roots. This supports the production of
prodigious fruit while denying competing plants light, nutrients and water.
However, the coco-de-mer must ensure that its seedlings don't compete
with the mother tree. A plummeting fruit the weight of a full suitcase is
hardly going to disperse on the breeze, there aren't any animals big enough
to carry them, and, unlike coconuts, they can't remain viable in seawater.
Instead, coco-de-mer has found another way. At least six months after
the fruit has fallen and the husk has rotted, a pale yellow, rope-like shoot
appears from the 'crotch' of the seed, containing the embryo of the seedling
in its tip. The shoot buries itself to about 15 centimetres (6 inches) and
grows underground horizontally until it is about 3.5 metres (12 feet) away
from the mother tree – far enough not to compete with her. It then sprouts
a conventional shoot upwards from the embryo and simultaneously puts
down roots, but it continues to be supplied with nutrients from the parent
seed for several years. The tree also creates an underground colander-like
structure about 1 metre (3 feet) across and 0.5 metre (1½ feet) below the
surface, through which the roots grow. This probably acts as an anchor –
handy for a tree that will bear on its boughs hundreds of kilograms of seeds.

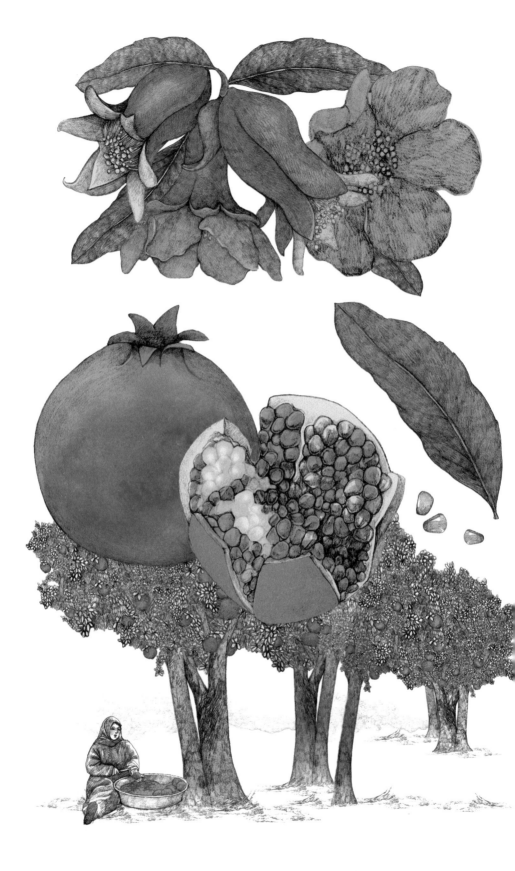

Pomegranate

Punica granatum

Pomegranates feature frequently in writings from ancient Egypt and classical Greece, in the Old Testament and Babylonian Talmud, and in the Qur'an. Their abundance of seeds and juice consistently link the fruit to fertility. The ancestors of the cultivated pomegranate grew several thousand years ago in arid, hilly regions between Iran and northern India, and today's cultivars still prefer hot days and cool nights. Small, many-branched trees of 5–12 metres (16–40 feet), with shiny leaves of deep green, they are long-lived, perhaps to 200 years. Pomegranate flowers are a sight to behold. Distinctive calyxes, protective layers around the base of each flower, form sturdy funnels from which crumpled petals burst exuberantly in lurid shades of scarlet and crimson.

Pomegranate fruit range in colour from yellow with a blush of pink to burnished rose or even maroon. They have a tough, leathery skin, ensuring the fruit last well after picking; historically, they were a refreshment taken on long journeys. Inside, held within a spongy cream membrane, are hundreds of seeds, each within a juicy sarcotesta (a swollen seed coat), ranging from translucent pink to deep purple. The turgid grains interlock satisfyingly with one another – a triumph of efficient packing – and the juice within each one is delectably sweet, tart and mildly astringent. These are ample compensations for the dry woodiness of the seeds and the dilemma, for some, of whether to spit or swallow.

While fresh pomegranate fruit, juice and cordials are widely available from the western Mediterranean to south Asia, the Iranians have truly embraced pomegranate culture. Specialist stalls stock juice from different cultivars. Mounds of seeds – fresh, dried or frozen – are ready to be sprinkled on top of juice or ice cream, sometimes with a pinch of thyme. In autumn, fresh juice is boiled until it thickens into dark-brown molasses, a key ingredient of *khoresht fesenjan*, a chicken and walnut stew. And of course, Tehran has the requisite annual pomegranate festival.

Pomegranates have a reputation for health benefits. Traditional uses for diarrhoea, dysentery and intestinal parasites are long established, and the fruit contains antioxidants that are likely to be beneficial; some gung-ho anti-cancer and anti-ageing claims, however, require better evidence. But perhaps we shouldn't dismiss the psychological benefits of a fruit whose consumption requires our undivided attention.

Wild Apple

Malus sieversii

From DNA analysis, we now know that the primary ancestor of all the apples we eat is the wild apple tree native to the forested slopes of Tian Shan, the 'heavenly mountains' of eastern Kazakhstan. This tree shares characteristics with many of its well-known descendants. It has familiar foliage, and its plentiful, fragrant white or pink-tinged blossom is hermaphroditic – both sexes are present within the same flower – but because they are 'self-incompatible', they need other trees for pollination. The tips of the flower stems swell to become fruit, called 'pomes', and the remains of the flower can be seen at the bottom of every apple. However, there the similarity with their cultivated descendants ends. Even though the wild apples are one species, there is enormous diversity in the size and shape of trees, many of which are surprisingly, and inconveniently, tall. Occasional large, sweet apples with unusual tastes of honey, aniseed or nuts would suit any supermarket display, but they grow next to small, astringent fruit, sometimes on adjacent branches of the same tree.

Apples were probably first domesticated, or at least deliberately planted, in this area between 5,000 and 10,000 years ago. Gradually the most desirable apples began to be transported westwards along the Silk Road. Undamaged when they pass through horses and even tamped by hooves into the earth and manured, the seeds were carried far and thrived. The riders would have packed the tastiest apples for their journey and thrown their cores along the route. The resulting trees would have cross-fertilized, but their fruit would still have been awkwardly out of reach and inconsistently sweet or sour: a tree grown from apple seed frequently does not resemble its parent, and rarely does the fruit taste the same.

Then, possibly as early as 1,800 BC in Mesopotamia, and certainly by 300 BC in classical Greece, the technique of grafting was developed. Grafting cuttings from a tree with desirable fruit on to 'dwarf' rootstocks from smaller trees made it possible to reproduce reliably any deliciousness that nature had chanced upon, and create trees that were practical to pick from. This is how all modern apple trees are propagated.

Over the centuries apples have been bred repeatedly for flavour and size, creating hundreds of gloriously diverse varieties. Sadly, global agriculture has focused on just a few dozen edible cultivars and about ten cloned rootstocks. Inbred and pollinated by close relatives, the apple's

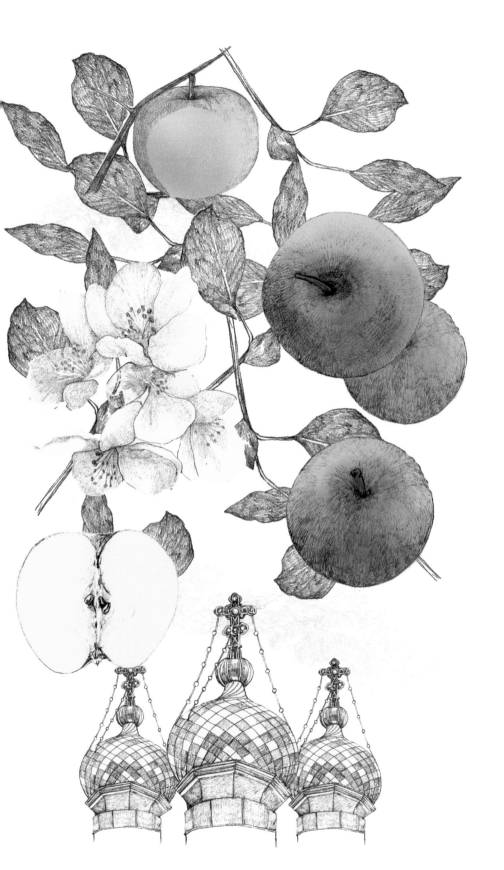

genetic diversity has slowly but surely been whittled away. The problem with this is that when we need new traits – such as resistance to disease without the need for expensive or unpleasant pesticides, or new flavours, or longer storage, or later ripening, or easy harvesting, or drought tolerance, or any one of myriad others – the genes that might confer these characteristics just aren't there any more. This is why the wild relatives of our modern apples are vital: it is the trees on central Asian hillsides that contain the genetic information that has been lost, and from which we must breed and cross again. Wild apple populations are scattered in central Asia, and although seeds are being collected and stored in seed banks, the species is endangered through loss of habitat and from genetic dilution: the result of cross-pollination with encroaching commercial varieties.

Apples have cultural and even religious significance; the fruit that Eve plucked and ate from the Biblical Tree of Knowledge could have been any one of a number of fruits – grape, pomegranate, fig or even lemon – but is usually portrayed as an apple. The remaining forests of Tian Shan, vibrant with the forerunners of apples (as well as apricots, nuts, plums and pears), are commercially significant. But they are also indeed a kind of Eden – a cradle of invaluable genetic information – and are worth protecting in their own right.

The white mulberry (p. 128) was also intimately connected with the Silk Road.

Dahurian Larch, Siberian Larch

Larix gmelinii, Larix sibirica

The largest wooded region on the planet is the boreal coniferous forest, which dwarfs the tropical rainforests and accounts for about a third of the Earth's total forest cover. It blankets a swathe around the Arctic Circle, across Alaska and northern Canada. It covers nearly 7.8 million square kilometres (3 million square miles) of Siberia alone, where it is known as the *taiga*. Vast amounts of carbon are locked up there, with so much vital biomass that worldwide levels of carbon dioxide and oxygen fluctuate markedly in time with its seasons. This is the realm of the larch.

The gigantic Yenisey River flows 3,200 kilometres (2,000 miles) from Mongolia to the Arctic, dividing Siberia in two. To the west, all the way to Finland, the Siberian larch, *Larix sibirica*, dominates the landscape. Eastwards to Kamchatka, almost the end of the land, is the domain of its close sibling the Dahurian larch, *L. gmelinii*. The two species are very similar, with only marginal differences in their habitats, but can be distinguished by their red-tinged cones, which stand erect on the branches – softly hairy on the Siberian, and with scales curving slightly outwards on the Dahurian. Larch needles are soft and fine, clustering a dozen at a time on horizontal branches. Their outer bark is silvery grey on young trees, becoming reddish-brown, thickened and furrowed with age, while the secret inner bark can be an enjoyably vivid maroon.

Siberia is ludicrously inhospitable. Over the course of a year the air temperature can vary by more than 100°C (185°F). In southern Siberia, these conifers grow to 30 metres (100 feet) or more, but near the Arctic Circle, stunted by the elements, they reach just 5 metres (16 feet). A characteristically short, sharp spring is followed by only two or three frost-free months when the temperature hits the high 30s °C (about 100°F). Winter is brutal. In some areas, the *average* monthly temperature for December to March is -40°C (-40°F), and cold nights can drop below -65°C (-85°F). Permafrost – impenetrable ground that never thaws – is common and not far below the surface. Somehow, the Dahurian larch, the cold-hardiest and northernmost-growing tree in the world, thrives in vast forests across the *taiga* and outcompetes other species there.

Larches in Siberia have evolved several adaptations to freezing temperatures and the related lack of liquid water. Like other high-latitude conifers, their narrow, conical profile shrugs off snow to prevent damage

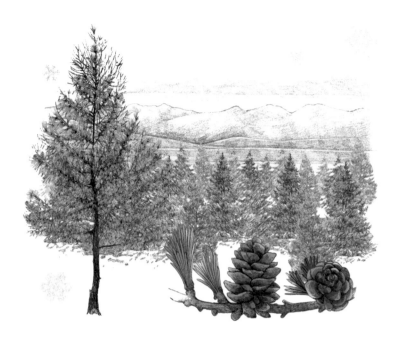

to the branches. Needle-like leaves have a small surface area, reducing evaporation, and their wax coating also prevents dehydration. (The wax particles are small enough to scatter the shortest wavelengths of sunlight, giving the tree a blueish tinge.) Unusually for conifers, larches are deciduous; in the dying days of summer they turn an eye-popping yellow-gold and shed their needles, cutting water loss even more. In autumn they adjust their antifreeze biochemistry by, for example, building up turpentine in their thick bark and wood, and replacing with various sugars the water that would otherwise freeze inside their cells and rupture them. If the main root of the Dahurian larch encounters permafrost, it dies off. For the rest of its life, the tree manages with a very shallow root system spread out in any upper soil that isn't completely frozen through.

In the nineteenth century Russians reportedly made fine gloves from Siberian larch bark, comparable to those of delicate chamois, and regarded them as stronger, cooler and more pleasant to wear in the summer. Larch wood is now commonly used in the construction of buildings and for timber cladding, boat-building and veneers, and as a source of pulp for paper. There are large plantations in Finland and Sweden – so much more readily accessible than northeastern Siberia.

An odd quirk means that Siberian and Dahurian larches, which cope so confidently with extremes of temperature, fare poorly in temperate climes. In western Europe, the tentative start to spring fools the tree into budding, whereupon they become susceptible to frost. Larches, it seems, can endure anything except uncertainty.

Cashew

Anacardium occidentale

T he cashew originated in Brazil, where it had been domesticated for hundreds of years by indigenous peoples before Portuguese colonists realized its value and spread it around their empire in the early seventeenth century. This is how it landed in Mozambique in eastern Africa and Goa on the west coast of India.

The tree is an evergreen, with bushy, spreading branches and leathery leaves. It grows to 15 metres (50 feet), although dwarf trees have been bred to make life easier for farmers. The tree develops stalks, or 'cashew apples', that swell to look like a fruit. (Real fruit develop from the ovary, the part of the flower that contains the egg cells.) The 'apple', which is about the size of a small pear, is perfectly edible, if slightly astringent (as its Tupi Indian name *acajú*, or 'mouth-puckering', suggests). The 'apple' attracts animals to disperse it, yet it contains no seeds. Instead, the structure containing the seed dangles strangely from the outside of the 'apple' like a miniature boxing glove. And it packs a nasty punch. The hard nut has a double layer containing a frightfully caustic oil, which causes immediate blistering and swelling brought on by cardol and anacardic acid. These are toxins similar in effect to those found in poison ivy, a plant in the same family as cashew. The oil protects the nut, which is dropped, uneaten, pretty quickly, but far enough from the parent tree not to compete with it.

For human consumption, the nuts are steamed open (even 'raw' nuts must be cooked) and the seeds roasted to drive out any remaining poison. One wonders at the ingenuity, or desperation, of the Tupi and the Arawak, who were the first to discover that cashew seeds were great food. The trial and error must have been painful. Goans distil a ferocious liquor called *fenny* from cashew apples, although it would be unfair to draw any comparison with the corrosive oil that protects the nut.

Brazilwood (p. 182) also has a strong link with Portugal.

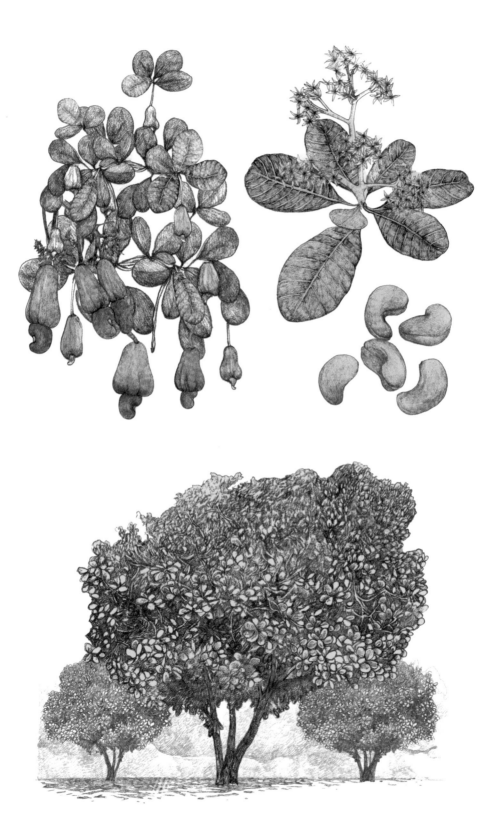

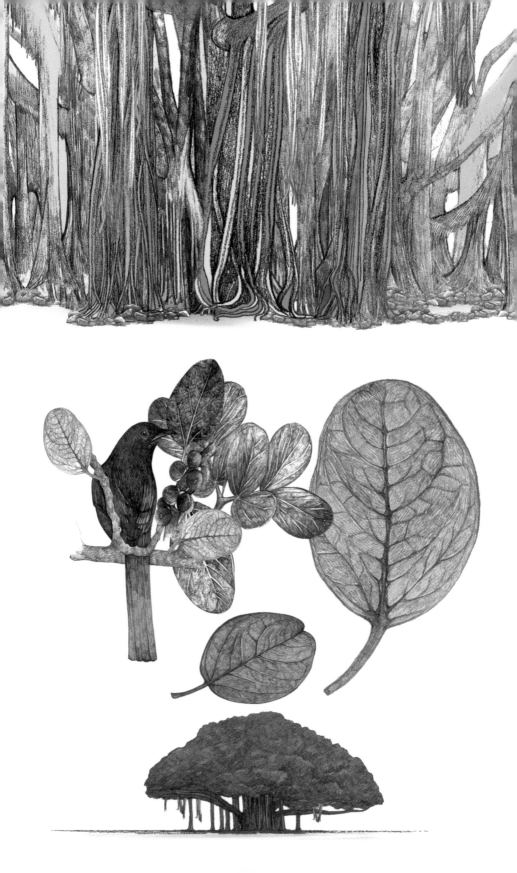

Banyan

Ficus benghalensis

L ike its biological sibling (and symbolically male partner) the peepul (see p. 122), the banyan is native to the Indian subcontinent, revered at temples and a meeting place for villagers – but this species has the biggest crown of any tree on Earth. It is named after *banians*, the general term for the traders whose entire teeming marketplace could be shaded by a single specimen.

This giant may begin life when its seed is deposited, along with a dollop of fertilizer, by a bird, bat or monkey in a moist cleft in a tree of a different species. It starts out as an epiphyte, using another plant only for support, while taking nutrients and water from its surroundings. The little sprout hurriedly puts down thin roots to the ground, and they begin to supply the growing tree above. They expand massively. Soon they are able to envelop the trunk of the host and bind together, or 'anastomose', to create a thick, smooth grey web. Eventually the host tree dies, starved and girdled, often leaving an impressive straitjacket of aerial banyan roots with a hollow centre where the dead tree once lived. In explorers' accounts from the eighteenth and nineteenth centuries, the 'strangler fig', of which the banyan is just one variety, epitomized the exotic, dangerous and much-embellished qualities of the Orient to an eager Western audience.

Mature banyans drop curtains of fine aerial roots that hang from their branches. On reaching soil, some plant themselves and thicken massively into prop roots that feed and support the growing limb above. This way, banyans can expand outwards, rather than upwards, over enormous areas. The record-holders, in Anantapur and Kolkata, each cover more than 1.8 hectares (4½ acres), have thousands of prop roots and are more than 0.8 kilometre (½ mile) round.

Kapok trees (p. 80) are also traditional meeting places.

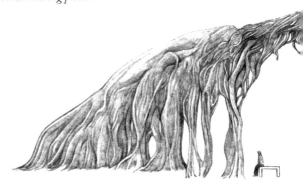

Areca Palm, Betel-nut Palm

Areca catechu

The areca palm looks impossibly slender for a tree that can grow to 30 metres (100 feet) tall, and the horizontal bands that often characterize its trunk – the vestiges of fallen fronds – give it the appearance of a tower of stacked discs. Deep-orange fruit in extravagant bunches each yield a seed the size of a large nutmeg and similarly marbled throughout. It is these 'nuts' – and the recreational drugs they contain – for which areca is cultivated in plantations from India across tropical Asia to Fiji. The world's annual production of areca nuts is more than a million tons; India produces, and consumes, about two-thirds of that.

Areca's flavour is reminiscent of citronella and clove, with notes of carbolic antiseptic, while a generous dash of tannin adds a mouth-puckering finish. However, the taste is secondary. Areca contains arecoline and other alkaloid drugs that are absorbed readily through the lining of the mouth when the nut is chewed. The effects are mild euphoria, heightened alertness and a relaxing warmth. Across Asia, areca is consumed daily by several hundred million people, mostly as a social lubricant, often as a digestive to counteract postprandial lethargy and habitually, if disturbingly, by long-distance lorry-drivers.

Areca is sold by specialist street vendors, known in India as *paanwallahs*. They wrap areca shavings in the heart-shaped leaves of the betel vine (*Piper betle*), adding a dab of slaked lime, which is extracted from ash and makes the mixture alkaline to help release the drugs. Seated behind trays of intriguing pots and potions, *paanwallahs* will gladly offer suggestions of flavourings such as cardamom, cinnamon, camphor or tobacco, along with congenial conversation. A packet or 'quid' of *paan* turns vermilion as it is chewed, and promotes copious saliva, to be ejected, never swallowed. This produces a marvellously clean feeling in the mouth but also pavements stained with blood-red gobs: it could only ever be a custom of outdoor cultures. In the days before lipstick, areca was used to stain lips seductively red, but chewing it also darkens and eventually blackens the teeth. Tastes change; in nineteenth-century Siam (now Thailand) darkened teeth were so desirable that sets of dentures were reportedly made in black. Although still increasing in India, the use of areca is levelling off elsewhere, partly because of its association with various cancers and partly (and ironically) because it is being replaced by tobacco, which is more aggressively marketed.

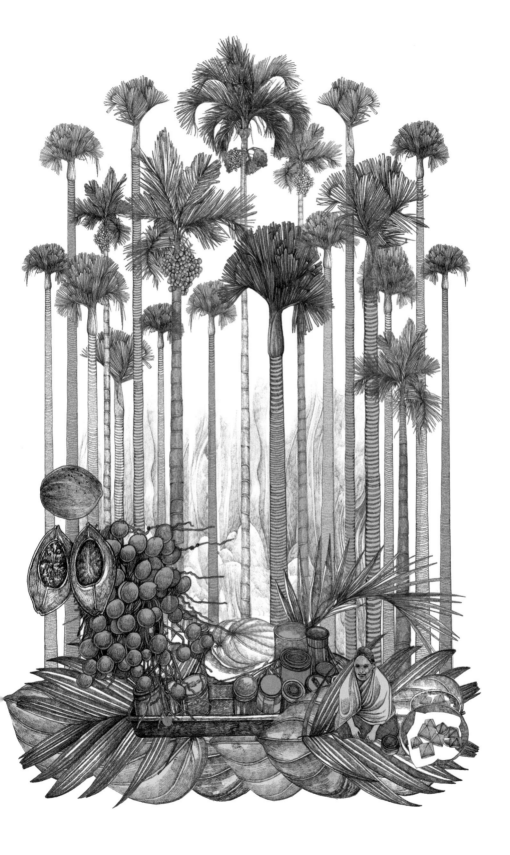

Neem

Azadirachta indica

Neem trees, millions of them, are a ubiquitous feature of the rural landscape of India. These attractively tall evergreens provide welcome shade and thrive in arid areas, even on infertile soil. They produce small, white, honey-scented flowers, which attract bees, and greenish-yellow, olive-like fruit, which yield an oil that features strongly in traditional medicine and folklore. Neem is used as a home-grown remedy for almost every ill, a culturally beloved panacea akin to chicken soup for Jews or tiger balm for South East Asians. Millions of Indians swear by chewing a twig of neem instead of using a toothbrush. Strings of its distinctively serrated leaves flutter above humble village doorways, hung as protection for those inside.

All this begs the question of how much of neem's reputation is based on groundless superstition and how much on scientific evidence. Modern analysis shows neem extract to contain a smorgasbord of antimicrobial compounds, and many of the claimed effects are well founded. Where neem really excels, though, and where peer-reviewed scientific evidence is particularly strong, is in its ability to modify the behaviour of insects.

When an insect sees a tree, it doubtless thinks, 'lunch'. Since trees cannot run or hide, they have developed many defences against being eaten, and the neem tree has done so in especially lavish style. Its leaves, bark and especially its oil contain a biochemical battery of insect repellents and steroid-like chemicals, which profoundly affect the life cycles of the insects that might attack the tree. Cunningly, these chemicals are not present in neem flowers or nectar, so bees and other beneficial pollinators are hardly affected.

Neem extract is so good at putting insects off their food that even a swarm of locusts will avoid crops that have been treated with it. Many species of insect would rather die of starvation than ingest the chemical cocktail, which disrupts vital behaviour such as metamorphosis and, critically, feeding. It is an excellent deterrent to many flying insects, including mosquitoes, and is effective in tiny concentrations of just ten parts per million. So those fluttering leaves on rural homes probably do have a real protective effect.

Neem does not appear to damage ecosystems as much as do synthetic insecticides, possibly because it is biodegradable and disappears after a

week or so of sunshine. It also acts differently from those pesticides that kill instantly by a single toxic effect. Instead, it contains a combination of chemicals that simultaneously disrupt different aspects of an insect's life, making it harder for them to evolve resistance to it. Although harmful to fish, it appears to have little effect on warm-blooded animals, such as humans. Neem fruit are often enjoyed by people and neem extract, which has been used in cosmetics and creams for thousands of years, has been licensed for use as an insecticide in North America and elsewhere, even for spraying children's bedding to control bedbugs.

Neem trees themselves have been planted with success among cotton crops in India and vegetable fields in West Africa. However, given that neem insecticide is effective, safe, cheap, sustainable and biodegradable (and that its supply would have the positive side effect of requiring environmentally helpful tree-planting), perhaps the most perplexing question is why it isn't in wider use around the world. The reason has more to do with economics than with science. Neem has a long tradition of use, which makes it difficult for commercial firms to patent products based on it. Without being able to protect a product from competition, those firms have little incentive to pay for regulatory approval of neem-oil products, or for advertising and distribution. Companies can more profitably sell patentable synthetic chemicals, even though in some instances they may be less effective or more harmful. The free market doesn't always get it right.

Peepul, Sacred Bo

Ficus religiosa

Native from Pakistan to Myanmar, the peepul is especially well rooted in the physical and cultural landscape of central and northern India. It forms an authentic backdrop to countless scenes in novels and films and is sacred to Buddhists, Hindus and Jains alike, so it is rare to find a village without one, or to find a peepul without a shrine at its base. To 'visit the peepul tree' is even a poetic euphemism for going to pray.

Reportedly living for thousands of years, the peepul grows quickly. Its trunk is smooth when young, often with faint horizontal lines, but as it ages it peels in patches, becoming fluted and buttressed. Aerial roots often run down the outside, adding strength, stability and shelter for other plants and creatures. The tree is deciduous, and drops its leaves in midwinter. New growth in April is vibrant with vermilion, copper and pink – a trait that is seen in many tree species. Insects and other herbivores prefer tender young leaves, so many tree species don't invest valuable green chlorophyll in them until they have toughened up. Without chlorophyll, the fledgling leaves are less nutritious and therefore less likely to be eaten, and the red colours, although they too require resources to make, are difficult for insects to see – reducing still further the chances of becoming a bite to eat. As they mature, the peepul leaves turn green and glossy on the top and duller and paler underneath, with pronounced yellow-green veins, which look fabulous when back-lit by strong sunshine. They grow to be hand-sized, almost triangular or heart-shaped. At the end of every leaf, a distinctive pointed drip-tip encourages rainwater to flow away quickly, rather than leaching minerals or sustaining light-hogging hangers-on. At night, with their texture of artificial leather and their long, flexible stalks, the leaves can be heard to swivel and jostle in the slightest air, giving the trees their distinctively eerie chattering sound.

Towards the end of the sixth century BC, it was while seated under a peepul tree that Siddhartha Gautama, the Buddha, is believed to have meditated and reached enlightenment. A large temple marks the spot at what is now Bodh Gaya – 'place of enlightenment' – in Bihar state, in northeastern India. A holy peepul or Bodhi tree grows there, a sapling from the Bodhi tree in Anuradhapura in Sri Lanka, which had in turn been propagated in 288 BC from a sprig of the original tree in Bodh Gaya that had shaded the Buddha.

Hindus, meanwhile, believe that the three principal gods – Brahma, Shiva and Vishnu – all have close associations with the peepul, and that the goddess Lakshmi's presence can bestow fertility and fortune on women who mark their devotion by tying a thread around the trunk, traditionally on Saturdays. When a peepul entwines a neem tree, their embrace is seen to be especially auspicious. The happy couple of trees may undergo a symbolic marriage ceremony, and if there wasn't already a shrine at the spot, one will be constructed.

As for the figs themselves, in common with other *Ficus* species, they are 'false fruit', composed of a fleshy receptacle with myriad flowers on the inside surface, pollinated by tiny wasps. Almost spherical, they grow all but stalk-less on the branches, ripening from greenish-yellow through deep purple to virtually black. The size of cherries and eaten by humans only in times of hardship, peepul figs are a favourite of starlings and bats, which spread the seeds to germinate in the moist clefts of other trees or in crevices of walls. This poses a problem for the religious or superstitious, who avoid uprooting the seedlings even if they threaten damage: according to custom, 'cutting the peepul tree is more sinful than killing a saint'. Would that more tree species around the world enjoyed such a taboo.

The leaf stalks of the quaking aspen (p. 210) are also flattened and cause the leaves to shimmer.

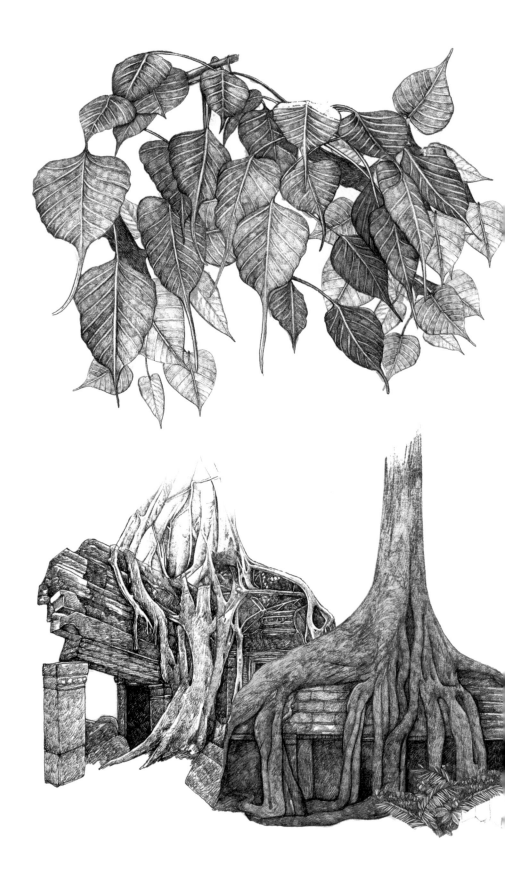

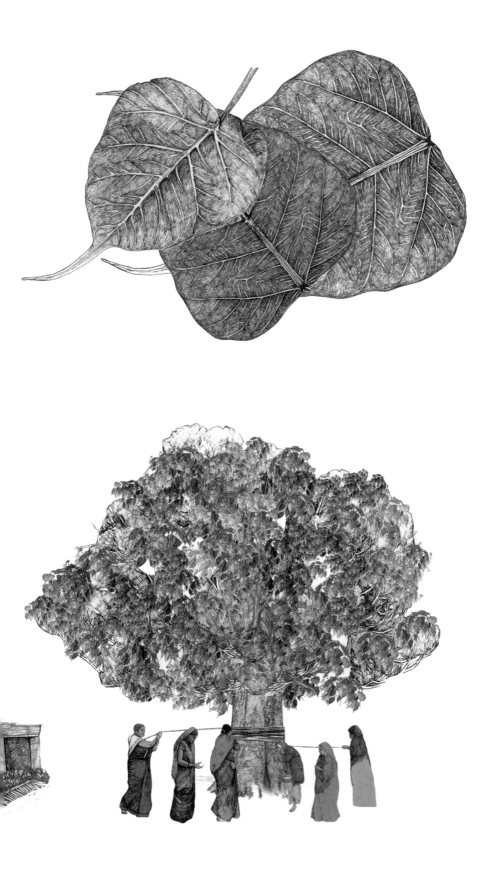

Szechuan Pepper

Zanthoxylum simulans

Despite its common name, the Szechuan pepper tree is unrelated to chillies, bell peppers or even the flowering vine that gives us everyday black pepper. It is, however, the source of another spice – one which has an unusual effect on us.

A small tree of the hilly forests of northern and central China, the Szechuan pepper is covered in prickly outgrowths from the bark. On the trunk and larger branches, these become woody, giving the tree a reptilian look and inspiring its North American common name, 'prickly ash'. In summer, a mantle of small white flowers stand out against the tree's glossy, dark-green compound leaves. The fruit that follow look like berries. Round, knobbly and dry, they eventually redden and split on one side to release their shiny black seeds. The husks surrounding the seeds contain a group of chemicals called sanshoöls (pronounced to rhyme with 'alcohols'), which play a peculiar trick on our senses.

Mint in the mouth feels cool, even when it isn't. Chillies fool us into perceiving heat, also without any actual temperature change. These are common examples of a nerve-trickery phenomenon called 'paraesthesia'. Less well known (at least outside China, Tibet, Nepal and Bhutan, where Szechuan pepper is popular in the cuisine) is that the mouth can be deceived into sensing vibration. According to research on impressively patient volunteers, within a minute of contact with the spice, they felt their lips and tongues were buzzing at about 50 times a second. Some people report that it is like licking one's tongue across a 9-volt battery. (Hey, we've all done it.) With the strong tingling come copious salivation and numbness, a temporary but curiously pleasurable combination that can make first-timers dribble without realizing. A relative of this tree has been used by Native Americans to mask the pain of toothache, and in a branch of science splendidly known as 'tingle psychophysics', sanshoöls are now being studied for a serious role in the understanding and management of pain.

Why Szechuan pepper has evolved to produce sanshoöls is not clear. Recent experiments have shown that these chemicals can protect rice seedlings from unwanted harm caused by weedkillers, so perhaps they are some kind of defence mechanism for the tree. Meanwhile, for Chinese-speakers the tingling, numbing sensation is sufficiently well understood that it can be described succinctly in a single syllable: *la*.

White Mulberry

Morus alba

T here are two widespread and intimately related species of mulberry. Both are mid-sized trees with pleasing, gnarled trunks; the 'black' has rough, heart-shaped leaves while the 'white' has smooth leaves. One of them changed the course of history.

The black mulberry (*Morus nigra*) originated in southwest Asia and has spread around Europe by cultivation and by birds that disperse its seeds. Its fruits deliciously balance acid and sweetness but are impossibly messy, staining everything in reach. They are also seldom sold because they damage easily – as Shakespeare put it, they 'will not hold the handling'.

The white mulberry, from eastern China, has beige or pale-purple fruit that are sweet but insipid. However, its leaves are the diet, par excellence, of silk-moth caterpillars. More than 4,500 years ago, the Chinese developed sericulture, the production of silk, by farming the wild silk moth, *Bombyx mandarina*. They bred and domesticated it so thoroughly that it became another species, *B. mori*, which is totally dependent on humans. These moths cannot even fly to find a mate. The caterpillars feast on trays of mulberry leaves and, from their saliva, they spin silk cocoons of protein filaments just a hundredth of a millimetre thick and 0.8 kilometre (½ mile) long. Each fibre shimmers, its triangular cross-section causing the flat faces to reflect and refract light. These fibres are spooled and spun together to make silk thread.

How the smoothness of silk must have felt to those who had known only the scratch of wool or linen! The lustrous, luxurious fabric was in such demand during the Han dynasty, about 2,000 years ago, that it triggered the establishment of a whole system of transportation and trade. The Silk Road became a network of overland and sea routes, first to central Asia, then connecting Korea and Japan with India, Arabia and Europe. It transported goods and ideas and contributed to the economic and intellectual development of all the civilizations in its path.

For several hundred years the Chinese managed to guard their secrets of sericulture from industrial espionage by foreign powers. They bolstered their monopoly by imposing a death sentence on locals smuggling silkworms or mulberry seeds. Even without this threat, most of the world's silk still comes from China, where it is still unravelled from the cocoons of silk moths fed on the leaves of white mulberry.

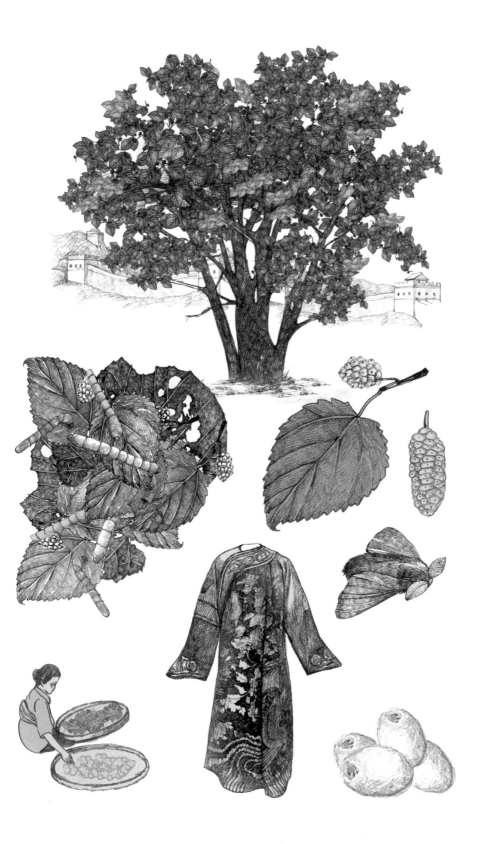

Chinese Lacquer

Toxicodendron vernicifluum

T he sap of the lacquer tree has given us a medium for exquisite craftsmanship, but it also has a disturbing history. Up to 20 metres (about 70 feet) tall, straight and with a decently symmetrical crown, it flourishes on hills and in mountain forests at elevations of up to 3,000 metres (10,000 feet). With large compound leaves, fuzzy underneath, and wrinkled, pea-sized fruit, lacquer trees are pretty enough but do not age gracefully; in their sixties, they become a little too sparse to be beautiful.

The lacquer tree is native to central China and was introduced to Japan about 5,000 years ago. The Japanese continually improved the craft of lacquering into a high art, particularly during the seventeenth century, and it became such a valuable industry that until the Meiji Revolution of 1868 every tree used for sap extraction had to be registered. There were severe punishments for injuring them or tapping them too often, and owners were even required to obtain special permission from the authorities to remove a dead stump. Nowadays most raw sap is imported, once again, from China.

The lacquering process begins in midsummer with many parallel slashes to bleed the tree. The prized muddy-yellow sap is collected only in small quantities, just 0.25 litre (½ pint) each year, for three or four years, before the tree is given a break. The sap is filtered, heat-treated and coloured with ground minerals such as scarlet cinnabar, black carbon powder or metallic dust, then painstakingly applied to a wooden, bamboo or papier-mâché base, layer upon layer, polishing and drying between each. Counter-intuitively, the lacquer requires a moist atmosphere to 'dry' and harden – it polymerizes in air to form a clear, hard, waterproof surface. In the days before modern plastics, lacquerware was an otherworldly material, and the precise details of some of the techniques and additives are still guarded closely.

Special pieces require dozens of coats of lacquer, and months of work. Intricate designs in gold leaf or rice paper are often incorporated and many of the resulting artefacts – musical instruments, screens, jewellery, boxes and bowls – are impossibly beautiful works of art.

True to its scientific name, though, the lacquer tree has an unpleasant side. An oily substance in its sap, called urushiol (from the Japanese word *urushi*, varnish), is a particularly nasty chemical, known and feared by

North Americans because it is also present in poison ivy, a close relative of the lacquer tree. By the fifth century Chinese scholars had recorded dermatitis as an occupational hazard among farmers and other people working with the tree. Liquid urushiol causes extreme rashes, and even its vapour promotes itching that can linger for months. Once hardened, however, lacquerware is safe even for storing foodstuffs.

The creepiest historical use of the lacquer tree must be that of an obscure sect of ascetic northern Japanese monks, intent on becoming *sokushinbutsu* or 'living Buddhas' as a route to enlightenment. The whole journey lasted several years and started with a slow reduction in the intake of food and an especially slimming diet of seeds, nuts, roots and bark. With the intention of their corpses becoming a 'whole-body relic', the monks then gradually embalmed or mummified themselves by drinking *urushi* tea, made from the sap of the lacquer tree. After becoming horribly dehydrated and dying slowly, their bodies were resistant to decay and too poisonous or unpleasant even for maggots. Three years after death, the monks' tombs were opened and those few who had not decomposed were said to have achieved Buddha-hood. Seen as assisted suicide, the practice was made illegal only in the late nineteenth century, and several Japanese temples still exhibit gruesomely well-preserved remains that are claimed to be those of self-mummified monks.

A chemical similar to urushiol surrounds cashew nuts (p. 114).

Yoshino Cherry

Prunus × yedoensis

There is no tree more significant to the Japanese than the ornamental cherry, or *sakura*. There are hundreds of distinct native species and domesticated hybrids, with flowers ranging from white to deep crimson, but the most popular is the five-petal Yoshino cherry. A compact deciduous tree, it bears blossom that is almost pure white, blushed with the palest pink near the stem. Flowers appear in spring before any leaves, so trees in full bloom are dazzling. The transience of cherry blossom's exquisite splendour, which lasts for less than a week, heightens the appreciation of its beauty and resonates with the Buddhist ideal of thriving in the present moment. Cherry blossom embodies *mono no aware*, which might be translated as 'the poignancy of things', a feeling that is nationally understood and regarded as part of the Japanese psyche.

The delightful pursuit of viewing and picnicking under cherry blossom is called *hanami* and goes back more than 1,000 years. Originally an aristocratic diversion, *hanami* parties took off in the Edo era of the seventeenth to nineteenth centuries, and nowadays virtually everyone in the country takes part. At Tokyo's Imperial Palace, for just a few days towards the end of March, the vast moat is dotted with couples in rowing boats leaving dark trails through a white scattering of floating blossom. At *hanami*-time city parks are bursting with families, while all schoolchildren and office workers expect, and are expected, to participate in mass social bonding. Daily media reports on the *sakura zensen* (cherry blossom front) as it travels up the country are closely followed. Indeed, the excellent records of blossom festivals in Japan have even been used to chart climate change across the centuries.

Once you start looking, cherry trees are everywhere in Japan: outside most schools and public buildings, at temples and along riverbanks. They are planted not just for the splendour of their blossom but also for their cultural, religious and even political importance, depicted on kimonos and stationery, on crockery, postage stamps, coins and even on people – cherry blossom is a frequent motif in *irezumi*, traditional Japanese tattooing. The Yoshino cherry is so intertwined with Japanese identity that it has been used as a potent rallying call for Japanese nationalism. The first kamikaze unit had a sub-unit called *Yamazakura*, 'wild cherry blossom'. Warriors were compared to *sakura* blossoms – born to live brilliantly and die young.

Rubber

Hevea brasiliensis

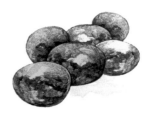

Tropical forests are a jumble, and many species are represented by just a few individuals per hectare, an isolation that keeps pests in balance. With so few potential mates nearby, successful cross-pollination relies on all the trees of the same species flowering at the same moment: they need a common calendar. At the equator, changes in day length are negligible, so trees cannot use that as a trigger. Instead, rubber trees respond to small increases in the brightness of sunlight around the equinoxes. Then they all bloom together, producing clusters of pungent yellow bell-shaped flowers, with midges and thrips the busy go-betweens. When fully ripe, the three-lobed fruit detonate, scattering large speckled seeds that float on nearby waterways to germinate elsewhere (unless their hard casings have been cracked first by piranhas).

Many tropical trees produce milky latex containing forms of rubber, but *Hevea brasiliensis*, which is native to the Amazon and Orinoco river basins of Brazil and Bolivia, is the best known. Originally called *caoutchouc*, from the indigenous *cauchu*, or 'weeping wood', the rubber tree is a member of the Euphorbiaceae (spurge) family. Its creamy latex is a suspension in water of about 50 per cent rubber, stored in lactifers in the bark, ready to be exuded and coagulate quickly to seal wounds. In fact, when zigzag incisions are made to tap the latex, anti-coagulant chemicals are applied to keep it running.

In 1531 Aztecs caused a stir at the Spanish court, not least with previously unknown bouncy rubber balls (actually derived from a different plant), which they used to demonstrate proto-basketball. By the 1770s the British were using coagulated *Hevea* latex for rubbing out pencil marks (hence the name 'rubber'), and in London little cubes of 'India rubber' fetched three shillings each – a small fortune at the time. Tribes in the upper Amazon basin had for centuries been using rubber to mould shoes, and they also used it for waterproofing long before the 1820s, when the Scotsman Charles Macintosh used dissolved rubber to treat fabric for his eponymous rainwear.

Unfortunately, rubber straight from the tree cracked in the cold and became impractically gummy in the heat. In 1839 the American Charles Goodyear discovered that cooking up raw rubber with sulphur made it tough and resistant to extremes of temperature. This 'vulcanized' rubber

appeared everywhere: in pumps and steam engines, combs and corsets. A popular theory suggested that Jack the Ripper wore silent rubber-soled boots to creep up on his victims. Demand for rubber soon far exceeded supply. The price rocketed, leading to a disorderly Amazon 'rubber rush' of men staking claims and over-exploiting wild trees. In 1876, in an act of blatant bio-piracy (or entrepreneurial far-sightedness, depending on your point of view), the Englishman Sir Henry Wickham shipped a huge consignment of 70,000 rubber seeds from Brazil to Kew Gardens. From there, seedlings were distributed to British colonies in Asia, where they were planted and eventually propagated with great success – the ancestors of today's huge rubber plantations.

Then rubber hit the road. In 1888, John Boyd Dunlop patented the first successful inflatable rubber bicycle tyre, and in the early twentieth century pneumatic tyres, rubber seals, gaskets, mats and hoses for vehicles fuelled companies such as Firestone, Goodyear, Michelin and Pirelli to become household names. This ultimately enabled roads to outcompete railways.

In 1928 Henry Ford, eager to bypass the British far-Eastern rubber monopoly, attempted to establish an alternative supply from the Amazon. The Brazilian government gave him access to 1 million hectares (2.5 million acres) for rubber cultivation and he built Fordlândia, a factory town to house 10,000 workers. It didn't last long, however: yellow fever, malaria and cultural misunderstandings (Ford specified no alcohol, tobacco, women or football) sapped the will of the local workforce. Botanical naivety among the managers meant that fungal leaf blight and insect pests spread among trees that had been planted too close together and on the wrong soil. Abandoned in 1934, Fordlândia is all but deserted now.

By the late 1930s a million tons of crude rubber were exported annually from South East Asia, and it was the single most valuable import into the United States. World War II, when the Axis powers gained control of most rubber plantations, prompted the urgent development of synthetic rubber from fossil fuels and their by-products. Half of all rubber still comes from trees, but, whatever the source, it does not come guilt-free. Grown most prolifically now in Thailand and Indonesia, it is tended and tapped in vast plantations that affect tropical ecosystems and are vulnerable to leaf blight. On the other hand, chemical factories that make synthetic rubber rely on polluting raw materials. Either route consumes a lot of energy and water, but where would we be without condoms and car tyres?

Rubber trees have seed pods that burst, but they are no match for the sandbox (p. 190).

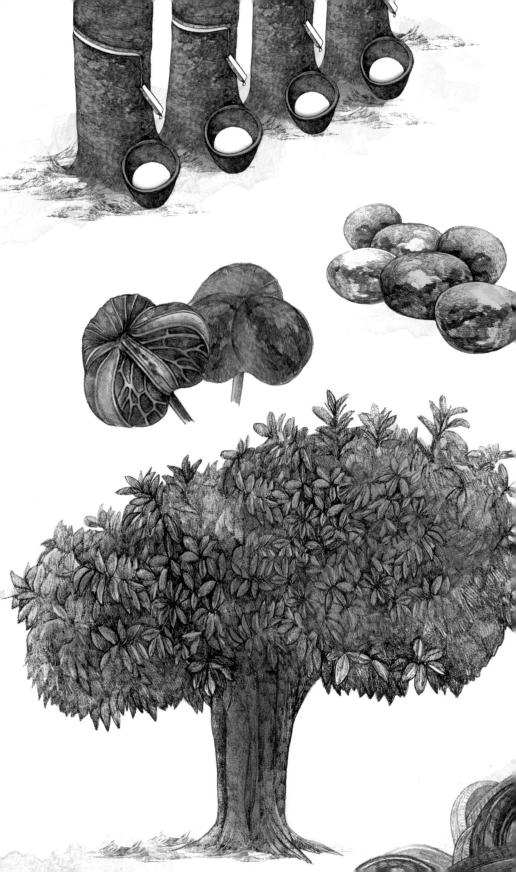

Durian

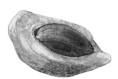

Durio zibethinus

For a tree bearing armoured fruit that can easily weigh 6 kilograms (13 lb), the durian is improbably graceful. Its leaves – elongated ovals with a sharp point and a distinct rib down the middle – have a smooth, olive-green upper surface and dull copper underside, and shimmer attractively in the breeze. Growing up to 45 metres (150 feet) tall in dense lowland forests with strong, slender branches that grow almost horizontally from a straight central trunk, the durian is a tree-climber's delight. Its flowers, which hang in bunches borne directly on the main stem and major limbs, are decorative, big and blowsy, almost white, and smell buttery or of milk just past its best. They are typical of flowers that have evolved to attract one particular pollinator. Although they open for business in mid-afternoon, in case bees might be tempted, their main trade is at night, when, in return for a copious supply of sweet nectar, the tree's pollen is carried far and wide by bats.

The durian tree is best known for its love-them or hate-them fruit – and what fruit they are! They hang in clusters on thick stalks, growing and ripening in just 14 weeks or so to the size of a rugby ball or bigger. In the Malay language, *duria* means 'thorn'. Each fruit is defended by a tough, yellow-green, semi-woody rind with sharp pyramid-shaped spines, which cover it so completely that if the stalk happens to break off, the fruit is a challenge to lift. When ripe, it splits to reveal white, slightly fibrous pith, in which four or five large custard-yellow segments are embedded, each containing a few large seeds. The fruit is notorious for its strong smell, which attracts large mammals such as wild boar and monkeys, who can disperse the fruit and seeds far from the mother tree. Elephants will wait patiently (and bravely, one would have thought) for durians to fall. When they devour the fruit, they swallow some seeds whole and deposit them at a considerable distance together with a handy pile of fertilizer.

Another, smaller mammal enjoys the fruit: *Homo sapiens*. Thanks to human activity the durian, which is native to Indonesia and Malaysia, is now also cultivated in Thailand, southern India and northwestern Australia. There is a vibrant soul-food subculture in the Far East centred on its consumption. It is common to see potential buyers scraping the outer skin with a fingernail, one ear to the fruit to hear if the pulp has shrunk away from the pith. Its flavour and fragrance can provoke other strong

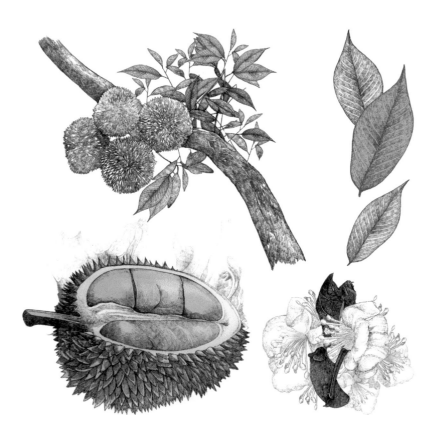

feelings, too: the English writer Anthony Burgess likened the experience to 'eating sweet raspberry blancmange in the lavatory', and the American chef and broadcaster Anthony Bourdain has been widely quoted as saying: 'Your breath will smell as if you'd been French-kissing your dead grandmother.'

In a confined space the smell can be overwhelming, and signs telling people not to bring durians into hotels or aircraft are common in Malaysia and Singapore. On the other hand, we are very suggestible when it comes to flavour, and perhaps Westerners who haven't grown up with the fruit are prejudiced by its reputation and primed to find it disagreeable. Not so Alfred Russel Wallace, the great nineteenth-century naturalist, who gushed, 'A rich butter-like custard highly flavoured with almonds gives the best general idea of it, but intermingled with it come wafts of … cream-cheese, onion-sauce, brown sherry, and other incongruities. Then there is a rich glutinous smoothness in the pulp which nothing else possesses, but which adds to its delicacy … the more you eat of it the less you feel inclined to stop. In fact to eat Durians is a new sensation, worth a voyage to the East to experience.'

Upas

Antiaris toxicaria

From the Middle Ages to the nineteenth century, European travellers to South East Asia returned with consistent reports of a tree so abhorrently toxic that just to look upon it was gravely dangerous. Birds perching on its branches would keel over dead, they said, and the merest touch would kill animals and people. In popular journalism and eventually through well-known writers such as Dickens and Pushkin, the upas became a widely used metaphor for the dangerously evil and the deadly.

The upas is a magnificent, tall deciduous tree that is happiest in tropical rainforests. Its buttressed trunk is straight and smooth and, like many rainforest trees, it has no branches up to where the crown begins – after all, there is little point in having leaves where there's so little light. Surprisingly, given the upas's reputation, the fruit are eaten and dispersed by birds, bats and mammals, and we now know that local people have blithely used the beaten inner bark to make clothing. That hardly sounds like the most treacherous tree in the world.

The upas legend started with a grain of truth, though. In what are now Malaysia and Indonesia, *upas* means 'poison', and the tree's latex does contain deadly cardiac glycosides. These chemicals, if they enter the bloodstream, interfere with the heart, making the beats weak and irregular before stopping them altogether. The latex can be collected, heated to a viscous paste and applied to blowpipe darts that are still used by tribal people for catching supper.

Hundreds of years ago poison darts were a weapon deployed against incursions by foreigners, principally the Dutch. Understandably, indigenous people wanted to protect the source of the poison from European invaders so they concocted the upas legend, or at least fanned its flames. They claimed that all manner of special precautions and protection were needed even to approach the tree, such as always having the wind at one's back in order to carry the poison away. The preposterous tales of the frightful upas were just the kind of story that travellers needed for their audiences back home. The tales gained credibility as they were repeated by men of learning and reputation, and that helped to keep the true source of upas poison secret for 400 years. As propagandists have always known, our wish to believe the unbelievable knows no bounds.

Gutta-percha

Palaquium gutta

D uring the second half of the nineteenth century gutta-percha utterly changed the world, and its curious name was everywhere in the newspapers of the day. Native to Sumatra, Borneo and the Malay peninsula, this is another typical rainforest species that, eager for light, grows tall and straight with few branches or leaves beneath its crown. The large oval berries are food for squirrels and bats. The leaves – shiny green and smooth on the upper surface, downy and bronzed underneath – are crowded at the tips of its branches.

The name gutta-percha derives from the Malay term for its greyish-white latex, which the tree has evolved to engulf insect invaders and to create a hermetic seal over wounds. In sun and air, it coagulates into a pinkish, inert, waterproof material. Unlike other famous kinds of latex, gutta-percha is tough yet not at all brittle: it is not chewable like chicle, nor is it elastic like rubber. However, when heated to 65–70°C (150–160°F), it becomes flexible and can be moulded easily, retaining its shape as it cools.

Indigenous people had been using gutta-percha to mould tools and machete handles for centuries when, in 1843, a British surgeon sent samples to London, wondering whether other applications might be developed. It quickly established itself as the modern wonder-material of its age. Companies were formed specifically to exploit it, touting it for unbreakable kitchenware, chessmen, speaking tubes and novelty walking-stick handles. The best golf balls of the first half of the nineteenth century had been laboriously made from stitched leather and feathers. Gutta-percha golf balls, or 'gutties', were a great improvement: robust, easy to mould and much cheaper. The game, like the balls, started to fly. 'Gutties' lasted for 50 years, until an even better ball was cunningly constructed from threads of rubber.

Then, a use for the latex was discovered that was far more important even than golf. The electric telegraph, a means of transmitting text messages over wires, had recently been invented, but international communications were stymied by the sea – electricity and water don't mix. Enter gutta-percha, resistant to seawater and an excellent electrical insulator. A German, Werner von Siemens (his family firm became today's Siemens company), working in London, invented a way to coat copper wires seamlessly with gutta-percha. Entrepreneurs and capitalists spotted the opportunity and the great cable race was on. After much trial and error and

derring-do on the high seas, the production and laying of reliable cables eventually became routine. In 1876 the British Empire was linked from London to New Zealand, and by the end of the nineteenth century more than 400,000 kilometres (¼ million miles) of telegraph cable girdled the Earth, alive with the hubbub of commerce, diplomacy and journalism.

That wasn't so good for the gutta-percha trees themselves, however. Rather than laboriously tapping latex, which flows slowly, whole trees were cut down to extract it quickly – but just a few pounds came from each one. Millions were felled to satisfy the insatiable demand for cable insulation. Eventually mixed forests were cleared and plantations established, but the depletion of such a strategic but only slowly renewable resource caused much anxiety in business circles. New regulations ensured that, rather than using whole tree trunks, latex could be extracted only from leaves, which were harvested, shredded and dunked in hot water. This enabled gutta-percha to remain the insulator on which international communications depended; it was replaced only gradually after 1933, when polyethylene was synthesized. The vast plantations are gone now, the land turned over to other agriculture. The only routine and widespread use of gutta-percha today is by dentists, who have yet to find a better filler for root-canal work – a prosaic use for a tree whose latex once spanned the globe.

Gutta-percha is still used for dental work. Chicle latex (p. 188) is associated with a product that is also used orally, but more enjoyably.

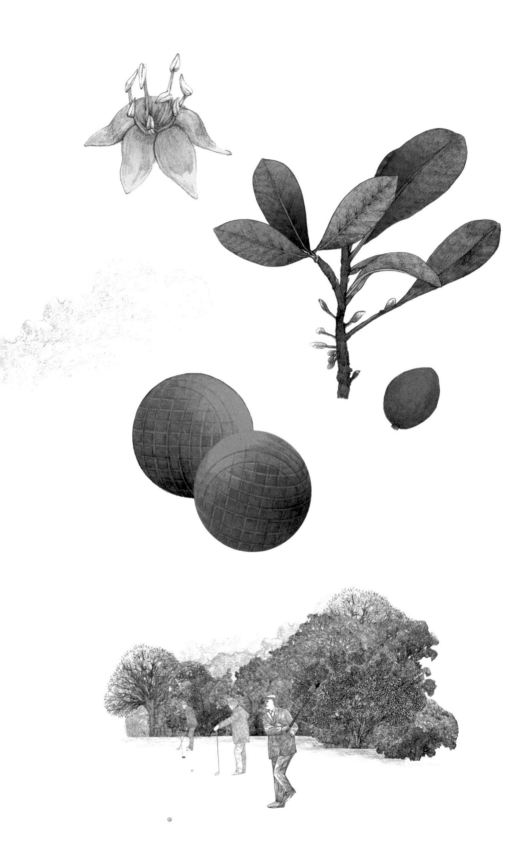

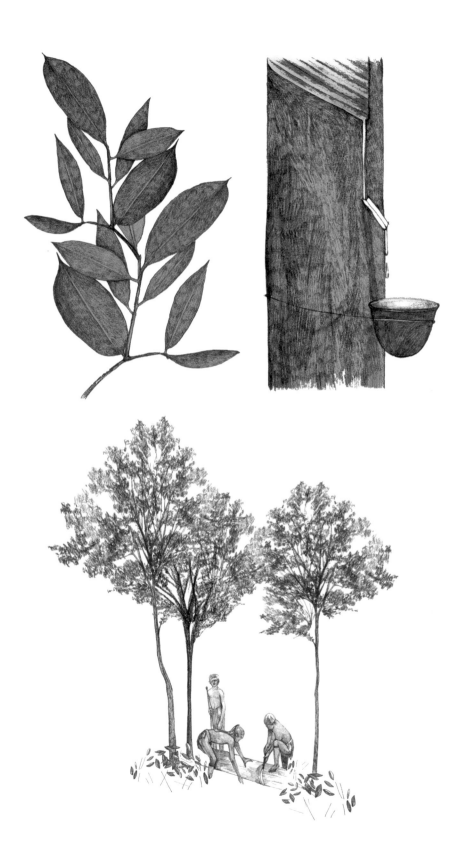

Jarrah

Eucalyptus marginata

Jarrah: a name that sounds quintessentially Australian. The word comes from the Nyungar language of the continent's far southwest. In pre-colonial times, there were millions of acres of jarrah forest on the leached soils of what is now called the Darling Plateau. It is a majestic tree, easily 40 metres (130 feet) high and its trunk 2 metres (6 feet) across, with rough, very dark-brown bark. Gloriously fragrant flowers, miniature white starbursts, festoon the tree in clusters of ten or so, attracting bees, which make a distinctively malty, caramel-flavoured honey from its nectar. Jarrah is the linchpin of an important and complex forest ecosystem, home to unspeakably cute marsupials with names to delight any Scrabble player: the numbat, the potoroo, the quoll and the quenda.

Jarrah trees are long-lived – at least 500 years and up to a millennium or more – if they get the chance. British colonists quickly saw the value in the rich red jarrah wood, which was immensely strong and resistant to rot, insects, wind and water. It was eagerly taken up for shipbuilding and harbour pilings. When convicts arrived en masse from 1850, the flood of cheap labour meant that jarrah could be exported across the British Empire to feed its insatiable appetite for railway sleepers and other durable infrastructure such as telegraph poles, wharves and even tea sheds. A network of steam-powered sawmills and railways sprang up to extract the timber.

On the other side of the world, Londoners were trying to work out what to use to pave their roads, which by the 1880s were hectic with horse-drawn traffic. Stone blocks and cobblestones were deployed on substantial sections of main roads, but they were expensive and caused horses to slip and skitter in the city's frequent rain. Tarmac, known then as macadam, would still need another few decades of development before it was robust enough. Then there was wood. Softwood deal and pine paving from the Baltic had advantages over stone: it was much quieter, more easily swept and kinder to horses' hooves. But those woods wore and rotted quickly, and would soak up the swill of equine urine and ordure and, under pressure from a heavy wheel, squirt it out at passers-by.

Unsurprisingly, then, when jarrah wood was exhibited in 1886 at the Indian and Colonial Exhibition in London and advertised as a durable paving material, there was immediate interest. It turned out to be extraordinarily hardwearing, losing only 3 millimetres (⅛ inch) a year

on busy roads. Lasting decades and blessedly non-porous, it was popular with man and beast alike. By 1897, despite the huge shipping costs and distance, some 30 kilometres (20 miles) of London's busiest and swankiest streets had been clad in Australian jarrah wood – millions and millions of blocks, mostly laid over concrete. Back in Australia, the huge demand spawned many competing and unregulated jarrah-wood companies. Competitors repeatedly dropped their prices to gain orders, to the point that in 1900 Australian jarrah was being sold in England for less than vastly inferior woods brought from nearby Sweden. It was a lucrative but ludicrously unsustainable business; the forests could never withstand such rapacious exploitation. Despite the rapid forest loss, it wasn't until the end of World War I that laws were introduced to manage more sensibly the trees that remained. And while asphalt replaced wooden paving blocks soon afterwards, the demand for jarrah timber for construction work never went away.

Aside from a few spectacular protected areas, most of the jarrah forests are gone now, felled for timber or to make way for agriculture and mining. What is left is at risk from global warming and the cascade of complex changes that come with it. The fungus-like organism *Phytophthora cinnamomi* is causing deadly dieback, and in summer there are increasingly frequent droughts and heatwaves. The original unbridled exploitation of jarrah and the depletion of its fragile ecosystem coincided with the demise of Nyungar culture. The remaining jarrah is again in danger, this time from climate change, to which we all contribute and by which all cultures are threatened.

Wollemi Pine

Wollemia nobilis

Thought to have been extinct, possibly for millions of years, the Wollemi 'pine' is one of the most astounding botanical finds ever made. The tree had long been known from fossils, and the rock layers in which it had been found showed that it lived alongside the dinosaurs, 65 million years ago. It was clearly a conifer, but not one like any living species. Then, in 1994, in a deep and isolated sandstone gorge in Wollemi National Park at the edge of the Blue Mountains in New South Wales (only 150 kilometres/90 miles northwest of Sydney), a park officer exploring the maze of rainforest canyons found a stand of the mystery species, alive and well. Comparison with fossils showed a convincing match, even down to the pollen. Appropriately, the name of the park – and subsequently this extraordinary tree – is said to derive from the aboriginal word for the area, meaning 'look around you'.

The tallest specimen is magnificent. Standing 40 metres (130 feet) high, measuring 1.2 metres (4 feet) across and maybe 1,000 years old, it's not a pine at all but a coniferous relative of the monkey puzzle tree. The trunks of old trees are composed of multiple stems of different ages, and their bark is densely covered with soft, spongy nodules that look like chocolate popcorn. Juvenile foliage is pale and unkempt; at first glance a second species, some wan waif of a climber, appears to be woven over the surface of the tree. Older leaves are fern-like and reptilian, arranged in serried ranks along branches, distinctively narrower and darker than the younger leaves at the tip. Even with age, *Wollemia* branches rarely subdivide, and from above the trees are variegated green starbursts. In cold months, when the tree is dormant, each growing bud is shielded by a waxy white coating that lasts until spring. Cones grow only on the tips of the branches: females look like shaggy pom-poms on the upper part of the tree, drooping males occur lower down. *Wollemia* never evolved to shed leaves that have become old and decrepit; instead it drops entire branches once the leaves are redundant.

The discovery of this ancient tree made world news. In order to remove the incentive for plant-rustlers, and to ensure the survival of the species even if there were to be a disaster at Wollemi, the Australian government has overseen the propagation of nursery plants. Around the world, gardeners and collectors have planted hundreds of thousands of

saplings. Botanic gardens had a craze for planting them in outdoor cages, both to grab attention and to symbolize their rarity in the wild, where fewer than 100 specimens are known.

The tiny population, concentrated in one minuscule area, makes wild *Wollemia* especially vulnerable, and to make matters worse, DNA analysis has shown that the trees display no discernible genetic variation. It is not clear if the trees are indeed all clones of one individual, perhaps spreading underground by root-suckering; if this just happens to be a species with precious little genetic variation; or whether at some stage there were even fewer survivors and the small number of remaining trees heroically managed to regenerate with only a restricted pool of genetic diversity to draw on. Whatever the reason, their extreme similarity means the trees are horribly susceptible to attack from plant pathogens that they haven't previously evolved to resist, because anything that could infect and injure one tree would hurt them all.

To prevent infection, the public are forbidden entry to the Wollemi site. However, some trespassers see this as a challenge, and may have introduced strains of *Phytophthora*, (Greek for 'plant-destroyer'), fungus-like water moulds that attack tree roots, via their unwashed boots. A living fossil that has survived 17 ice ages and countless bush fires may yet succumb in the wild to an infection spread needlessly by humans.

One of the closest living relatives of the wollemi pine is another prehistoric throwback, the monkey puzzle (p. 170).

Blue Quandong

Elaeocarpus angustifolius

The blue quandong – a corruption of *guwandhang*, a word of the Wiradjuri aboriginal people of Australia – is a very tall, elaborately buttressed, fast-growing evergreen. It grows from South East Asia to the south of Queensland and northern New South Wales, preferring rainforests and the banks of streams. Its rich green leaves, finely serrated and elliptical in shape, grow mainly at the extremities of the open crown and turn red as they age, occasionally bestowing the quandong with a whole branch of scarlet leaves. Generous clusters of fragrant bell-shaped flowers hang downwards, fringed as if wearing little white grass skirts.

The fruit is highly unusual. Spherical and about the size of a large marble, it is a vivid cobalt blue. However, unlike the world's relatively few other blue fruits, which contain coloured chemicals called anthocyanins, the fruit of the blue quandong has no pigment at all. It achieves its blue colour by means of a surface structure that reflects blue light, in a similar way to peacock feathers and the wing scales of iridescent butterflies, but a method almost unknown in plants. The remarkable structure is called an iridosome, a network of strands arranged with great precision just underneath the outer cell walls of the skin of the fruit. These cause interference between light waves that bounce off the front and back surfaces, creating colour. The bright and remarkably constant blue is dependent on consistent fabrication to an accuracy of a few millionths of a millimetre. This so-called structural colour gives the seeds an advantage: even as they age, they still shine bright blue, attracting attention on the forest floor. Unlike most other fruit, blue quandong also allow light to pass through the outer skin to a layer below that can photosynthesize, contributing to their growth.

The fruit are important in the diet of many forest inhabitants, including cassowaries, wompoo pigeons and spectacled flying foxes, all of which can distinguish blue from other forest colours. They eat the flesh and disperse the curiously wrinkled stone inside without harming the seeds it contains. The stones, which appear almost as though they have been finely carved, each contain a few seeds and are used by Buddhists and Hindus as prayer beads, or to make necklaces.

Although its astringency catches the throat if it is picked too early, the blue quandong fruit is quite pleasant when a little over-ripe. The trouble is that putting sky-blue food in one's mouth never feels right.

Sève Bleue

Pycnandra acuminata

The French territory of New Caledonia, halfway between Australia and Fiji, isn't all swaying palms and coral reefs. Through a quirk in geology, the main island, Grand Terre, which is 350 kilometres (220 miles) long and about 65 kilometres (40 miles) wide, holds an astonishing fifth of all the world's known deposits of nickel. Open-cast mining satisfies about a tenth of the total world demand for this metal, most of which is used to make stainless steel.

Stuck with so much fairly poisonous metal in nutrient-poor soil, the sève bleue has evolved to make the most of it. It grows to about 15 metres (50 feet) tall and has small white flowers. So far so normal, but cut the tree and the latex that is exuded from the inner bark is a lurid bluish-green. Nick a twig and glistening globules of turquoise appear. Sève bleue means 'blue sap', and a remarkable 11 per cent of the weight of the sticky latex, or more than a quarter of its dry weight, can be nickel, a concentration far in excess of any other living material. A mature tree can contain more than 35 kilograms (75 lb) of the metal.

The sève bleue sequesters nickel by forming a complex compound with citric acid, which it shunts into latex, out of the way of vital cell processes. However, other plants growing nearby avoid this rigmarole by not absorbing nickel from the soil in the first place. The reason sève bleue doesn't do the same appears to be that it uses the nickel as a cheap poison to repel insects that would otherwise eat the tree. Sève bleue is the most extreme example of metal hyper-accumulation, but there are many plants around the world that can absorb heavy metals. These are being researched and deployed for a process called phytoremediation, to clear contaminated land.

The Mediterranean cypress (p. 70) has a close association with another important metal.

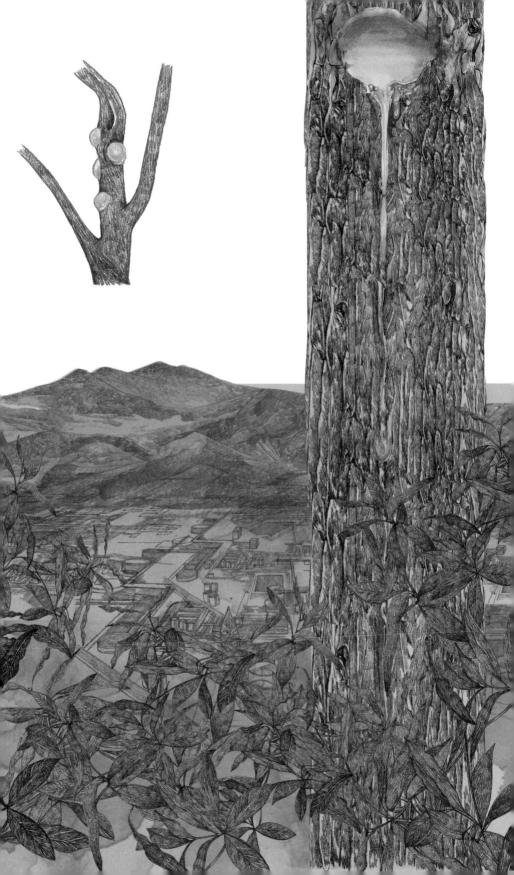

Kauri

Agathis australis

In its stature and historic cultural role, the kauri is the Antipodean counterpart of the Californian coastal redwood (see p. 206). Confined to the northern tip of New Zealand, it is a magnificent tree that can grow to a height of 45 metres (150 feet), and many live for 500–800 years. Robust 'peg roots', as long as 5 metres (16 feet), branch downwards from the tree's lateral roots, providing an exceptionally solid anchor against strong wind. The kauri is particularly imposing, since its smoothly-plated grey trunk is often remarkably cylindrical with no visible taper and can be 5 metres (16 feet) across, with branches starting only at a great height. Whenever a parasitic plant tries to attach itself to the trunk, the kauri cunningly sheds patches of bark to throw it off. However, the crown supports a whole ecosystem, including orchids, ferns and even other trees.

The kauri has another well-developed defence mechanism, too: resin. As well as having powerful bacteriocidal and fungicidal properties, resin creates a physical barrier, covering wounds and swamping and trapping burrowing insects. Kauri trees produce a lot of it, oozing here and there and collecting in forks between branches. Between 30,000 and 50,000 years ago, as successive waves of kauri lived and died, enormous amounts of resin fell to earth and fossilized, accumulating in layers up to 10 metres (35 feet) below the ground.

Maori people, who probably arrived from Polynesia in about the thirteenth century, used the resin for kindling, medicinally as a mouth cleanser, and for communal chewing as a social lubricant. They also burned it to a black powder and combined it with fat to create a greenish blue-black pigment for tattooing, painfully introducing the mixture into lacerations made using chisels of animal bone.

The *pakeha*, or incomers from Europe, arrived in a big way in the 1840s. They used kauri timber for bridges and shipbuilding but, other than firelighters and novelty carvings, couldn't find a profitable use for all the resin that was lying around. They sent samples to the United States and London, where, finally, a manufacturer found that kauri resin could be dissolved in various oils to make an extremely tough outdoor varnish, useful for boat decks and railway carriages. Suddenly it was a valuable commodity.

Soon, any resin just lying around had been gathered and sold, but a great deal more lay just beneath the surface, or in swamps. There was

a huge influx of thousands of resin prospectors – reminiscent of the Californian gold rush – who were known as 'gum-diggers' (a misnomer, because gums, unlike resins, dissolve in water). The diggers didn't need expensive mining equipment. Deposits were found using a thin, sharpened rod of tempered steel that was hammered into the ground. The timbre of the rod's vibrations revealed to the gum-diggers the presence of resin, which was found in accumulations ranging from small nuggets to huge pieces that required three men to lift. For 50 years kauri 'gum' was New Zealand's most important export, more so than wool, gold or timber, and during the heyday of gum digging, between the late 1890s and World War I, there were as many as 10,000 prospectors who exported 150,000 tons of resin, worth almost a billion pounds in today's money. In exchange for gum-digging licences, the Crown often specified that land should be cleared and drained, and these payments, along with export taxes, paid for New Zealand's infrastructure of schools, roads and hospitals.

As the fossil resin became exhausted, men turned to tapping trees using a scarily unlikely method of walking up them in spiked shoes, carrying a tomahawk. They slashed the bark and returned every six months to collect resin from the wounds and make new incisions. Greed caused many to overdo it, however, shortening the life of the trees.

In 1910 the business was given a fillip when linseed oil, cork particles and low-grade resin chips were rolled together onto fabric to make a solid, easily cleaned and durable material: linoleum. It wasn't until just after World War II that varnish- and lino-makers found synthetic substitutes and the market for kauri resin collapsed. Looking out over farmland and orchards in the north of New Zealand now, it is hard to believe that just 120 years ago the main industry was gum digging, which underpinned the prosperity of the country, and even harder to believe that before the Maoris and the *pakeha* arrived, kauri forests covered 15,500 square kilometres (6,000 square miles).

Kauri resin brought a 'rush' of men to exploit it, as did rubber (p. 136).

Paper Mulberry

Broussonetia papyrifera

The paper mulberry reached Tonga from Taiwan in a series of hops, along with settlers migrating towards Polynesia. Enjoying the moist volcanic soils of the Pacific islands, it would happily reach 20 metres (65 feet) tall, were it not harvested at 3–4 metres (10–13 feet) after little more than a year of frantic growth. The tree's treasure is the fibre from its inner bark, which provides structural support for the vessels that shuttle sugars and other chemicals around the plant. Made from long strands of cells held together by pectins and gums, paper mulberry fibre is particularly strong, and the Polynesians use it for one special function: making bark cloth, or *tapa*. In Tonga, the tree is cultivated specially for this purpose. In Japan, the inner bark is used to make *washi*, a tough paper that finds a use for many traditional crafts; it was also employed in China for the very first paper-making, in about AD 100.

First, strips of bark a couple of metres (a few feet) long and the width of a hand are carefully removed, then washed and scraped. The strips are pummelled to nearly three times their original width, then laid over one another and felted together by hammering, with a little tapioca starch if they don't stick together well enough. The rhythmic tonk-tonk of wooden mallets is a common sound in Tongan villages. The resulting beige squares are joined together, then stamped, dyed, painted or stencilled with traditional geometric patterns in shades of black and dark brown. The designs are sophisticated, often with stylized fish or plants, and make impressive hangings; for a public building they might be 3 metres (10 feet) wide and 15–30 metres (50–100 feet) long.

In Tonga, the finished pieces are called *ngatu*. They are valuable gifts at ceremonies such as marriages and funerals, to be used as wall hangings or room dividers. Originally, the *tapa* cloth was also used for clothing – often with a waterproof coating of oil or resin – and it is still sometimes used for traditional wedding outfits.

Tapa-making provides important handicraft income, but perhaps the greatest value is that, for significant pieces, it is a communal endeavour. Polynesians rediscovering their heritage say that the process of binding the pounded strips draws together the people who make the *tapa*, and that this helps to explain the current revival of *tapa*-making in Hawaii and by expatriate Tongans and Fijians in New Zealand.

Koa

Acacia koa

The Hawaiian archipelago is a string of volcanic islands in the Pacific more than 3,200 kilometres (2,000 miles) from the nearest large land mass. The koa, which grows naturally nowhere else on Earth, evolved there from ancestors that probably arrived from Australia more than 1.5 million years ago. It is an eager tree that can grow 10 metres (35 feet) in its first five years and in its mature form it varies from a mangy shrub to a gnarled and spreading giant with gothic tracery. The species is a generous donor to the ecosystem. It provides food and lodging for birds and insects, the rough and scaly bark of older trees often sports attractive vermilion lichen, and its special root nodules harbour nitrogen-fixing bacteria, enabling it to grow in poor soil and fertilizing it with leaf litter. The leaves themselves are unusual. Young koas have pretty, silver-green compound leaves, but mature trees additionally develop crescent-shaped 'phyllodes', flattened leaf stalks as long as a man's hand. The flexibility of having both leaf types seems to help the tree to grow from shade into full sun.

Incredibly, 16,000 kilometres (10,000 miles) away, on the island of Réunion in the Indian Ocean, there is a species, *Acacia heterophylla*, exquisitely similar to the Hawaiian koa. Genetic analysis has shown this to be the probable result of the world's furthest known single seed dispersal. The koa's brown bean-like seeds are contained in hand-length pods that follow the tree's sprays of small, puffy, pale-yellow flowers. Since koa seeds are damaged by seawater, a bird probably brought a seed from Hawaii to Réunion in its stomach or stuck to its feet, about 1.4 million years ago.

Before humans arrived, Hawaii had no land mammals other than the odd bat, so there was no pressure for koa (or most other plants on the island) to evolve thorns, poisons or acrid chemicals. Koa is therefore defenceless against the now-numerous grazing cattle, which regard its seedlings as prime fodder and which trample its shallow roots. The trees are protected now, but while stocks regenerate koa is one of the most expensive timbers in the world. Traditionally used for fine furniture and ukuleles, it can be polished to a glowing mahogany, lustrous with reds and golden browns. Like the semi-precious stone tiger's eye, it displays chatoyance: an illusion of shimmering, holographic depth.

Koa's pride of place in Hawaiian culture comes from its association with the long canoe, *wa'a peleleu*. These massive ocean-going craft, 30 metres

(100 feet) long and 2–3 metres (6½–10 feet) deep, with large floating outriggers to prevent them from tipping over in rough seas, were once the principal means of travel and transportation among the islands. Each hull was made from one huge koa trunk, which was hard and durable enough to survive repeated voyages and repay the enormous effort that went into making it. Some versions had double hulls and sails.

Commissioning a long canoe was such an undertaking that only chiefs could afford it. Carpenters, who inherited their jobs and had a monopoly on ocean-going boat-building, negotiated excellent pay, as well as food for themselves and their families. Crops of taro, breadfruit, coconuts and sweet potato would be planted before work began, and gifts had to be provided or the workers might down tools. However, this was a spiritual activity, too. All parts of the process had a ritual aspect and were overseen by a special priest, an expert in canoe-building: the *kahuna kalaiwaʻa*. The *kahuna* helped to select a suitable tree in the forest and, while it was laboriously felled and dressed using a stone adze, he kept an eye out for ill omens. During the production phase a *kapu* was applied. This religious prohibition (from which, via the Tongan word *tapu*, the English word 'taboo' derives), forbade the intrusion of outsiders and governed the foods that could be eaten by the workers and when. The finished canoe was decorated with a lacquer-like mixture of plant extracts and oils. The *kahuna* and the chief launched the vessel with a sacred feast of pig, fish and coconut – not so different from the modern Western ritual of a VIP smashing a bottle of champagne on a ship's bow, while reciting 'May God bless this ship and all who sail in her.'

The alder (p. 58) also harbours nitrogen-fixing bacteria in its root nodules.

Monkey Puzzle

Araucaria araucana

The monkey puzzle's armour of sharp leaves might seem ferociously over-engineered, but this tree is a throwback that needed to fend off herbivorous dinosaurs. Now the national tree of Chile, in the Cretaceous period it had close relatives that grew in what are now the Low Countries of Europe until climate change and competition from newly evolving species killed them off.

Araucaria araucana is a tall evergreen conifer, native to the foothills of the Andes in Chile and Argentina, and occasionally along the coast by dint of its tolerance to salt. This is a volcanic region, as well as an area that is prone to lightning, and the trees have adapted by growing thick bark, which gives them an advantage over upstart competitors when fire sweeps by.

Able to live for perhaps 1,300 years, the tree has a reptilian demeanour. Groups of branches grow from single points on the trunk, curling and dividing like pipe-cleaners. Glossy dark-green leaves, paler at the branches' growing tips, are exceedingly sharp, arranged spirally and so densely as to clothe each branch completely. Young trees are pyramidal, but as they mature they shed their lower branches so that older trees have trunks that are unusually tall and straight for mountain species, their bark sometimes curiously tessellated, and with a distinctive umbrella crown of branches. The seeds of the next generation are borne in rust-orange cones, although it was only recently that the mystery of their dispersal was solved. Scientists embedded tiny magnets in hundreds of individual seeds and tracked them, discovering that they were mainly collected by rodents between 3 PM and 9 PM and hoarded in their burrows; the rest were dispersed by birds and cattle.

The local name for this *Araucaria* species is *pehuén*. For centuries its protein-rich seeds, *piñones*, have been such an important part of the diet and culture that one of the indigenous Mapuche tribes, the Pehuenche, has taken its name from the tree. *Piñones* are eaten roasted, or ground and fermented into a kind of beer called *muday*, using an unusually cold-tolerant yeast. *Araucaria* has religious as well as economic significance for the Mapuche people, and takes centre stage in local harvest and fertility ceremonies.

The species was first encountered by Europeans in about 1780 by a Spanish explorer. It was introduced to England by Archibald Menzies, a plant collector and surgeon on Captain George Vancouver's circumnavigation of the globe in 1795. The story goes that at the end of

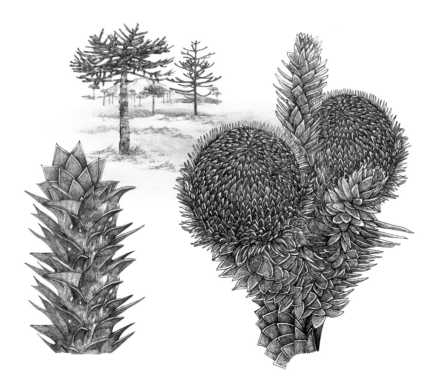

supper with the governor of Chile, Menzies was served a bowlful of seeds and quietly pocketed a few for planting. Given that unroasted seeds are none too palatable, perhaps he just picked up a stray cone on his way back to the ship. Either way, the seeds germinated on board and he returned to England with several healthy plants. One of them lived for nearly 100 years as a celebrated attraction at Kew Gardens.

The origin of the popular name monkey puzzle is British, from about 1850, when the species was still very rare. A barrister visiting a garden in Cornwall, where the owner had paid the extravagant sum of 20 guineas for his specimen, reportedly quipped that 'it would puzzle a monkey to climb', and a terrific piece of marketing was born. By late Victorian times, a craze for creating impressive avenues of monkey puzzles on large estates had created sufficient demand for collectors to supply seeds in bulk. The price dropped dramatically, allowing them to be domesticated in suburban settings, where, in Britain at least, they are sometimes seen nowadays as rather vulgar.

In the Chilean wild, the monkey puzzle is now endangered through the destruction of its habitat for agriculture, despite the whole species having been declared a protected National Monument. The real puzzle now is how to conserve a tree that outlasted the dinosaurs but must compete for space with man.

Blue Jacaranda

Jacaranda mimosifolia

The jacaranda, surely one of northern Argentina's most beautiful exports, is an especially graceful tree that garlands the streets of subtropical and warmer temperate cities. Slender branches form a filigreed, rounded crown, and in late spring, before any leaves that might detract from the opening spectacle, the jacaranda puts on its flower show. For two months the entire tree is densely blanketed in bee-beckoning clusters of fragrant, lavender-blue trumpets, hallucinatorily intense blossom that compels the gaze and lifts the spirits. When the delicate foliage appears, fluttering compound leaves cast gentle shade, their bold fern-green setting off the vivid blooms. In Sydney, Pretoria and Lisbon, in Pakistan and the Caribbean, jacarandas have been planted with delightful abandon, creating mauve necklaces for boulevards and amethyst canopies over narrower suburban streets. As the petals fall, they lay a purple carpet underneath – a joy to all except neat-freaks and occasional mean-spirited motorists complaining about stains on their paintwork.

To those impoverished souls for whom gladness needs further justification, street trees should be regarded as a great investment. Ample research demonstrates their contribution to air quality, urban cooling, flood prevention, good mental health and community cohesion: a profusion of benefits far outweighing their costs. The mix of species needs careful thought, for every neighbourhood has its own character and ecosystem, but if you live in warm enough climes, adding some jacarandas to your street might be an effective and public-spirited way to increase the value of your property.

The Yoshino cherry (p. 134) is also planted in cities for its beauty.

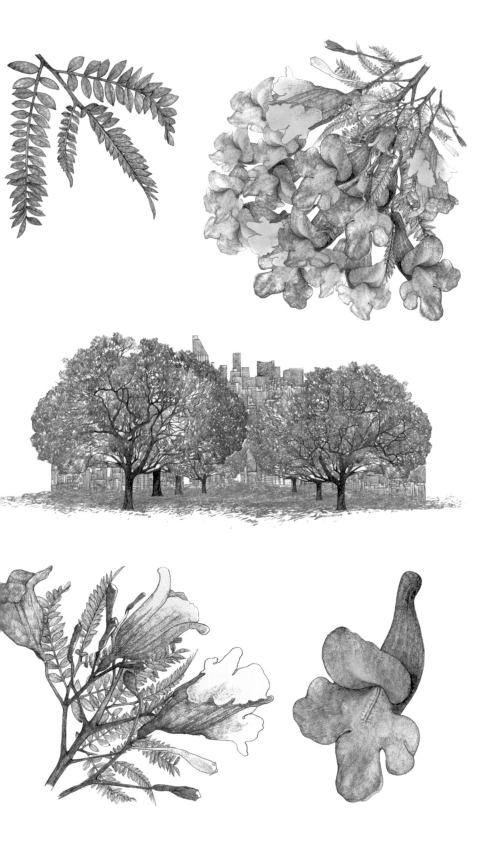

Quinine

Cinchona spp.

N ow the national tree of Peru and Ecuador, *Cinchona* changed
the course of world history. There are more than 20 species
of this handsome 25-metre (80-foot) tree with large, shiny,
conspicuously veined leaves and deliciously fragrant, white to lilac-pink
(sometimes hairy) flowers that grow in small clusters, generally pollinated
by butterflies and hummingbirds. But its real claim to fame is the
effectiveness of its bark for treating malaria.

In the early seventeenth century, when Spanish colonists and Jesuit
missionaries in Peru were first introduced to *Cinchona* bark, there was no
malaria in South America. Some historians suggest that *Cinchona* was an
indigenous Quechua medicine used to treat an unrelated fever, and that
it was this that inspired Europeans to make an incredibly lucky guess. In
Europe, where malaria or 'ague' was endemic, they found that *Cinchona*
bark could both cure and prevent the disease. Its reputation and use spread
quickly through Spain. (Ironically, it was probably the Spanish, via their
African slave trade, who brought malaria to the one continent that didn't
have the disease but had a cure for it.) They built an industry around it in a
loose but controlling 'partnership' with the Quechua, and massive logging of
Cinchona trees began, with fleets of ships carrying the bark back to Europe.

'Jesuit's bark' was regarded with suspicion by Protestants because of
the connection to Spain and Catholicism. In England, Oliver Cromwell died
of malarial complications rather than take the 'powder of the Devil'. But in
1679 *Cinchona* cured the son of Louis XIV of France, and it was soon widely
accepted as the only preventative and cure for malaria. It remained so for
more than 250 years, when alternatives were synthesized.

We now know that *Cinchona* bark contains a cocktail of alkaloid drugs
– probably evolved as a defence against insects – that would indeed have
been medically valuable to the Quechua. The name 'quinine' came from the
Quechua language, *quina-quina*, 'the bark of all barks'. But quinine alkaloids
have the rare capability of making certain components of our blood
poisonous to the malaria parasite.

Malaria was a problem in Europe until the twentieth century, but
in the tropics the disease was the limiting factor to European colonial
ambitions: virulent strains killed more than half of all Europeans who
ventured to some parts of Africa and Asia. In North America, in the British

settlements of Virginia, more people died from 'swamp fever' than at the hands of the Native Americans. Anything that might check the disease was of the utmost strategic significance and would command a pretty price. In order to protect their lucrative monopoly, the countries of South America imposed a death sentence on anyone exporting cuttings or seeds. However, their forests could not meet the voracious demand for quinine, and in the nineteenth century the Dutch and the British managed to smuggle *Cinchona* out of South America to start their own plantations.

By the 1930s the Dutch East Indies supplied most of the world's quinine, but it remained a source of strategic power right through World War II. When Java and its quinine supplies were captured by Japan, the United States imported hundreds of tons of *Cinchona* from Peru. Even that wasn't enough: tens of thousands of US troops in Africa and the South Pacific were incapacitated for lack of quinine.

Without *Cinchona*, the European colonies would not have expanded in tropical parts of the world. In India, the British Raj depended on quinine, the white powder extracted from the bark, which was taken daily in 'tonic water'. To disguise the bitter taste, gin, lemon and sugar were added to make it more palatable, resulting in the forerunner of today's G&T. Modern tonic water has more sugar and much less quinine – enough, though, to make it fluoresce pale blue under the glow of ultraviolet nightclub lights.

Quinine was the subject of imperial strategic planning, as was the breadfruit (p. 194).

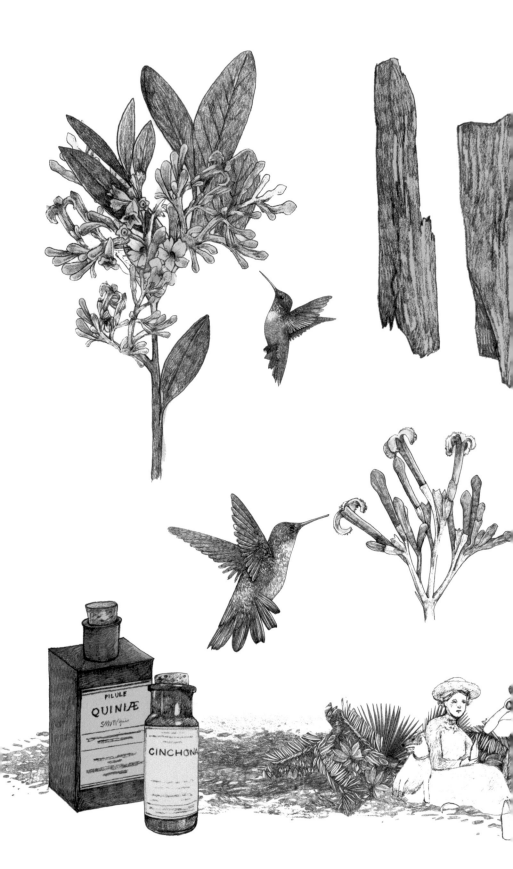

Balsa

Ochroma pyramidale

M ost of the world's balsa, which is native to tropical America, comes from forests and plantations in Ecuador, where it lives fast and dies young. *Ochroma* means 'pallid', and its pale-beige, featherweight wood is well known to model makers. It has also – perhaps surprisingly – been indispensable to pioneers of the sea and the sky.

Balsa flowers are special. Often growing perfectly upright, the buds are the size and shape of velvety ice-cream cones. The flower opens in the evening to reveal five large, thick, creamy-white petals – a brash invitation to a very generous helping of nectar. Nocturnal flowering often signifies pollination by bats, but balsa pollen is transferred by capuchin monkeys and two other adorable forest mammals: the kinkajou and the olingo.

In a patch of light, the trees grow in a frenzy, with smooth, almost unnaturally cylindrical silver trunks. In seven years they can reach 30 metres (100 feet) tall, with a girth beyond an adult's clasp. Like many fast growers, balsa has large cells that contain water, making the wood spongy. However, once thoroughly dried, the remaining cell structure is rigid, making seasoned balsa surprisingly stiff for its absurdly light weight. A block the size of a carry-on suitcase weighs less than 2.5 kilograms (5½ lb).

Such light wood has often been used by raft-builders and, indeed, the Spanish word for a raft is *balsa*. In 1947 the Norwegian ethnographer (and notorious non-swimmer) Thor Heyerdahl built the *Kon Tiki*, a raft of lashed balsa logs, to demonstrate that early contact between South America and Polynesia was possible. He sailed it 8,000 kilometres (5,000 miles) across the Pacific from Peru and landed near Tahiti. The three-month voyage was an epic vindication of balsa-wood rafting (although we now think that Polynesia was originally populated by migration from South East Asia).

During World War II Britain was short of aluminium but had plenty of woodworkers, and the de Havilland Aircraft Company turned to timber for its nimble Mosquito warplane. With a speed of more than 640 kilometres (400 miles) per hour, the 'Balsa Bomber' was one of the world's fastest operational aircraft. The fuselage was made from light sheets of balsa glued between layers of birch. Balsa composite materials are still used now for wind-turbine blades and surfboards. As children, de Havilland's engineers would have constructed balsa model aeroplanes. What could have been more natural to them than to build the real thing using the same strange wood?

Brazil Nut

Bertholletia excelsa

Brazil nuts grow throughout the Amazon and Orinoco basins – but most exports are from Bolivia, not Brazil, and technically they're not nuts but seeds. Otherwise, the name's fine. The brazil-nut tree towers 50 metres (165 feet) over the forest floor and is easily recognized by its deeply fissured, straight and greyish trunk, usually devoid of lower branches and with a cauliflower-shaped canopy perched on top. Its large white flowers are pollinated by large and heavy species of bees but seen only rarely by people, if one happens to flutter to the ground.

After the flowers fade, the fruit take more than a year to grow and ripen into round, woody capsules the size of baseballs. Weighing 2 kilograms (4½ lb) each and plummeting to the ground unannounced at up to 100 kilometres (60 miles) per hour, they arrive impressively unscathed but make harvesting a treacherous operation. The pods are hard to get into. For seed dispersal, the tree depends on agoutis, small rodents related to guinea pigs, with notoriously sharp teeth. They're tenacious enough to penetrate the outer casing and sufficiently nimble to be able to retrieve the seeds inside, which are wedged in like orange segments, between 10 and 20 to a pod. Each in its own individual shell, the kernels are irritatingly resistant to the nutcracker but not to the agoutis, which eat some and bury the rest, often conveniently forgetting where they put them. The seeds can remain dormant for years, until a fallen tree creates a patch of sunlight and gives them the chance to germinate.

Brazil nuts are one of the very few widely traded commodities that are still principally collected from the wild, in this case by indigenous people for whom they are an important source of protein and fat as well as income. In just one year, a single tree can produce 300 or more fruit pods containing 100 kilograms (220 lb) of nuts. Such valuable non-timber forest produce provides a strong incentive to protect the trees.

A peculiar feature of the species is its unusual talent for taking up minute quantities of radioactive elements that occur naturally in the soil and concentrating them in its fruit. Nut-munching nuclear workers, who undergo regular checks, have occasionally become sufficiently radioactive to cause puzzlement among technicians, though not enough to be a health concern.

Brazilwood

Paubrasilia ⋆ *echinata*

Despite being the national tree of Brazil and native to its Atlantic coastal forests, the brazilwood did not take its name from the country. It was the other way around. The brazilwood is a pretty thing, about 15 metres (50 feet) high, with bright-yellow flowers that hang in gaudy sprays, dozens to a stalk. Sweetly citrus-scented and full of nectar, each flower has a striking, blood-red bull's eye near the middle. The fruit are curious thin oval seed pods, like spiny green biscuits, and the dark-brown bark of the trunk flakes in large patches, revealing both the brazilwood's claim to fame and also its downfall: the heartwood underneath.

For the European fop-about-town during the Renaissance, richly coloured clothing was a sign of wealth. Red velvet was especially luxurious, the province of kings and cardinals, but the colour didn't come cheaply, or easily. One of the most important sources of red dye was the sappan tree (*Caesalpinia sappan*), known in Asia since the second century BC and in Europe since the Middle Ages. At the time it was known as brasilwood, probably derived from the Portuguese word *brasa* for a fire's embers (the same root as 'braise' in English). Timber was brought at considerable trouble and expense from the Far East, then laboriously powdered, sometimes by prisoners such as those at the Amsterdam Rasphuis or 'rasp-house', before being applied to wool or silk treated with alum to fix the bright-red dye.

In 1500 the Portuguese arrived in South America and couldn't believe their luck when, alerted by locals adorned with bright pigments, they found brasilwood's dye-bearing sibling, which they called by the same name. It was very near the coast, as if just waiting to be logged and taken to market. The Portuguese Crown granted an export monopoly and a highly profitable industry arose, staffed by *brasileiros*, for felling the logs and shipping them back to Europe – a much easier journey than from the Far East. On account of this trade, the country's original Portuguese name of Terra de Vera Cruz (Land of the True Cross) became simply Terra do Brasil (Land of Brazil).

All this commercial activity prompted other nations to try to harvest, smuggle or intercept the valuable commodity and, despite armed escorts, Portuguese ships loaded with brazilwood (as it came to be spelled) were favourite targets for marauders. The French and Portuguese tussled repeatedly with each other and with the indigenous Indians. In 1555 a French expedition made an unsuccessful attempt to establish a colony in

present-day Rio de Janeiro, motivated in large part by the potential for exploitation of brazilwood. Then in 1630 the Dutch West India Company took possession of most of the brazilwood-growing area and for 20 years felled trees systematically, extracting 3,000 tons of wood, which was sent to the ports of the Netherlands.

By the 1870s synthetic red dyes had almost totally replaced brazilwood, but its population had already been decimated and the species has never had a chance to recover because its timber has another irresistible quality: a unique combination of stiffness, heft and resonance. From the eighteenth century to the present day, it has been unsurpassed for the most noteworthy violin and cello bows, for which the wood is generally known as Pernambuco (named after a Brazilian state). Fewer than 2,000 trees now survive in the wild, so exports have been banned and there have been concerted efforts at cultivation. However, bows made from wild forest timber, which is slightly more dense, have superior sound quality. The main threat to wild brazilwood is poaching, and a black market in Pernambuco is worth millions of dollars a year. Exquisite music has its jarring notes.

★ In 2016 taxonomists renamed the genus *Paubrasilia* ('Brazilian wood'). Since 1785 it had been known as *Caesalpinia*.

Avocado

Persea americana

Avocados are among the most nutritious and widely known fruit, yet they are still full of surprises. Tropical evergreens of humid lowland forests, avocado trees grow quickly, typically to 20 metres (65 feet), with an irregular, dense crown of thick, glossy leaves. Dark green above and paler below, the leaves smell temptingly of aniseed when crushed, but are well defended: they are very poisonous, especially to domestic animals.

Dainty in their shades of pale green, avocado flowers cluster at the ends of branches. Each flower contains both male and female organs, which mature at different times. To prevent self-fertilization, avocado flowers have adopted truly bizarre behaviour. They open twice, first when the female parts are ready to receive pollen. Then they close. They open again, many hours later, when the male parts are ready to shed pollen. Incredibly, all the trees in an area open and close their flowers in perfect synchrony. Pollination works only because there are two kinds of avocado tree, which reach male and female maturity at exactly complementary times, ready for insects to flit between them. That is why lone trees rarely produce fruit and commercial orchards must plant both types of tree.

The fruit is usually pear-shaped, containing a single, large, rounded seed surrounded by firm, lime-green flesh, darker towards the outside, all encased in a leathery, dark-green or aubergine skin. The native, undomesticated and nearly black *criollos* are small, but the fruit of some cultivated varieties can weigh 2 kilograms (4½ lb). Large, heavy fruit need something to disperse their seed when they fall, so that they don't compete with the mother tree. Avocado seeds are poisonous, so rodents, for example, cannot be expected to hoard and bury them. There is no animal in the region that is big enough to ingest whole avocados with their seeds. The likeliest explanation is that in prehistoric times the fruit was eaten by giant ground sloths – long extinct – with relatively small, blunt teeth. They could have swallowed the fruit whole and excreted the seed in dung, ready to sprout. Avocados depend on us now to disperse the species, and we have done so with considerably more gusto than the giant sloth: avocado cultivation is driving forest loss in south and central America.

Introduced to Florida and California in the late nineteenth century, the fruit was known in the United States as 'alligator pear' after its reptilian

skin, but growers in the 1920s, wishing to avoid the association with
something deadly and unpleasant, rebranded the fruit as the 'avocado'.
However, they still found it hard to sell a Mexican food to blinkered white
consumers. They needed an angle.

Among the ancient Maya, avocados were culturally entwined with
procreation, and the tree's original Nahuatl name, *āhuacatl*, means 'testicle
tree', perhaps because the fruit sometimes dangle in pairs. In 1672 William
Hughes, an English horticulture writer, enthused, 'it nourisheth and
strengtheneth the body ... procuring lust exceedingly.' Spanish monks
came to the same conclusion and banned it from monastery gardens. All
this sounded very promising indeed to the avocado industry. In a moment of
marketing genius (which carries the whiff of urban legend), growers loudly
denied the 'scurrilous rumours' of lust-inducing qualities, thereby stoking
rampant desire, at least for the fruit. In fact, highly nutritious foods are
routinely upheld as aphrodisiacs, hunger being the enemy of libido.

The avocado contains a lot of unsaturated fat, plus vitamins and trace
minerals, but, unusually, virtually no sugar. It is one of the few fruits that
must be eaten raw, since cooking makes it taste bitter and rancid. Recently,
with a combination of luck and canny advertising, avocados have become
associated strongly in the United States with the Super Bowl. Tortilla
chips with guacamole (from *ahuacamolli*, meaning avocado soup or sauce)
are now as all-American as Thanksgiving turkey, although, 10,000 years
after hunter-gatherers settled down and began to cultivate avocados in the
region, Mexico is the world's largest producer.

*While uncertainty surrounds the avocado's original means of spreading its seed, the blue
quandong (p. 156) has fruit with a very unusual surface feature to aid dispersal.*

185

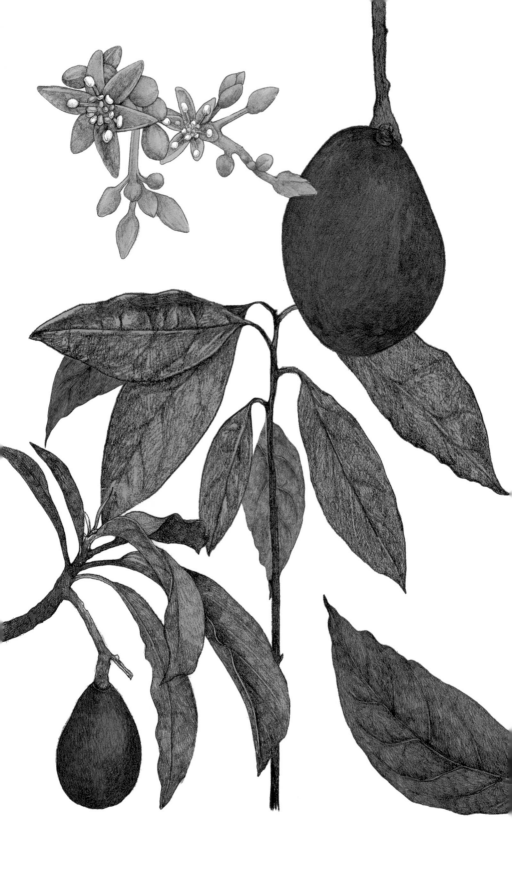

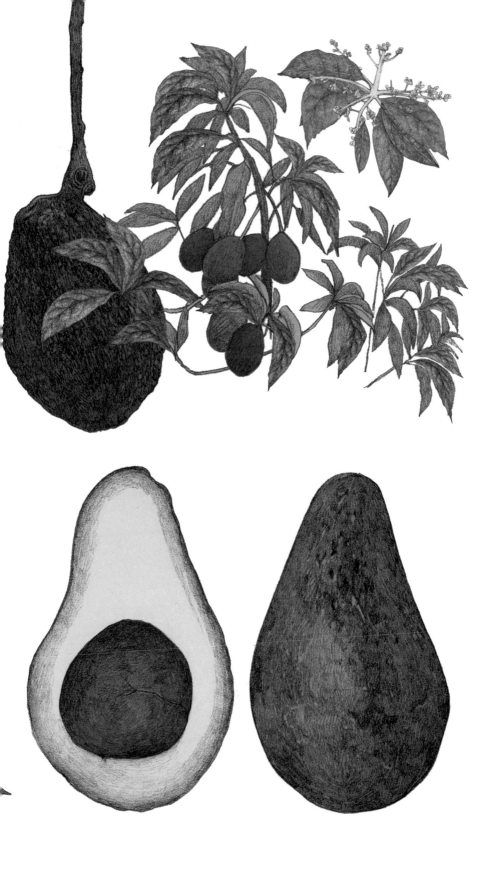

Sapodilla, Chicle

Manilkara zapota

Throughout the Spanish encountered this tree, which they named sapodilla (from the Nahuatl *tzapotl*), during their conquest of Central America. They introduced it to the Philippines, from where it spread across southern and South East Asia, where it is much loved across the region. The fruit has rough brownish skin like that of a kiwi, a slightly grainy texture and a sweet, malty, pear-like flavour. It is pleasant enough – but it's not for this that the tree has been globally influential.

Known as chicle in its native range of southern Mexico, Guatemala and northern Belize, it is a slow-growing evergreen with a large, dense, dark-green canopy of leathery leaves. When the pink inner bark is injured, chicle trees produce latex – a milky suspension of tiny droplets of organic matter in water – that dries to leave a natural sticking plaster to keep infection at bay. This latex has been collected for hundreds, probably even thousands, of years by the Aztecs and Mayans to make chewing gum and for use as a breath-freshener and thirst-quencher.

There is machismo in the harvest. *Chicleros* use machetes to slash zigzags from which the copious latex is collected, before it is boiled to coagulate and purify it. In the mid nineteenth century an enterprising New Yorker, Thomas Adams, acquired a supply of chicle gum, discovered its traditional use and cooked it up with sugar and flavourings. In the early twentieth century large-scale commercial exploitation took off. Adams' gum company was followed by William Wrigley's and, with clever advertising and marketing (not least when sticks of gum were included in American soldiers' ration packs), a multibillion-dollar global industry was born. By the 1930s the United States was importing 8,000 tons of chicle a year. Inevitably, trees were over-exploited and damaged, but in the 1940s continued demand from the US military spurred the development of synthetic vinyl substitutes based on petroleum, the main ingredients of almost all chewing gum ever since. Today there are just a few boutique manufacturers of natural chicle gum. Their business supports modern-day *chicleros* and gives poor communities an incentive to protect the forest.

Chicle or sapodilla? This is one tree with quite different cultural associations according to geography. Gum-chewing has a long history in the Americas but is regarded in Asia as uncouth, although the fruit, far from home, is a source of local pride.

Sandbox

Hura crepitans

Throughout tropical Central and South America and parts of the Caribbean, *Hura crepitans* is known by common names including monkey-no-climb, poison tree, dynamite tree and sandbox. Each one highlights a different aspect of this dangerous tree.

The trunk of the sandbox, which can easily reach over 50 metres (165 feet), discourages casual contact. Every inch is extraordinarily well armoured by stubby but razor-sharp thorns that are capable of inflicting real damage. It's just as well, therefore, that the male flowers can be enjoyed safely with binoculars: the deep crimson of a couple of hundred miniature flowers clustered on drooping 15-centimetre (6-inch) pyramids scintillates against the canopy of bright-green heart-shaped leaves.

In common with many other members of the spurge family (Euphorbiaceae), the sandbox has caustic milky-white sap that deters almost anything that might consider eating its leaves. It is sufficiently poisonous and quick-acting to be used for blowpipe darts, and the indigenous Carib people made arrow poison from its sap for killing fish.

What sets this tree apart is the astonishing way it disperses its seeds. Most plants that dispatch their seeds by air make them light enough to carry in the breeze; some have even evolved to give them wings. The seeds of the sandbox, on the other hand, must germinate in the gloom of the forest floor before the seedling can get each sunlight, so they must travel with the nutrients they will require. They are therefore quite substantial: rounded, flattened beans the size of a pound coin and colour of a tarnished penny.

These seeds, which are poisonous (of course), are held inside seed pods. The pods, which develop unshielded by leaves, are the shape of a peeled tangerine with about 16 segments, or carpels, in which the seeds are packed. The pods turn from olive-green to dark brown and woody, standing upright and horizontal as they ripen. As they lose moisture, some parts dry out and shrink faster than others. Enormous tension builds up until there's a sudden release, usually on a hot, dry day, and the pod explodes. The seeds are jettisoned with astonishing force, accompanied by a huge bang. A mid-nineteenth-century German botanical magazine reported on a naturalist who put a seed case in a glass bell jar: ten years later it 'burst

with a noise like the report of a pistol, and its divisions, with the fragments of the glass, were scattered about the room'.

Scientists have observed seeds being ejected at over 70 metres (230 feet) per second – more than 240 kilometres (150 miles) per hour. Amazingly, they are launched at an angle that, taking into account the drag of air-resistance, almost perfectly optimizes the distance they can travel. They also spin like miniature frisbees, which helps them to fly up to 45 metres (nearly 150 feet): far enough to ensure that new seedlings don't compete with their parent.

Once the pods begin to ripen, colonies of small ants often make their way through crevices to take up residence and nurture their young in the cavities between the segments. The ants never attack the pods themselves, presumably because any puncture would be followed by a copious discharge of sticky, caustic latex. The pods of the sandbox are a well-defended and well-appointed mansion for the ant colonies – dry, snug and secure against birds and other predators – with the slight drawback that at any moment their whole world may be blown to smithereens. The only non-deadly feature worthy of a nickname, it seems, are the unripe seed pods, which were sold in the early eighteenth century as decorative boxes to hold the sand used to soak up ink on pages written with a quill pen: the executive desk ornaments of their day.

The sandbox hurls its seeds through the air. The brazil nut (p. 180) has a different approach.

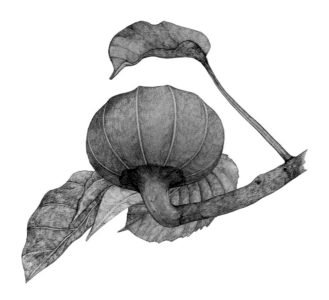

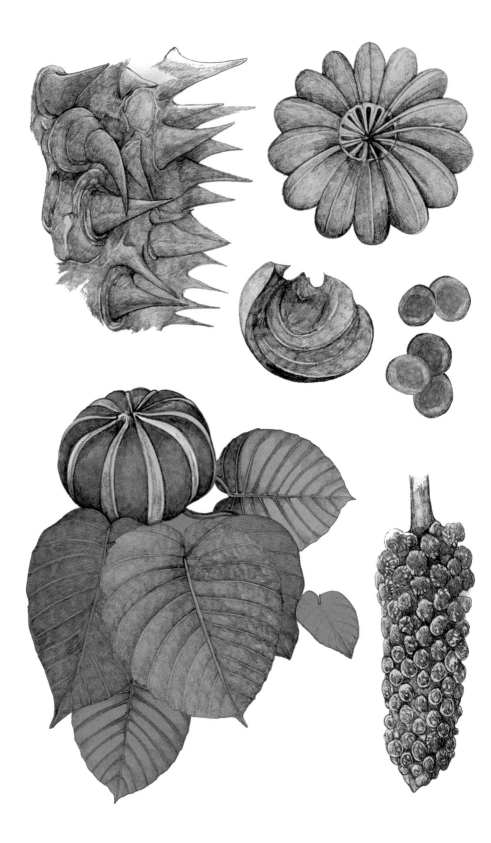

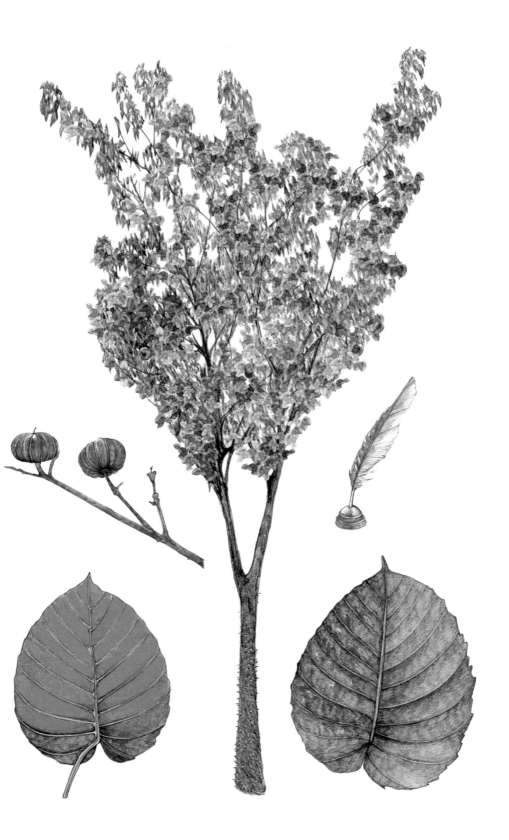

Breadfruit

Artocarpus altilis

The wild ancestor of the breadfruit, a native of Papua New Guinea and nearby islands, was first domesticated by migrants to the western Pacific about 3,000 years ago. The botanical characteristics of the tree, which is now cultivated throughout the humid tropics, arguably led to the most notorious mutiny of all time.

The breadfruit is an imposing species, growing up to 25 metres (80 feet) high with a sturdy grey-brown trunk. It casts dense shade from a canopy of huge, dark leaves, often deeply lobed like Matisse stencils. When cut, every part of the tree and its unripe fruit exudes gummy white latex, which has many uses: for treating skin ailments, for caulking boats, as a glue and even, in Hawaii, for temporarily trapping birds.

Flowers of both genders bloom on the same tree, and each inflorescence is composed of thousands of tiny florets attached to a spongy core; the males are club-shaped, while the females are spherical. It is the female flowers that fuse and develop into the fleshy, edible breadfruit, which is round or slightly oval and roughly the size of a ten-pin bowling ball. Light green, yellowing as they ripen, their thin skin is tough and tessellated in four- to seven-sided segments. Each of these polygons, which are either smooth or spiny, was once an individual floret. This starchy fruit is a staple of Oceania; its creamy-white or pale-yellow flesh is high in carbohydrates and some vitamins. Similar in use and taste to the potato, it has a fragrance and texture that is at least slightly reminiscent of bread.

Breadfruit seeds are sterile, ephemeral or bred to be non-existent and, because the trees don't spread by root-suckering, they are dependent on humans to propagate them from cuttings. With warmth and plenty of rain, however, breadfruit trees are eagerly prolific. They can bear a crop after three years, eventually yielding 200 nutritious fruit a year – perhaps half a ton – with little human effort other than plucking them or removing windfalls before they attract billows of fruit flies and decompose into slimy heaps.

In 1769 Joseph Banks, the botanist on Captain Cook's famous expedition, remarked on the easy life of Tahitians, who managed to thrive without the constant toil of tilling crops. His account reached plantation owners in the British colony of Jamaica, where the main (and

very profitable) export was sugar cane, and where weather and politics had disrupted supplies of plantains and yams, the main foods eaten by the African slaves. Plantation owners were looking for replacements that would be easy to grow and yet leave the best land for cash crops, and breadfruit sounded ideal. In 1787, underwritten by the British government, Captain Robert Bligh, commanding the HMS *Bounty*, sailed from England to bring breadfruit from Tahiti to the Caribbean. Since the breadfruit tree lacked viable seeds, the crew was forced to pass time for six months while a shipload of plants could take root from cuttings. During that time they acquired a taste for island life and formed relationships with local women. Reluctant to give up their new lifestyle, they mutinied just after setting sail, casting Bligh adrift with his few loyal men. Against the odds, he survived, fetched another ship from England, returned to Tahiti and, in 1793, arrived in Jamaica with several hundred little breadfruit trees that had survived the journey.

When the fruit developed, they were immediately unpopular. The authorities and contemporary commentators were nonplussed, but by that time the familiar foods from Africa were again available, and spurning breadfruit may have been one of the few ways by which the enslaved people were able to assert themselves. Since independence in 1962, breadfruit has shed its colonial association and become a mainstay of Jamaican culinary and barbecue culture. There are even breadfruit festivals. Across the tropics, breadfruit saplings are still being distributed to developing countries, now independent, to bolster food security.

The edible fig (p. 66) also has deeply lobed leaves.

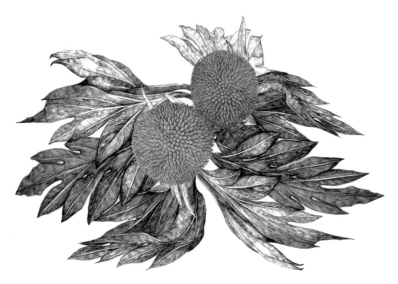

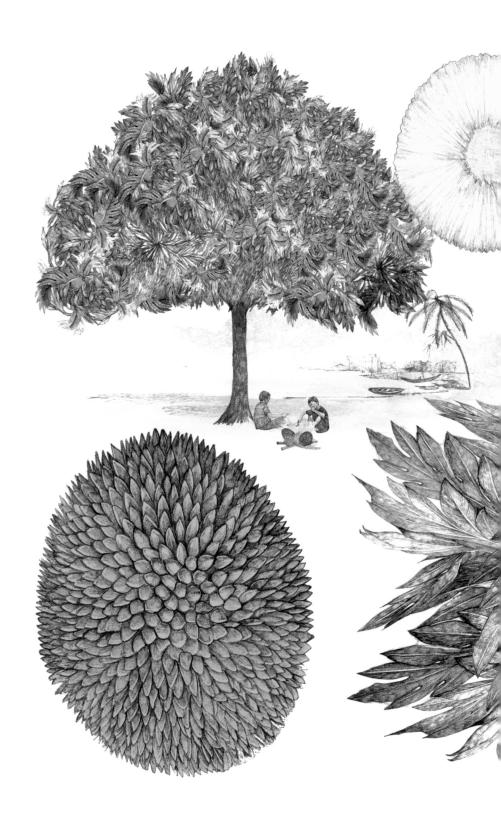

Lignum Vitae

Guaiacum officinale

T he national tree of the Bahamas is an ostentatious beauty with a heart of iron. With its unusual branching near the ground, lignum vitae is a popular street tree, often trained into a neat inverted pyramid. Rare old specimens at home in the dry lowland forests of Central America and the Caribbean can be marvellously crooked and, given the chance, they might live for 1,000 years.

Lignum vitae puts on a terrific show, with shiny, evergreen, paddle-shaped compound leaves and bark that flakes to reveal multicoloured mottling; pretty blue or lavender blossoms, profuse and long-lasting, densely adorn the foliage. As they age, the blooms fade to white and the tree shimmers with variegated colour. Then the second act begins: clusters of flattish pink-tinged capsules ripen to gold and burst to expose scarlet sarcotesta, fleshy seed coats surrounding a pair of jet-black seeds.

The most unusual aspect of the tree is its wood, which is possibly the hardest and certainly among the heaviest in the world – it is far too dense to float in water. The strangeness of the material, with its silky feel, its exotic vanilla fragrance and rumours of its use by the indigenous Arawak people to treat venereal disease, caused physicians in the early sixteenth century to ascribe to it special powers, calling it the 'wood of life'. In the 1520s the powdered wood and resin commanded an extortionate price – far beyond their likely efficacy – for treating syphilis. Often alarmingly combined with mercury, it was used until the nineteenth century. Nowadays Bahamians infuse lignum vitae to create a supposedly aphrodisiac tonic – for this purpose, belief in the outcome is probably enough to make it work.

However, there is no doubting lignum vitae's strength and durability. It has been exported for auctioneers' gavels and croquet mallets, mortars and pestles, heavyweight bails for stormy-weather cricket, and British policemen's impressively hefty truncheons. The wood has a tight, interlocking grain, making it almost impossible to split, and giving it unrivalled resistance to wear and water. Its resinous oiliness causes its surfaces to be self-lubricating. Throughout the golden age of steam, these qualities made lignum vitae essential for the bearings of the propeller shafts that powered the world's biggest ships, a use that continued even in the 1950s on the USS *Nautilus*, the first nuclear-powered submarine.

Pomegranate seeds (p. 106) are renowned for their vivid and juicy sarcotestae.

Lodgepole Pine

Pinus contorta var. *latifolia*

The lodgepole pine is a coniferous linchpin of the forest ecosystem in a vast area that encompasses the western Canadian province of British Columbia and runs down the Rocky Mountains into the United States. Tall, straight and slender, it takes its name from its use by First People for teepees and by subsequent settlers for the construction of buildings.

Many lodgepole cones exhibit serotiny: they can remain on the tree for a decade, tightly closed and secured with resin, waiting for a forest fire to melt the seal. Once the fire has laid low the parent trees and safely passed, the stored seeds are showered over fertile ash and a blanket of new seedlings shoots up ahead of any competition.

The lodgepole is the main host of the mountain pine beetle, which shares its territory and attacks it constantly. In summer, female beetles bore holes in the trunk and lay their eggs in galleries excavated in the inner bark. The beetles have a symbiotic partnership with blue stain fungus, which they carry in special sacs in their mouthparts. As the beetles chew, the fungus colonizes cells of the inner bark, interfering with the tree's flow of fluids and disrupting its normal defence of producing toxic resin. The beetles get an easy ride and so does the fungus: inside the insects' chambers, it creates spores, ready to be spread the next summer by the beetles that emerge and go off to find another host tree.

Extreme winters kill almost all beetle larvae, and healthy trees are able to live with, or fend off, routine attacks by the remaining insects. In fact, having some beetle activity picking off weak trees ensures enough deadwood fuel that when lightning sparks a fire, the lodgepoles, with their serotinous cones, have the advantage over other species. However, global warming has made the last few decades anything but routine. Mild winters have allowed the beetle population to explode, and the lodgepole pines' defences have been overwhelmed. Infected wood turns a grim blue-grey, needles turn brown and formerly healthy trees have died in huge numbers. A staggering 18 million hectares (45,000 acres) of forest have been affected, and Canadian authorities have spent or committed $2 billion to fight the beetle, which is spreading dramatically beyond its native range. Our dependence on cheap energy from fossil fuels is understandable, but the associated climate change surely has a price.

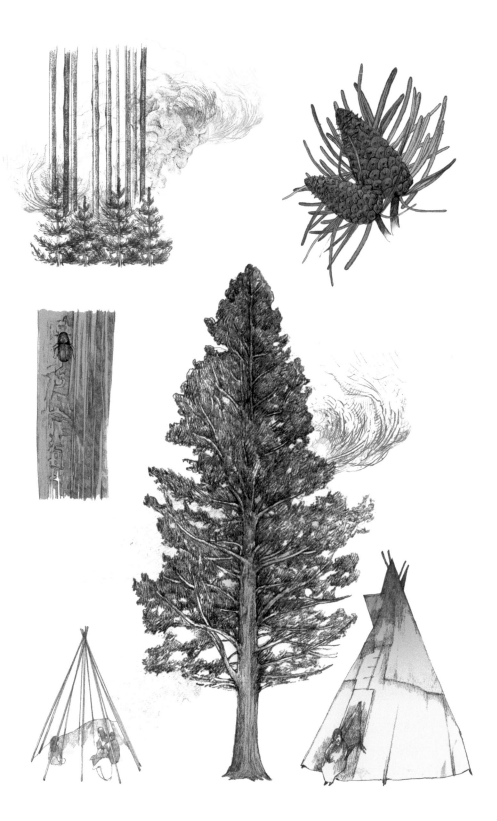

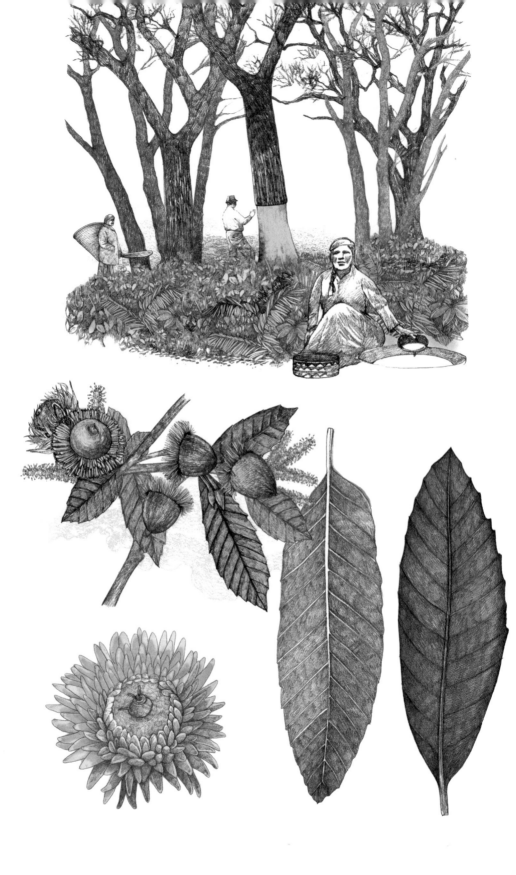

Tanoak

Notholithocarpus densiflorus

The tanoak is an evergreen hardwood of the humid, seaward-facing hills of northern California and southern Oregon. It has the character of both oak and sweet chestnut. Often 50 metres (165 feet) high, twisted, gnarled and broadly crowned when given space, it has thick greyish-brown bark, fissured with age. When new, its serrated leaves are woolly underneath, probably to conserve water. The male flowers blossom along catkins, like dense, yellowish dreadlocks the size of fingers. Clusters of female flowers appear at the base of each catkin, developing into tough-shelled acorns. These become frilled as they ripen (rather than scaled, like the acorns of true oaks), and can grow to the size of a small egg.

Historically, salmon and large tanoak acorns were the staple fare for Native Americans in these coastal regions. The acorns, containing protein, carbohydrate and substantial amounts of fat, were ground, leached in water and prepared as a nutritious soup, porridge or bread. But by the mid nineteenth century acorns were diverted by European migrants to feed hogs for the pork demanded by booming gold-mining towns.

The influx of people and horses also increased the demand for leather. To make leather supple and rot-proof, raw animal hides are 'tanned' in vats containing tannin, a chemical that trees use to deter insects and animals that might attack their bark. Tanoak was the best source, especially for tanning heavy items such as soles or saddles. By the 1860s Californian leather was being transported further afield, to manufacturers in New York and Pennsylvania, and the demand for tannin was insatiable. Trees were over-exploited, leading in the 1920s to a shortage of tannin and the gradual decline of the American leather industry.

After World War II tanoaks were planted for their strong and fine-grained timber, but the market preferred faster-growing and more easily processed conifer softwoods. In 100 years tanoaks had made the journey from vital indigenous food source to worthless weed. Foresters set about them with defoliants, throwing the ecosystem out of balance and making the remaining trees susceptible to infection. Since the 1990s millions of tanoak trees have succumbed to the cankers of 'sudden oak death' caused by *Phytophthora ramorum*, an invasive fungus-like organism related to the one that caused the potato blight and subsequent famine in Ireland in the mid nineteenth century.

Western Hemlock

Tsuga heterophylla

T he western hemlock is a towering conifer of the cool, moist Pacific coast that runs through Oregon, Washington and British Columbia – home to black bears and some of the most beautiful old-growth forests in the world. Distinguishable from afar by its drooping leading central shoot, with brown and lightly furrowed bark, the hemlock prunes itself as it matures, its branches falling away from the lower three-quarters of the trunk to leave huge, straight columns. Its short needles are flat and glossy, each with distinctive white bands underneath.

The tree's common name derives from the characteristic mousy smell of crushed leaves – similar to that of the horribly poisonous but completely unrelated perennial water hemlock (*Conium maculatum*), best known as the plant that killed Socrates. The western hemlock, however, has been valued by indigenous West Coast peoples for its edible inner bark and as a treatment for various ailments. Tender branches with soft, feathery foliage were used as bedding; bent trunks were carved into large feast dishes; bark tannin treated leather and made a reddish dye used as a cosmetic blusher.

The hemlock forest blots out a great deal of light. Despite rich soil, the only sizeable plants that thrive on the forest floor are ferns, which can grow thigh-deep. That leaves hemlock seedlings, shade-tolerant though they are, with a problem. Even when a gap in the canopy appears, perhaps when a tree is chopped down or blown over, seeds on the ground rarely flourish in the shadow of the ferns. Some tree species tackle this kind of problem by producing large seeds that pack enough nutrients to reach the light under their own steam, but the western hemlock has another way. When a big tree topples, its diameter is sufficient that the top of the horizontal log can remain clear of the undergrowth. Hemlock seeds landing there can grow from the surface, using rich nutrients released by fungi as they decompose the log. The seedling sends down roots that appear to flow over and around trunks and stumps. There's something spooky – even primeval – about this new life emerging from, and engulfing, a seedling's dead brethren. Roots grow and dead wood rots, until eventually a new tree is left standing on thick stilts. Decades later, growth and detritus fill the gaps, but occasionally an enduring cedar log can be seen, still in the clutches of an ancient hemlock.

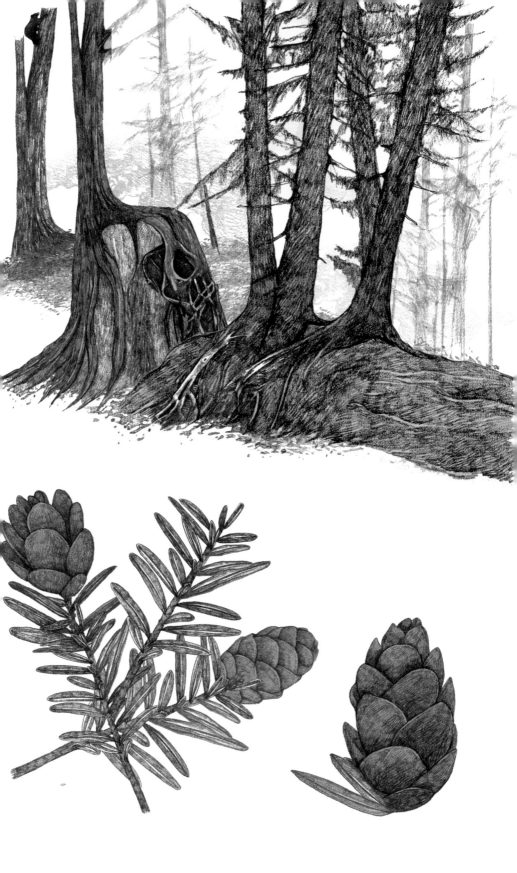

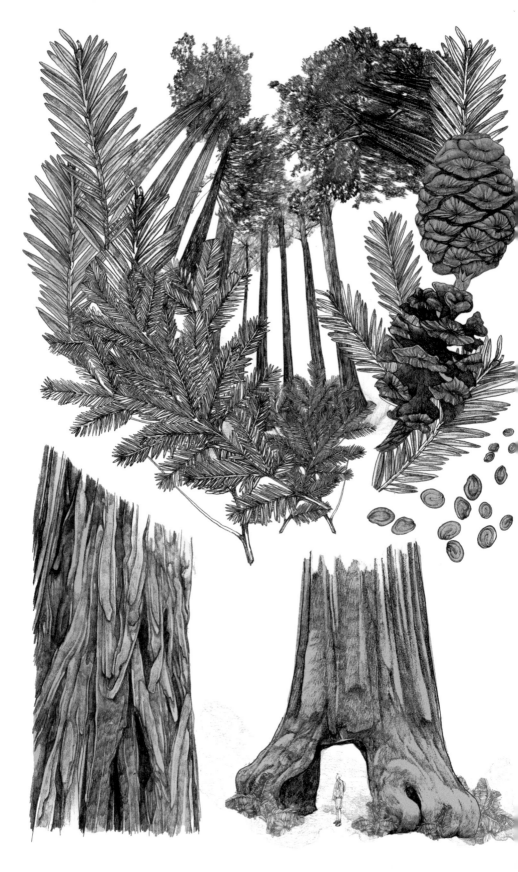

Coastal Redwood

Sequoia sempervirens

N ative to the foggy hills of the Pacific North West, the colossal coastal redwoods are the world's highest trees, and among its oldest. The tallest tree on Earth, a redwood called Hyperion, stands a staggering 115 metres (380 feet) tall. Gazing upwards, one might wonder whether there's any limit to how high a tree can grow. Historically, it turns out that the world's tallest individual redwoods all reached just a little more than 120 metres (394 feet). And the same is true of the very tallest specimens of other giant tree species. Can that be pure coincidence? To answer the question, we must understand water, its role as the lifeblood of a tree, and how it reaches the top.

As with any plant, most of the solid matter of a tree is constructed (synthesized) using two simple ingredients: carbon dioxide and water. It's possibly the most important chemical reaction on Earth, and it's powered by sunlight, hence its name, *photo*synthesis. Every square millimetre of every leaf has hundreds of tiny pores, which allow carbon dioxide from the surrounding air to enter. But the only way that trees can draw water up from the roots to the top of the tree is if some of that water evaporates through the leaf pores. As individual cells near the surface of the leaf dry out, they suck water from the next wettest cell below, then the next and the next, until the pull reaches a vein in the leaf and sucks on the tiny tubes, perhaps just a thirtieth of a millimetre across, carrying water all the way up through the woody part of the tree.

This is a clever way to transport water since it uses energy from the sun – rather than energy from the tree itself – to cause water at the top of the tree to evaporate. It relies on a curious property of water, which is made up of molecules with strong positive and negative ends that cling together like magnets. Water is remarkably cohesive, which is why rain forms into such neat little droplets, and also why a narrow, continuous column of water can support itself. The theoretical limit to the height that columns of water inside trees can be lifted is about 120 metres. Any taller and gravity would overpower the cohesion between water molecules and the top of the tree would dehydrate and die. It turns out that trees can't grow any taller because of fundamental laws of physics.

Jojoba

Simmondsia chinensis

D espite its scientific name, jojoba has nothing to do with China
– *chinensis* was the result of a nineteenth-century botanist's
misreading of a scrawled label. Native to the western Sonoran
Desert of Mexico, southern California and Arizona, jojoba is a low
evergreen shrub or occasionally a bushy tree, up to 4 metres (13 feet)
high, well adapted for desert survival. Long taproots can draw water from
10 metres (33 feet) underground, and its leathery, grey-green leaves are
waxy to reduce water loss. They are jointed, too, so that in the blaze of
midday they point vertically, keeping cooler, which makes photosynthesis
more efficient. As a result, there's surprisingly little shade under a jojoba
(nor beneath some varieties of eucalyptus that have learned the same trick).
The positioning of these leaves also creates eddies of wind that channel
pollen from the yellowish clusters of flowers on male trees to the pale-green
flowers at the leaf nodes of female trees. It's the females that bear fruit, the
size and shape of acorns, which turn golden-brown as they ripen.

Within each fruit, the seeds contain half their weight in golden oil,
a liquid wax that has long been used in skin and hair preparations. It is
also especially prized as a high-temperature machine lubricant to replace
sperm-whale oil, which was banned widely in the 1970s. The demand led to
widespread planting in hot, dry countries, but jojoba has been difficult to
cultivate commercially. It's a finicky business. Farmers must wait for several
years until the plants flower, and then they have to thin out the males,
which will not bear seeds, leaving just enough to fertilize the rest.

Jojoba oil has also recently been touted as a potential treatment for
obesity. Cows fed on seed cakes left over from oil-pressing seem to lose
weight, and Native Americans once used jojoba as an appetite suppressant,
although only during times of great hardship. Although research has not
shown jojoba extract to be harmless, and it is not licensed for medicinal or
weight-loss use, legal loopholes allow it to be sold as a 'food supplement'.

Jojoba provides year-round cover and food for a web of birds and
animals, but only the charmingly named Bailey's pocket mouse is known
to be able to digest the wax in the fruit. In other species, including
humans, it acts as a mild laxative, an attribute that helps to spread and
fertilize its seeds.

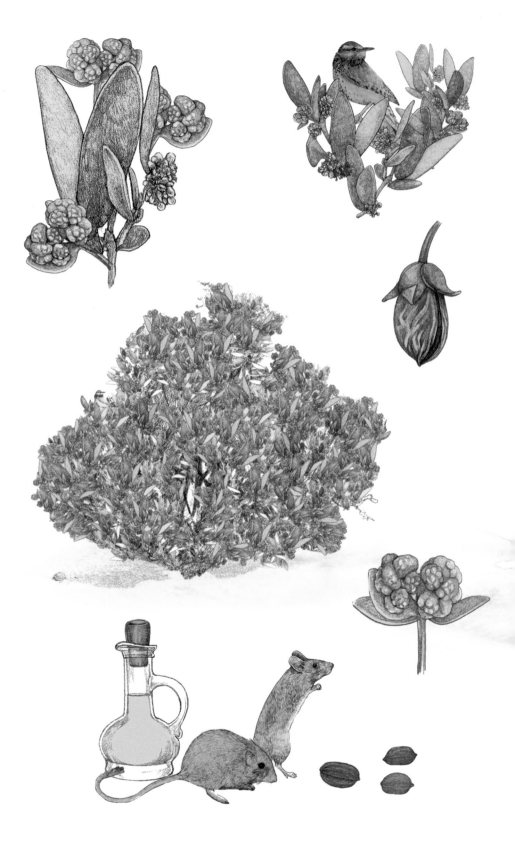

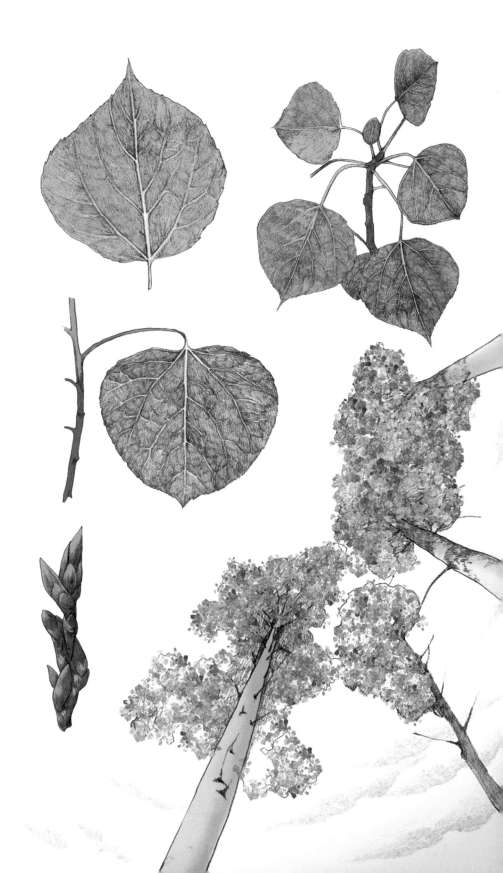

Quaking Aspen

Populus tremuloides

T he most widespread North American tree species, the quaking aspen, thrives in the high country of the west, especially in Colorado and in Utah, where it is the state tree. A stand of aspen makes the heart leap. Its leaves flicker and shimmer, vivid green on top and pale grey underneath, becoming first yellow and then brilliant gold in autumn, glorious against clear mountain skies. The leaf stalks, or petioles, are long and flattened like ribbons so that leaves bend and twist in the slightest air, rustling with the soothing sound of a rippling stream. Nobody knows for sure why aspen leaves have evolved to quiver. One theory is that the flexibility of the stalks helps aspens to avoid having their leaves stripped by mountain winds. The constant movement might also allow light to filter through dense woods to the aspens' pale trunks, which – tinged green with chlorophyll – can also photosynthesize.

The aspen hates shade. It can't reproduce beneath its own canopy, let alone compete with a blanket of pines, but after a fire it can quickly repopulate fire-cleared ground before other species. That is why there are often whole groves of aspens of exactly the same height, having all sprouted simultaneously. Out west, where dry spells make life hard for seeds, aspens abstain from sexual reproduction and instead generate new tree stems directly by suckering. What look like separate trees may actually be genetically identical tree trunks rising from a common root system, collectively known as a clone. In fact, the heaviest known living organism on the planet may be a single stand of quaking aspens in Utah, affectionately called Pando (Latin for 'I spread'), which contains 45,000 trees, covers more than 40 hectares (100 acres) and probably weighs 6,500 tons. The colony (but not any individual tree) may be 80,000 years old.

The risk of reproducing this way is that plants may lack the genetic diversity to overcome disease or to adapt quickly to a changing environment. However, distinct aspen populations are remarkably diverse and can also revert to sexual reproduction; as a result, the species is very successful. Counter-intuitively, one of the main threats to large groups of aspen is the presence of protected areas and visitor centres with campsites. This is not because of what campers might do to the trees, but because fire in such places is more likely to be controlled or extinguished, giving the edge to competing shade-tolerant conifers.

Black Walnut

Juglans nigra

The black walnut is a stately native of the United States east of the Rocky Mountains, with a huge crown and dark, ridged bark. Its nuts have been used for their oil and protein by indigenous people for at least 4,000 years, and its timber – durable and chocolate-brown – has for centuries been over-exploited for veneers and furniture.

Two-thirds of the annual black walnut harvest in the United States comes from Missouri. Their flavour is more intense than that of the common, cultivated 'English' kind but their tough, deeply corrugated shells are hard work for a casual snack – possibly an adaptation to dissuade rodents from polishing off the next generation of trees.

The black walnut has a long and varied relationship with the military. Its wood is solid, shock-resistant and easy to machine and it buffs beautifully, with a subtle, raised fingerprint grain for an assured grip. In the mid nineteenth century it was such an obvious choice for gunstocks that 'shouldering walnut' became a metaphor for army service.

Walnut trees protect themselves with juglone, a natural herbicide that discourages competing plants, and tannin, an insect repellent. For humans, though, these chemicals work as dye and fixer, handily delivered in one package. During the American Civil War, walnut husks were used to dye homespun uniforms a brownish-grey for Confederate soldiers and to make the ink they used to scratch out letters to loved ones back home.

During World War I, black walnut was specified for aircraft propellers because it could withstand huge forces without fragmenting. By World War II, walnut had been so depleted that the US government ran a campaign to encourage private individuals to donate trees to the war effort. Simultaneously, powdered walnut shells were combined with nitroglycerine to make a form of dynamite. With such associations, it is perhaps appropriate that black walnut wood has also long been popular for upmarket coffins.

The invasive tree of heaven (p. 222) also releases chemicals to undermine competitors.

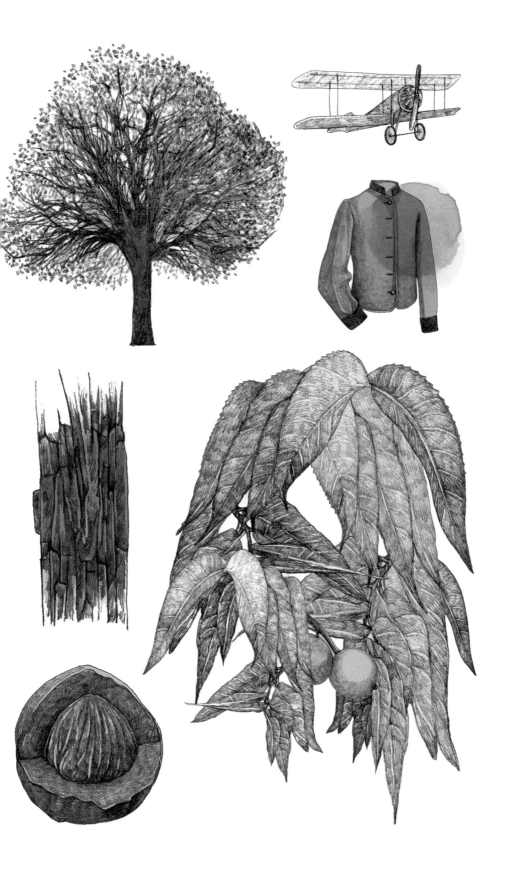

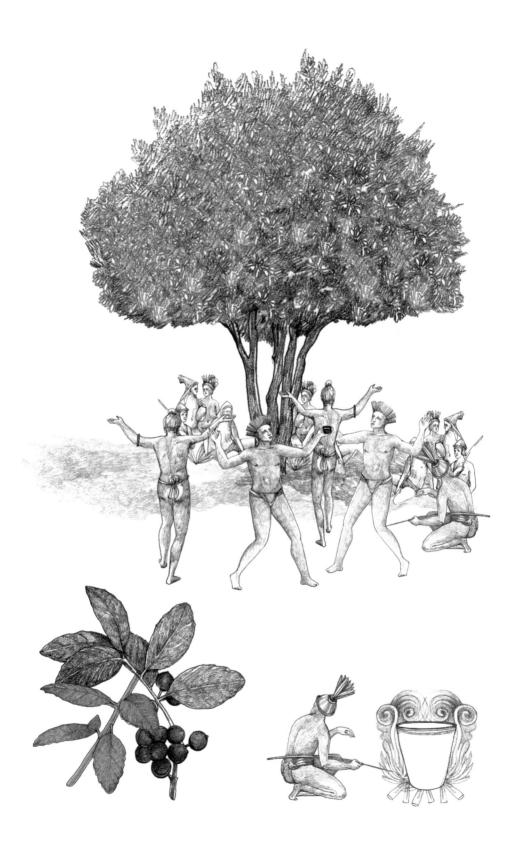

Yaupon, Indian Black Tea

Ilex vomitoria

Before the European conquest of North America yaupon, or Indian black tea, was a valuable commodity; indigenous people travelled long distances to harvest its leaves. The mystery is why it is not widely known and consumed these days.

Yaupon is a common small evergreen, a brother to yerba maté and holly, with prickly leaves and dense clusters of translucent red berries. It grows easily in the sandy coastal plains along the Gulf of Mexico from Texas to Florida and has few, if any, insect pests, probably on account of the caffeine it contains.

It was that caffeine, in the yaupon tea brewed by the Timucua and other indigenous American tribes, that made the tree so important to them. Most cultures have developed caffeine rituals, ranging from the therapeutic cuppa, via the hand-crafted coffee craze and African kola swaps, to elaborate ceremonies of tea preparation and consumption. In some Native American cultures, men frequently shared yaupon tea as a sign of peaceful intention. It also featured in big, culturally significant gatherings, with music, dancing and black tea quaffed from conch shells.

Now the yaupon story becomes a little strange. Among indigenous peoples of North and South America, a common means of ritual purging and purification was vomiting, which would have been a frequent sight at religious ceremonies. Given the ubiquity of black tea, Europeans incorrectly linked yaupon with throwing up and gave it the charming name *vomitoria*. In fact, yaupon is no more emetic than tea or coffee. The vomiting might have been a learned skill – or perhaps black tea was cut with other drugs – but the reputation stuck. The Europeans' distaste was amplified by their association of the drink with the ceremonies of a subjugated (or dead) people. With that kind of PR, how could yaupon compete with professionally marketed tea and coffee? Excepting a brief spell during which the Spanish ran short of coffee, it never took off with European invaders or their descendants.

Yaupon is due a marketing makeover. Readily cultivated and a viable alternative to tea and coffee, it tastes a little like oolong and does well in blind tastings against yerba maté and other infusions. It's sold locally as 'cassina' – a café-culture rebranding with a mid-European feel, except that the word is itself almost all that's left of the now-extinct Timucua tribe.

Bald Cypress, Swamp Cypress

Taxodium distichum

The steamy swamps of the southeastern United States are the domain of the bald cypress, which flourishes in sodden and flooded places where other species might rot, topple or suffocate. Not a true cypress, but related to the majestic redwoods, it is a towering, stately tree. Its trunk is flared and fluted with buttresses that provide it with a stable foundation. The impressive solidity of its deeply furrowed, dark-tan bark, which greys with age, contrasts with its lush foliage, delicate to the eye and feather-soft to the touch. Green seed cones are borne towards the end of the branches; their scales interlock prettily and conceal a red, fragrant and liquid resin. In autumn the needles become burnt-orange and eventually drop, along with the smaller twigs – hence the species' common name. As might be expected of a tree that can thrive in ooze, its old-growth timber is so resistant to decay that it was once known as 'the wood eternal'.

Bald cypresses growing in wet conditions develop distinctive 'knees': hollow vertical extensions of the roots that thrust upwards from the ground or above the waterline within a few metres of the main trunk, sometimes the height and width of a person. They were used by Native Americans for beehives, and there have been various theories as to the purpose they serve for the tree. They have been thought to help to steady the tree or provide a store of carbohydrates, or perhaps to channel rotting vegetation as it floats by, building up nutrient-laden solid material and silt that might otherwise be swept away. These are interesting explanations, but not supported by good scientific evidence.

Contrary to what one might think, although tree roots grow underground, they need oxygen to function. Most soil that trees inhabit has enough cracks and spaces for gases to permeate, but swamps are tough on roots. The bald cypress could be expected to have evolved a method of feeding oxygen to its waterlogged roots, and the knees have been suspected of being pneumatophores – structures that can do exactly that. In 2015 researchers at last showed that the amount of oxygen down in the roots was indeed linked to the knees' absorption of oxygen from the air. However, bald cypresses still grow even if their knees are severed. Maybe the knees originally evolved to cope with other ancient environmental pressures, now past. Although such questions may sound esoteric, searching for the answers can help to illuminate prehistory.

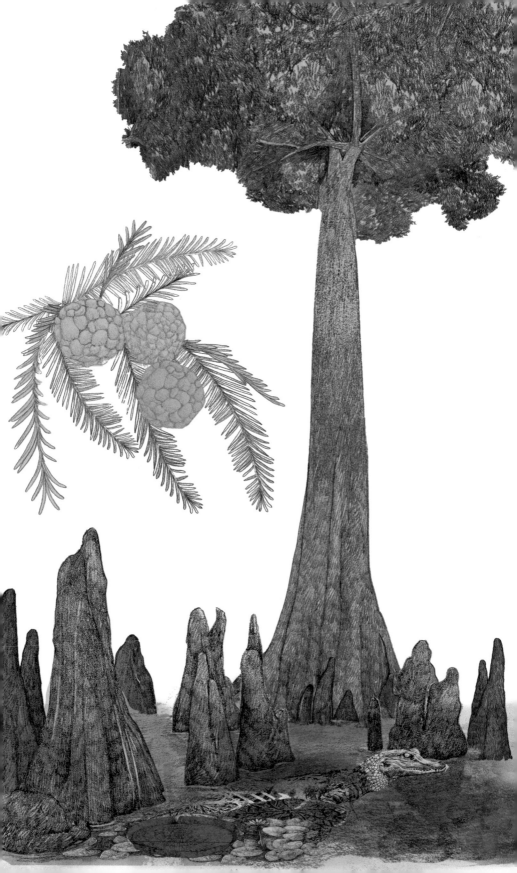

Red Mangrove

Rhizophora mangle

There are about 60 species of mangrove, uniquely adapted to life on tropical shores and in coastal swamps, bays and lagoons. The red mangrove usually grows to 8 metres (26 feet) tall, occasionally up to 20 metres (65 feet), along coasts from the eastern side of tropical America to West Africa. There are especially large forests, up to 6.5 kilometres (4 miles) wide, along the Gulf coast of southern Florida. Despite its name, red mangrove bark is actually a very dark grey, but scratch beneath the surface and you will find a tannin-rich, reddish-brown layer, which will stain stagnant water the colour of tea. Its leaves are large and leathery, dark glossy green above, often speckled below. Its flowers are pale cream and yellow, and surprisingly sweetly scented for a wind-pollinated species that has no need to attract insects.

Mangroves are rare in the plant world in bearing live young. Their seeds germinate while still attached to the tree and the seedling develops an unusually long, stiff stem between its leaves and its hard, sharpened root tip. These 30-centimetre (12-inch) spear-like seedlings, called sea pencils or propagules, detach from the tree and plummet into sand or mud like a dart, hold fast against the scour of the tide and explode into growth. Those that splash into water float and continue to grow, waiting for the moment when they touch the bottom, at which point they quickly take root.

Perhaps the most obvious adaptation to the shifting sands of the water's edge are the red mangrove's stilt-like roots, or rhizophores, which can be several metres long. They anchor the trees against wind and water and form dense thickets of sturdy, overlapping prop roots that grow into one another, forming lattices that calm turbulent water and trap sediment. Tree roots need oxygen, but waterlogged mud contains very little. The mangrove has pores – lenticels – that open and close with the tide, allowing the exchange of gases and connecting to spongy tissue that can store air.

Red mangrove sap can be almost salt-free, thanks to a desalination system that runs on solar power. Sunshine causes moisture to evaporate from its leaves, creating a vacuum that sucks columns of water at high pressure through special membranes in the tree's roots, leaving the salt behind. Engineers have mimicked this 'ultra-filtration' method for commercial desalination. The black mangrove (*Avicennia germinans*), another

Florida species, does it differently. Despite its name, its leaves are powdery white with salt that it has ingested but managed to excrete, as a quick lick will confirm. Other mangrove species shunt salt to their oldest leaves, then shed them.

Mangroves support a wealth of aquatic life. They grow fine roots into bright-orange fire sponges, receiving nitrogen compounds in exchange for carbohydrates. Organic matter is food for crabs, molluscs and insects. The fish that depend on the shelter and nutrients among mangrove roots have fabulous names such as the snook, the tarpon and the schoolmaster snapper. Higher up the food chain, crocodiles, egrets, sea-turtles, manatees and most of the big game fish all depend on the mangrove's unusual ability to thrive in the saline water of the ocean and feed the ecosystem.

Worldwide, mangroves are adaptable survivors, but they are threatened – by shrimp farming, coastal development, charcoal making and also climate change. They can grow only in the tiny gap between mean sea level and the highest tides. If the sea level rises, they must move inland, where space may already be taken. Once mangroves disappear, time and tide erode and reshape the shore, often making it difficult for the species to re-establish itself.

However, left to themselves, mangroves can stabilize the coastline, protect against storm surges and even conjure new land from the sea. Different species, each with their own environmental niche, work together. In Florida, red mangrove builds a framework and traps sediment, providing food and shelter for black mangroves. The black mangroves throw up thousands of aerial roots that poke vertically from the mud to absorb oxygen. Both red and black mangroves add biomass from their leaves and from other flora and fauna entering the system. Finally, white mangroves (*Laguncularia racemosa*) gain a foothold and club together with other trees on what is now terra firma. The red mangrove stays at the ocean boundary as it moves outwards – the first colonizer.

The kauri (p. 160) also supports an entire ecosystem – this time in its branches.

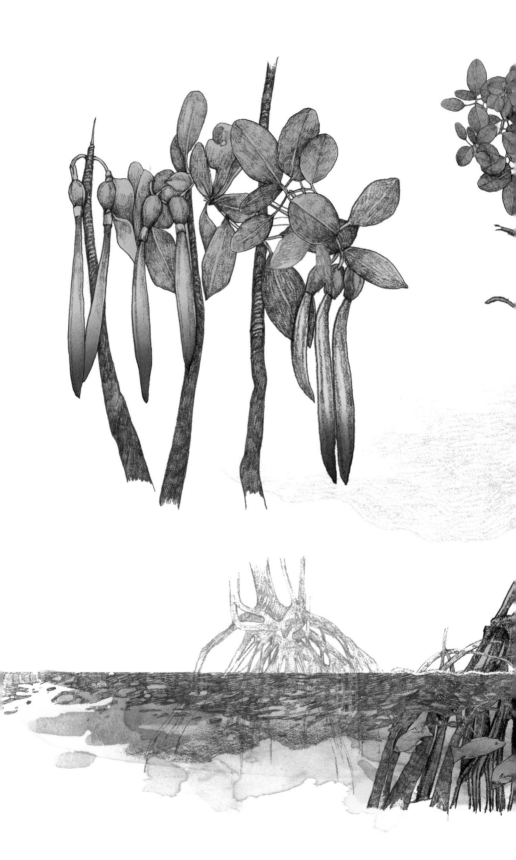

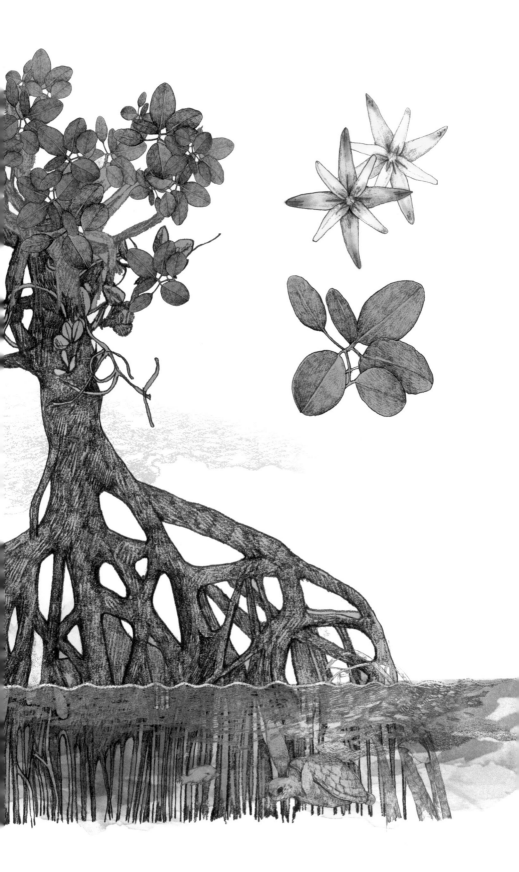

Tree of Heaven

Ailanthus altissima

The tree of heaven is at once cherished and despised. It gets its scientific name from the Moluccan *ai lantit*, which roughly means 'tall as the sky'. It can very quickly reach a height of more than 25 metres (80 feet), with smooth, pale bark and, unusually for large broadleaves, an almost perfectly cylindrical trunk. The leaves are spectacularly big – several feet long – and made up from a couple of dozen smaller leaflets, giving it a distinctly tropical feel.

The tree is native to China, but when its seed was introduced in 1820 in New York state, it impressed plant aficionados with its generous shade and unfamiliar ornamental quality. With what would later become a terrible irony, the seeds of this new arrival were even distributed by the US Department of Agriculture, after it had scoured Europe and Asia for sturdy plants that might be popular. Then, during the gold rush of the 1840s, Chinese miners brought seeds to plant as a source of traditional medicine and, apparently, to remind them of home, where the tree was a common food for silk moths. By the mid nineteenth century it had become common in nurseries across the eastern United States because it could be grown anywhere by even the least green-fingered. That should have been a warning.

While the name of the tree in most European languages emphasizes its height or how fast it grows, its name in northern and central China, *chòuchūn*, ominously translates as 'foul-smelling tree'. Crush the leaves or break a stem and you'll suffer a waft of cat pee or perhaps rancid peanuts. But it's not until June, when there are large, showy clusters of small yellowish-green flowers, that things really get nasty. Trees can be of either gender, and the reek from the male flowers could stun an ox: descriptions include rotting gym socks, stale urine or even human semen. Doubtless this special fragrance is intoxicatingly lovely for the insects that carry pollen from male to female flowers.

In summer a female tree can produce 350,000 seeds, each one at the centre of a samara – a wing of fibrous papery tissue – which ripens from amber to crimson. They spin prettily as they fall, carry far on the slightest breeze and can germinate just about anywhere. Easily colonizing disturbed land along railway lines or on building sites, the tree can cope with cement dust and noxious industrial fumes. Storing water in its root system, it is drought-tolerant, too, and will thrive where few others survive.

That is why Betty Smith used the tree of heaven as a metaphor for immigrant life in her classic American novel *A Tree Grows in Brooklyn* (1943), in which the titular sapling tenaciously makes a success in poor conditions, despite being under-appreciated and struggling to reach the sky. As they say in Brooklyn, what's not to like? Actually, plenty.

Ailanthus is not just tolerant of hardship but also hugely invasive and practically indestructible. Most references concentrate on how to get rid of it. Cut it and the stump can resprout at a rate of 2.5 centimetres (1 inch) a day, or an amazing 4 metres (13 feet) in a season. Burn or poison it and the risk is that it will send out suckers, partly fed by the mother tree, that can regenerate on their own. Although the species rarely lives for more than 50 years, this suckering ability makes it possible for the tree to clone itself indefinitely. The bark causes contact dermatitis among tree surgeons and the roots are forceful enough to damage underground sewers and pipes. *Ailanthus* even sees off competition by creating its own powerful herbicides, to which its own seedlings are immune.

Growing like crazy, antisocial and able to reproduce sexually at only 2 years old, the tree of heaven is often banned from cultivation. Even in China, where it is held in check by competitors and insects with which it has co-evolved, its reputation is such that a wayward child might be called a 'worthless ailanthus sprout'. For some gardeners, however, it's a much-maligned tree of surprisingly exotic splendour. There is truth in both views. As Betty Smith put it in the introduction to her story, 'It would be considered beautiful but there are too many of it.'

Eastern White Pine

Pinus strobus

The most economically and strategically valuable feature of the eastern white pine (often just called 'white pine') of the northeastern United States has been its stem, which is stiff and sturdy for its weight and unusually straight and tall. The tree has become a symbol of American independence, both for its role in colonial history and because it is a favourite nesting place for bald eagles.

In its early years white pine will often lose out to other species in the competition for light, but among its own kind it can grow 45 metres (150 feet) tall or more, eventually towering head and shoulders above other trees in the forest. It also has ruses that allow it to thrive even when it is surrounded by taller individuals. White pine is adept at mining the soil for organic nitrogen, then – having decreased the fertility of the surrounding soil – using this store of nitrogen compounds to outcompete other species. Its branches are almost horizontal, or even rise slightly. With age, it loses its youthful pyramidal shape and takes on an irregular and rather frayed appearance. The soft, slender needles are blue-green and three-sided, each with a line of white, so the boughs sparkle pleasingly in a breeze.

Like most conifers, the white pine has not evolved the knack of commandeering insects to transport its pollen. It is magnificently profligate, manufacturing yellow clouds of the stuff to be borne on the wind and causing early sailors to wonder at the fall of brimstone on their decks as they passed close to the shore.

Native Americans had scores of uses for the white pine. They made an anti-scurvy tea from the needles, which contain vitamin C, and used the soaked bark to soothe wounds. Resin was used as an antiseptic and also a caulk for cracks and joints in their canoes, which they made by hollowing out smaller trees with fire.

Colonists had their own use for the tree. In the days of sail, the taller and stronger a mast, the more power a ship could draw from the wind and the faster it could go. Whether carrying cargo, chasing down pirates or fighting wars, the slightest edge on the competition was immensely valuable. In the early seventeenth century England depended on the Baltic states for ships' masts, for which the country competed uneasily with the French, Dutch and Spanish. When the English gained access to the towering forests of New England, there was huge excitement about the

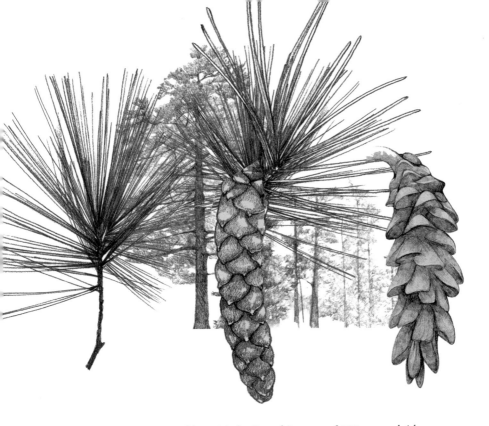

strategic opportunity, and in 1634 the first shipment of 100 masts, laid horizontally in a specially adapted ship, left New Hampshire for England. Over the decades, colonists developed the skill to stop the 10-ton trees from splintering when they fell and to transport them with teams of oxen and down rivers. They made fortunes from selling white-pine masts and at the same time established a network of sawmills, using the pale timber that gave the tree its name for building their homes and fitting out their churches. Large trees were being depleted at an alarming rate.

The masts were so critical for the continued dominance of the English Royal Navy and for the prosperity of the country that in the seventeenth and eighteenth centuries the British Parliament and its agents passed strict laws reserving white pines for the Crown. Surveyors claimed the best trees by marking their trunks with the King's Broad Arrow – three distinctive hatchet marks – and there were stiff penalties for those who felled them. Having such valuable trees close at hand but out of reach led to great resentment among the settlers, and cutting down the trees was one of the first acts of rebellion against British rule. In 1774 Congress prohibited the export of white pine, and two years later Colonial warships carried a flag depicting the white pine on top of their masts: a symbol of power and defiance in the War of Independence that their British opponents would have keenly understood.

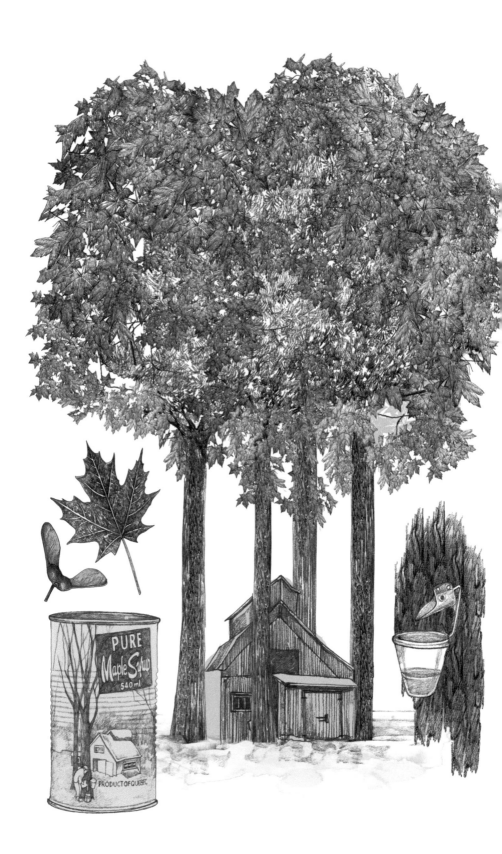

Sugar Maple

Acer saccharum

The sugar maple is most proudly associated with Quebec, Ontario and the US state of Vermont, and is known for its delectable pancake-smothering syrup, its timber – solid enough for baseball bats – and its leaves that proudly shout: 'Canada!' Less widely understood is why deciduous trees in this region, especially its maples, stage such a gorgeous show of autumn colour.

Leaves are chemical factories that conjure sugars out of carbon dioxide and water, using sunlight to drive the reaction. In order to enable this process of photosynthesis, plants make chlorophyll, which is bright green. Leaves also produce orange and yellow antioxidant chemicals – carotenes and xanthophylls – to mop up any highly reactive oxygen produced as a by-product of photosynthesis and make the most of the sun's rays by channelling light of different colours to the chlorophyll molecules.

Those glorious yellow and orange colours are always there, but masked by the green chlorophyll. In autumn, when the trees begin to slow down, they recycle anything that could be useful the next year. As chlorophyll is broken down and reabsorbed, the leaves' green colouring disappears, leaving the oranges and yellows unobscured. At the same time, red and purple anthocyanins are produced. *Voilà*: the leaves change colour.

But maple trees in eastern North America have a flourish to add to this magic show. As deciduous leaves die, especially maple leaves, sugar that the tree hasn't yet reabsorbed from its leaves turns gradually into bright-red anthocyanins. This requires an autumn typical of the region: crisp, frosty nights to slow the sugar's journey out of the leaves, followed by sunny, warm days to allow anthocyanins to be produced. In Europe, autumn is often cool and overcast during the day, or not so cold at night. That is why the very same maple species, when planted in more temperate climates, is so much less vibrant.

Maple leaves redden as they age; the leaves of peepul (p. 122) are red when they are new.

Where to go next

I live close to the spectacular living collection at the Royal Botanic
Gardens, Kew, London, where I have been able to see many species
at different times of the year. I recommend you begin your tree
journey at a botanic garden, where you will be able to take an
arboricultural tour of at least some part of the world without
going on an expensive journey. To find the garden nearest to you,
take a look at Botanic Gardens Conservation International at
bgci.org. Most botanic gardens have enthusiastic staff and helpful
literature.

While researching this book, I consulted many journals and
scientific papers. As this is not an academic title, I have not
included an exhaustive list of references, but here are some sources
I recommend if your appetite has been whetted. Most publications
on this list are readily available but others may require a library
visit or a trawl of second-hand bookshops. Where the book's
subject isn't immediately obvious from its title, or where I thought
a short description would be useful, I have added it.

To suit any enthusiastic lay reader

Trees: Their Natural History, Peter A. Thomas (Cambridge University Press, 2014) If you would like to understand the science of how trees work and what they do, this is the clearest source I've found.

Between Earth and Sky, N. M. Nadkarni (University of California Press, 2008) Combines the human and scientific in a charming manner.

The Forest Unseen, D. G. Haskell (Penguin Books, 2013) A meticulous and unexpectedly poetic observation of a square-metre patch of old-growth Tennessee forest.

The Tree: Meaning and Myth, F. Carey (The British Museum Press, 2012) Covers about 30 interesting species from a cultural point of view. Text and illustrations are excellent.

Delving deeper

If you want to learn more (of course you do!):

Biology of Plants (*7th Edition*), P. H. Raven, R. F. Evert and S. E. Eichhorn (W. H. Freeman and Company, 2005) My most-thumbed general textbook on plant science.

The Plant-book, D. J. Mabberley (Cambridge University Press, 2006) Species-by-species notes. Breathtakingly comprehensive, though firmly aimed at aficionados.

The Oxford Encyclopedia of Trees of the World, ed. B. Hora (Oxford University Press, 1987)

International Book of Wood (Mitchell Beazley, 1989)

The Life of a Leaf, S. Vogel (University of Chicago Press, 2012) Includes plenty of kitchen table science, which is unusual in a book aimed squarely at adults.

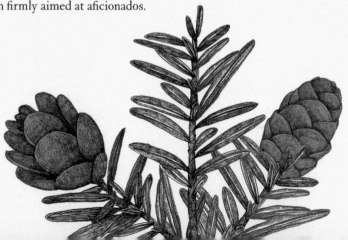

By location

Europe
Arboretum, Owen Johnson
(Whittet Books, 2015)
With lovely descriptions of both
native and introduced species
and their histories in the UK
and Ireland.

Flora Celtica, W. Milliken and S.
Bridgewater (Birlinn Limited, 2013)
About plants and people in Scotland.

Mediterranean
*Trees and Timber in the Ancient
Mediterranean World*, R. Meiggs
(Oxford University Press, 1982)

Plants of the Bible, M. Zohary
(Cambridge University Press, 1982)

Illustrated Encyclopedia of Bible Plants,
F. N. Hepper (Inter Varsity Press,
1992)

Africa
Travels and Life in Ashanti & Jaman,
R. Austin Freeman (Archibold
Constable & Co, 1898)
Austin Freeman was an expedition
doctor in West Africa. His excellent
account and enlightened attitude
were way ahead of his time.

*People's Plants: A guide to useful
plants of Southern Africa*, B-E. van
Wyk and N. Gericke (Briza
Publications, 2007)

India
Sacred Plants of India, N. Krishna and
M. Amirthalingam (Penguin Books
India, 2014)

Jungle Trees of Central India,
P. Krishen (Penguin Books
India, 2013)

South East Asia
*A Dictionary of the Economic Products
of the Malay Peninsula*, I. H. Burkill
(Crown Agents for the
Colonies, 1935)
A monumental work that says as
much about Empire as the many tree
species and their uses it describes.

*Fruits of South East Asia: Facts
and Folklore*, J. M. Piper (Oxford
University Press, 1989)

*A Garden of Eden: Plant Life in
South-East Asia*, W. Veevers-Carter
(Oxford University Press, 1986)

On the Forests of Tropical Asia,
P. Ashton (Royal Botanic Gardens
Kew, 2014)

North America
The Urban Tree Book, A. Plotnik
(Three Rivers Press, 2000)

Oceania
*Traditional Trees of Pacific
Islands: Their Culture, Environment,
and Use*, C. R. Elevitch (PAR, 2006)

By theme

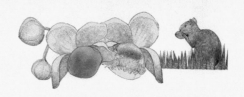

Biodiversity and Plant-Animal Relationships

Sustaining Life: How human health depends on biodiversity, E. Chivian and A. Bernstein (Oxford University Press, 2008). Required reading for every politician and policy-maker on the planet.

Leaf Defence, E. E. Farmer (Oxford University Press, 2014)

Plant–Animal Communication, H. M. Schaefer and G. D. Ruxton (Oxford University Press, 2011)

Colour

Nature's Palette, D. Lee (University of Chicago Press, 2007)
A delightful book on the science of plant colour. Witty, opinionated and very scientific.

Economic botany

Plants in Our World, B. B. Simpson and M. C. Ogorzaly, 4th edition (McGraw-Hill, 2013)
An excellent general work on the uses of plants by humans.

Plants from Roots to Riches, K. Willis and C. Fry (John Murray, 2014)

Forestry and siviculture

The New Sylva, G. Hemery and S. Simblet (Bloomsbury, 2014)
A modern re-telling of John Evelyn's *Sylva* of 1664.

The CABI Encyclopedia of Forest Trees (CAB International, 2013)
A Manual of the Timbers of the World, A. L. Howard (Macmillan and Co., 1920)

Medicine

Medicinal Plants of the World, B-E. van Wyk and M. Wink (Timber Press, 2005)

Mind Altering and Poisonous Plants of the World, B-E. van Wyk and M. Wink (Timber Press, 2008)

Strange Plants

Bizarre Plants, William A. Emboden (Cassell & Collier Macmillan Publishers Ltd., 1974)

Fantastic trees, Edwin A. Menninger (Timber Press, 1995)

The Strangest Plants in the World, S. Talalaj (Robert Hale Ltd., 1992)

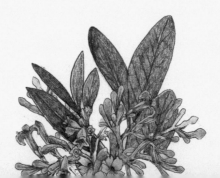

Social and Cultural History
Compendium of Symbolic and Ritual Plants in Europe (originally *Compendium van Rituele Planten in Europa*), M. De Cleene & M. C. Lejeune (Man & Culture Publishers, 2003)

A Forest Journey: The role of wood in the development of civilization, J. Perlin (W. W. Norton & Co, 1989)

In the Shadow of Slavery: Africa's botanical legacy in the Atlantic world, J. A. Carney and R. N. Rosomoff (University of California Press, 2011)

The Tropics
Tropical & Subtropical Trees: A worldwide encyclopaedic guide, M. Barwick (Thames & Hudson, 2004)

Even more specialized sources

There are many books available on individual genera and even species. Here are a few that are particularly enjoyable reads:

A Book of Baobabs, Ellen Drake (Aardvark Press, 2006)

Betel Chewing Traditions in South-East Asia, D. F. Rooney (Oxford University Press, 1993)

Black Drink: A native American tea, C. M. Hudson, ed. (University of Georgia Press, 2004) Essays on different aspects of *Ilex vomitoria*, or Indian Black Tea.

The Story of Boxwood, C. McCarty (The Dietz Press Inc., 1950)

Devil's Milk: A social history of rubber, John Tully (Monthly Review Press, 2011)

The Tanoak Tree, F. Bowcutt (University of Washington Press, 2015)

The Fever Trail: The hunt for the cure for malaria, M. Honigsbaum (Macmillan, 2001)

Chicle: The chewing gum of the Americas from the ancient Maya to William Wrigley, J. P. Mathews and G. P. Schultz (University of Arizona Press, 2009)

Handbook of Coniferae, W. Dallimore and B. Jackson (Edward Arnold & Co., 1948)

Sagas of the Evergreens, F. H. Lamb (W. W. Norton & Co. Inc., 1938)

Online resources with free access

plantsoftheworldonline.org
From Kew, detailed
descriptions of tens of
thousands of species. An
excellent first port of call.

agroforestry.org
Specializing in
Pacific plants.

ARKive.org
Especially helpful on
endangered plant and
animal species. Well-
illustrated and written.

anpsa.org.au
The Australian native
plants society.

bgci.org
Botanic Gardens
Conservation
International. Try their
GardenSearch to discover
local resources.

conifers.org
Gymnosperm database:
information on conifers
and their allies.

eol.org
Encyclopedia of Life:
Contains an entry for
every known species, with
key attributes, maps and
photographs.

globaltrees.org
Has a very good section on
endangered species.

LNtreasures.com
Living National Treasures:
Find animal and plant
species that are endemic to
any country.

monumentaltrees.com
Find the champion trees of
any species and be sure to
look at the world map.

naeb.brit.org
Native American
Ethnobotany: Worth
persevering beyond the
difficult interface to find
the many uses of plants by
indigenous people.

nativetreesociety.org
Mostly North American
species but includes a lot of
cultural discussion.

onezoom.org
A miraculous, easily
navigable representation
of the entire tree of life
and the inter-relationship
between species. Hours
of fun.

plants.usda.gov
US Department
of Agriculture:
Characteristics and
distribution of many
indigenous and native
species.

sciencedaily.com
Excellent and accessible
reporting of up-to-the-
minute scientific research.
Well curated, with plenty
of plant stories.

**TreesAndShrubsOnline.
org**
From the International
Dendrology Society.
Excellent descriptions of
temperate plants.

wood-database.com
Natural Resources
Conservation Service
Wood Database.
Information about
commercial woods and
timbers.

Index

Index

About the Illustrator

Lucille Clerc is a French illustrator who set up her studio after graduating from ENSAAMA in Paris with a DSAA in Visual Communication and Central Saint Martins in London with an MA in Communication Design. She works primarily in editorial design but has also carried out interior design and installation projects. In the past two years she has worked with Berluti, Dior, DC Comics, Farrow & Ball, Fortnum & Mason, Hôtel de Paris, M & S, the V & A Museum, Winsor & Newton and Historical Royal Palaces. She produces most of her work by hand, through drawing and screen printing. Much of her personal work is inspired by London and the relationship between nature and cities.

Author's Acknowledgements

My editor, Sara Goldsmith, has been everything that a first-time writer, indeed any writer, could wish for – responsive and good-humoured, a stickler for quality with superb judgment and the tact of a saint. I was always going to have fun researching and writing about trees but she has made the project a joy. I am also hugely grateful to, and frankly in awe of, Lucille Clerc for her talent and patience. I hope you feel as I do, that her illustrations delightfully complement the text. Masumi Brizzo and Felicity Awdry have also been instrumental in making this book into what I feel is a beautiful and harmonious object.

The staff at the fabulous library and archive at the Royal Botanic Gardens, Kew have been endlessly and efficiently helpful. Anne Marshall there has been a star. I would especially like to thank my Kew scientist friends who generously gave of their own time to read the manuscript – Jo Osborne, Stuart Cable, Jonas Mueller and Mark Nesbitt (the doyen of economic botany) and also Mike Maunder at the Eden Project. Any howlers that remain are my own fault.

I have been fortunate in having a close association with Kew, The Woodland Trust and the World Wide Fund for Nature. The staff of those organisations do a wonderful job. They have my support and they deserve yours.

Most of what I have done is to report on the work of others; the scientists and historians who have for centuries painstakingly observed, collected, organised and researched their fields, accreting the sum-total of human knowledge, piece by piece. Without them, this book would truly not have been possible.

My wife Tracy and son Jacob have politely endured and even displayed interest in my boundless enthusiasm for all the crazy things that trees get up to. Ha! They have caught the bug now, the way my parents infected me.